HIRSCHFELD'S
BRITISH AISLES

INTERMISSION TEA IN LONDON THEATRE

1958

Perhaps the most pungent of all Al Hirschfeld's theater drawings has for its subject a dreaded hazard that for many of us halted the proceedings at every matinee in the London theatre. Just as we most wanted to know what happened next, teacups and saucers, plates and pieces of cake, were passed from hand to hand. Once done with, they had to be disposed of. The toilets meanwhile were besieged. New acquaintances were eager to talk. The drama waited, but the formula of the 'afternoon out' prevailed. To all of this, Al Hirschfeld bore witness — not as a scold, but as a lifelong student of manners and modes.

Without his 'The Afternoon Tea,' the social history of London would not be complete. Among the more than 500 drawings that document Hirschfeld's benevolent Anglomania, this is social history. Its subject matter may not rank with the Battle of Trafalgar, but this is inmost England, and is indispensable. — *John Russell*

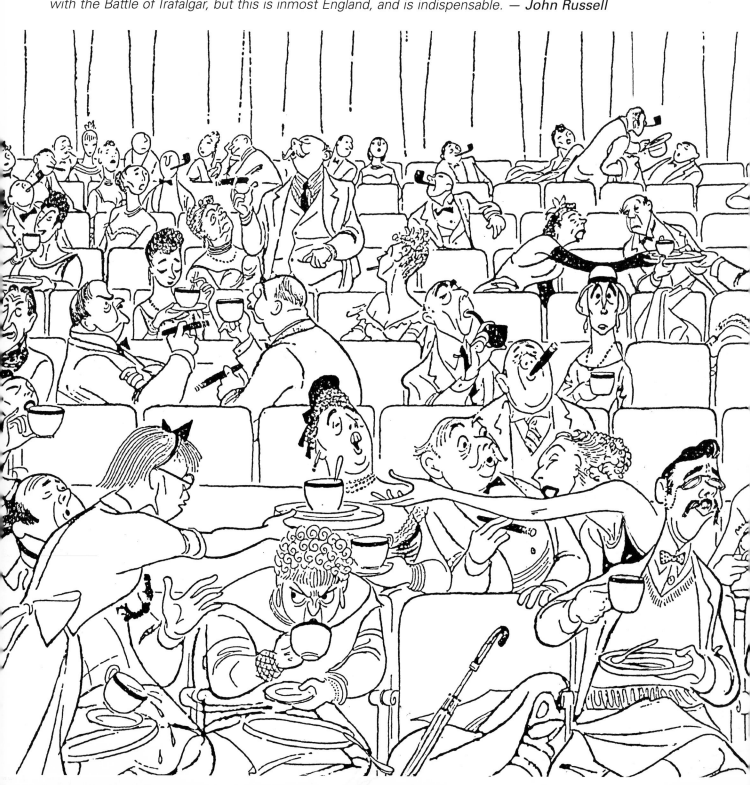

HIRSCHFELD'S
BRITISH AISLES

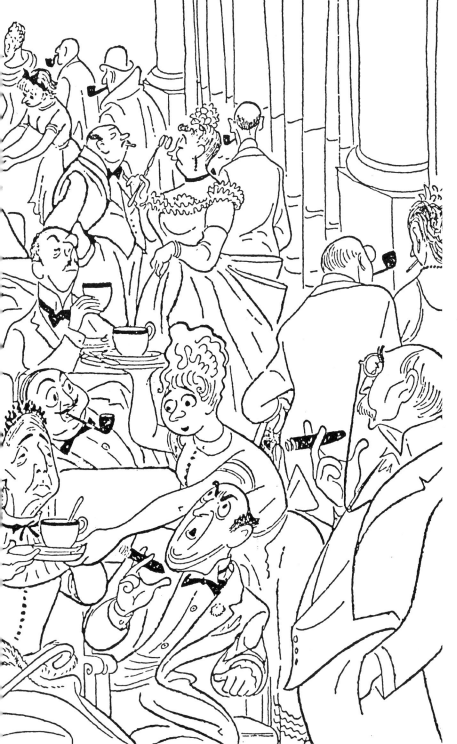

AL HIRSCHFELD

COMMENTARY BY

JULIE ANDREWS
MICHAEL BLAKEMORE
KEVIN BROWNLOW
SIMON CALLOW
JULIE CHRISTIE
DAME EDNA EVERAGE
MEL GUSSOW
LOUISE KERZ HIRSCHFELD
BARRY HUMPHRIES
SIR CAMERON MACKINTOSH
SHERIDAN MORLEY
LYNN REDGRAVE
JOHN RUSSELL
SIR PETER SHAFFER
RALPH STEADMAN
TONY WALTON
NICHOLAS WRIGHT
&
AL HIRSCHFELD

GLENN YOUNG
BOOKS

A GLENN YOUNG ORIGINAL
HIRSCHFELD'S BRITISH AISLES

British Library Catalog in Publication Data

A catalog record for this book is available from the British Library

Cataloging-in-Publication Data

Hirschfeld, Al.
 Hirschfeld's British Aisles / Al Hirschfeld ; [compiled by Louise Kerz Hirschfeld]; commentary by Julie Andrews ... [et al].
— 1st ed. —London ; New York : Glenn Young Books, 2006.

 p. ; cm.
 "A Glenn Young original."—T.p. verso.
 Includes index.
 ISBN: 1-55783-674-4

 1. Actors—Great Britain—Caricatures and cartoons. 2. Actresses—Great Britain—Caricatures and cartoons. 3. Theater—Great Britain—Caricatures and cartoons. 4. Motion pictures—Great Britain—Caricatures and cartoons. 5. Performing arts—Great Britain—Caricatures and cartoons. 6. Politicians—Great Britain—Caricatures and cartoons. 7. Great Britain—In art. I. Hirschfeld, Louise Kerz. II. Andrews, Julie. III. Title.

NC1429.H57 A4 2005
741.5/9—dc22 0507

FIRST EDITION

10 9 8 7 6 5 4 3 2 1

Editor and Publisher: Glenn Young
Curator: Louise Kerz Hirschfeld
Associate Publisher: Jacqueline Miller Rice
Associate Editor and Production Chief: Greg Collins
Chief Design Consultant: Tony Walton
Publicity Directors: Kay Radtke, Sharon Kelly, and Robert Ward
Printing: Westcom Graphics / R. R. Donnelley
Associate Design Consultant: Sue Knopf
Back Cover Photo: John Weitz, 1984

The publisher gratefully acknowledges the extraordinary assistance of Robert Lantz, Robert Wise, Tony Walton, Sue Knopf, Margo Feiden, the staff of the Margo Feiden Galleries, Dennis Aspland, Helen Kim, Lois Sieff, Victor and Marilyn Lownes, Gen LeRoy, Michael Messina, Victor Seitles and Michael White.

GLENN YOUNG BOOKS
are distributed to the trade in the United Kingdom by
OMNIBUS PRESS/MUSIC SALES
http://www.musicsales.co.uk

in North America by
HAL LEONARD/APPLAUSE BOOKS
1-800-637-2852 Fax 414-774-3259
www.applausepub.com
Printed in Mexico

Charles McGloin, bartender,
P. J. Clarke's; grandfather of G. Collins;
drawing by Hirschfeld, 1940

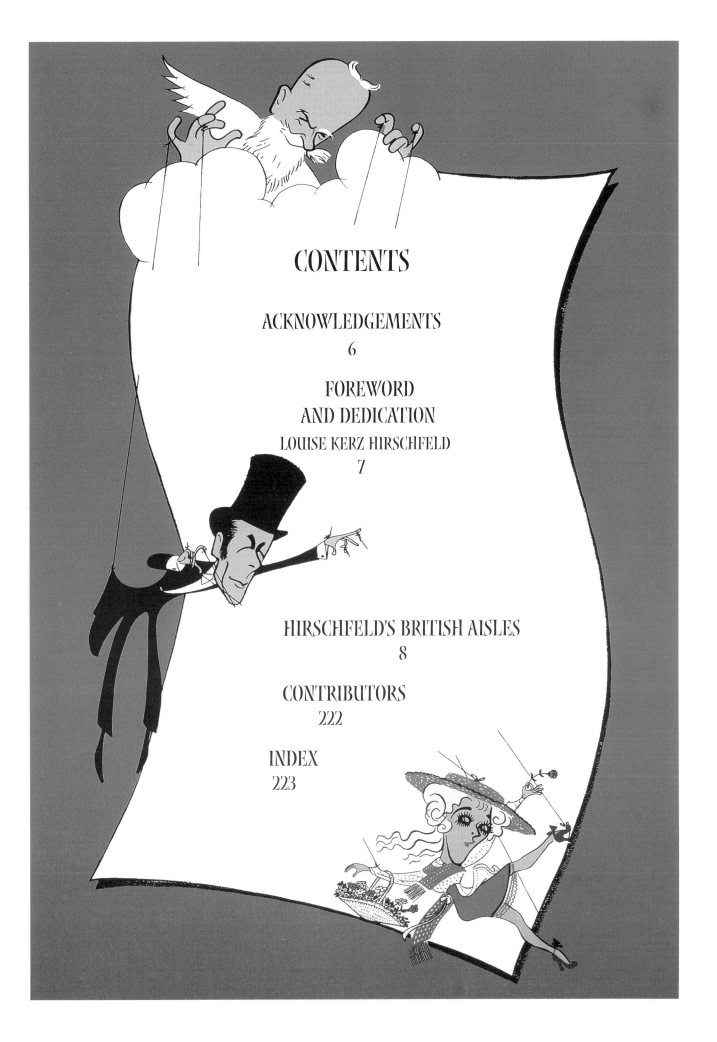

CONTENTS

ACKNOWLEDGEMENTS

Mr. Hirschfeld gave Glenn Young his trust, which is, I suppose, the greatest gift an artist can bestow upon a publisher. And nobody could have honored that trust with more indefatigable hands-on care, imaginative design and editorial astuteness. I remember the first day Robby Lantz brought Glenn over to discuss his notion of creating a breathing, vibrant archive of Al's work on the page. Now into our fourth book under Glenn's stewardship, he and I have worked closely together on every aspect of the book you're holding — and against time constraints the traditional breed of publisher would have paled and cringed at.

Robert Lantz, debonair overseer of Hirschfeld's literary life

David Leopold — the talented and invaluable Hirschfeld archivist

Publishing Staff: Greg Collins, Sheila Paige, Sue Knopf, Kay Radtke, Vic Seitles

The brilliant and incomparable Tony Walton

Ellen Harrington, Academy of Motion Picture Arts and Sciences, Los Angeles

Arthur Gelb, Linda Amster, and Phyllis Collazo, *The New York Times*

Margo Feiden and her gallery staff

The V & A Theatre Museum

John Langley and his staff at the Royal National Theatre

Frederic W. Wilson, The Harvard Theatre Collection

Rosy Runciman, archivist, Cameron Mackintosh, Ltd.

Bill Jacklin, Susan Kohner Weitz

Sam Buckland, Ronald Gerver, James Sage and Lois Sieff, London

London Honorary Committee: Julie Andrews, Frith Banbury, Michael Blakemore, Kevin Brownlow, Arthur Gelb, Nicholas Hytner, Barry Humphries, Sir Cameron Mackintosh, Liam Neeson, Harold Prince, Lynn Redgrave, Natasha Richardson, John Russell, Sir Peter Shaffer, Andrew Lloyd Webber and Tony Walton

London Patrons Committee: The Al Hirschfeld Foundation, The Mortimer Levitt Foundation, Inc., The Cameron Mackintosh Foundation, Chase Mishkin, The New York Times Foundation, Harold Prince, Melvin R. Seiden Fund, Martin E. Segal and the Dorothy Strelsin Foundation

HIRSCHFELD BY BILL JACKLIN

Drawings that first appeared in *The New York Times* are noted as **NYT** in the credit block. Works commissioned by Margo Feiden are noted as **MF**. Private commissions were arranged by the Margo Feiden Gallery. Actors are listed left to right unless otherwise noted.

— Louise Kerz Hirschfeld

FOREWORD AND DEDICATION

Louise Kerz Hirschfeld

We sat in deck chairs under the main QE2 stack as the New York skyline receded in grand cinematic style. The deck captain greeted him with 'Welcome on board, Mr. Hirschfeld. Would you care for the usual?' — as a Pims Cup materialized out of dark blue skies. Clearly I was traveling with a Cunard veteran. He had in fact been sailing between the two ports for nearly seventy years.

In the early 1930s, Hirschfeld visited with his friend designer Roger Furse in London. But upon his return from a Moscow Theatre Festival in 1936, he was sufficiently enchanted with his new surroundings and sufficiently disenchanted with Moscow's brand of politics that he actually studied lithography at the London County Council.

PHOTO: PAMELA STANFIELD

My future husband showed me the London he loved and its theatre which inspired him. We toured the new Globe Theatre, took nostalgic walks, visited his old drinking haunts, had dinner with Frith Banbury and reminisced about the artist's old friends, Chaplin, Olivier and Gielgud. The artist's Anglomania was in full, virulent force. Al created a full page of theatre highlights of 1996 (see page 209) — a season when every moment seemed a highlight — for *The New York Times*.

What hadn't been clear until they began to emerge from the archives were the hundreds of Hirschfeld drawings dedicated to British performing arts and culture. When I'd organized this major body of work, I confess my first instinct was to go up and proudly tell Al what I'd discovered. My second instinct was to approach the V & A Theatre Museum in Covent Garden. Their immediate enthusiasm ignited the London Celebration, 'Hirschfeld's Brits on Broadway.' The Academy of Motion Picture Arts and Sciences in Los Angeles stepped forth to sponsor 'Hirschfeld's Hollywood' at the National Theatre.

This book is an expanded version of those exhibitions together with comments from celebrated members of the (mostly) British theatrical community. The reader might find a few surprising comments on the artistry of the drawing, the production, the acting, the play or all of the above. We ever so briefly contemplated a bit of selective editing of these comments until editor Glenn Young asked me: 'If Al had read these, what would he have said?' 'That's simple,' I channeled. 'If you ask an artist for a reaction, print it as it comes off his pen.' Thanks, dear Al, for that.

And now, Ladies and Gentlemen, if you'll kindly find your way to your seats — all, of course, on the aisle for this performance — the show is about to begin . . .

This book is dedicated to Mel Gussow, New York's London bridge
from Times Square to Piccadilly Circus

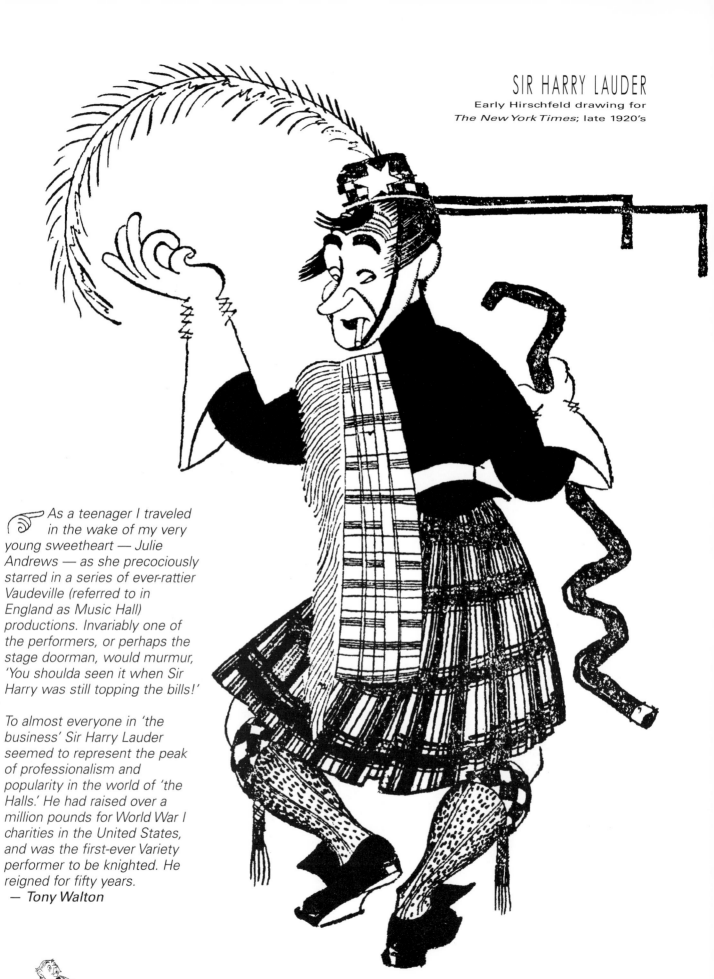

SIR HARRY LAUDER
Early Hirschfeld drawing for
The New York Times; late 1920's

As a teenager I traveled in the wake of my very young sweetheart — Julie Andrews — as she precociously starred in a series of ever-rattier Vaudeville (referred to in England as Music Hall) productions. Invariably one of the performers, or perhaps the stage doorman, would murmur, 'You shoulda seen it when Sir Harry was still topping the bills!'

To almost everyone in 'the business' Sir Harry Lauder seemed to represent the peak of professionalism and popularity in the world of 'the Halls.' He had raised over a million pounds for World War I charities in the United States, and was the first-ever Variety performer to be knighted. He reigned for fifty years.
— Tony Walton

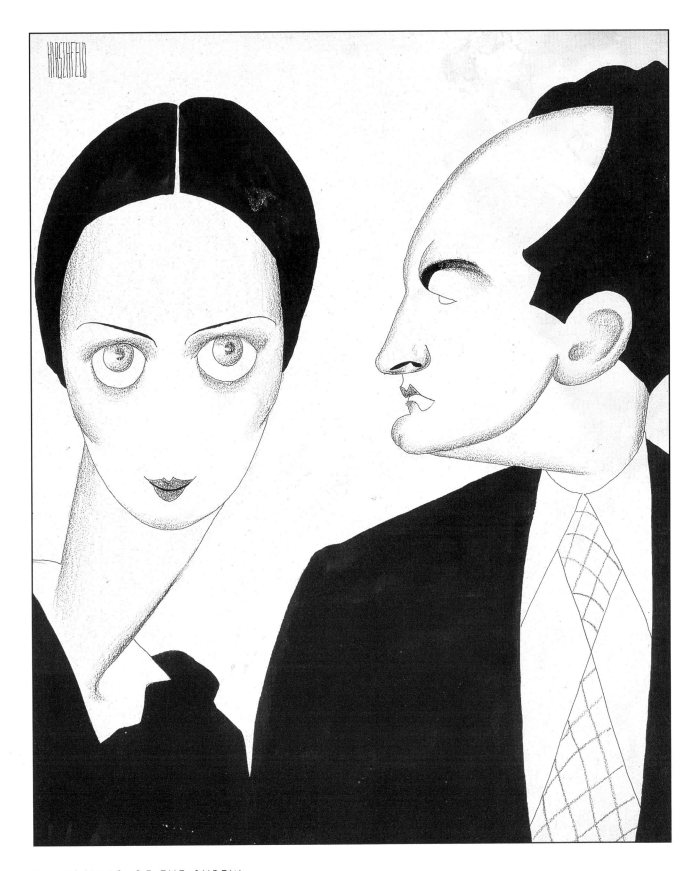

THE TAMING OF THE SHREW
Produced by the Garrick Players; actors: Mary Ellis & Basil Sidney; *The Morning Telegraph,* 1927

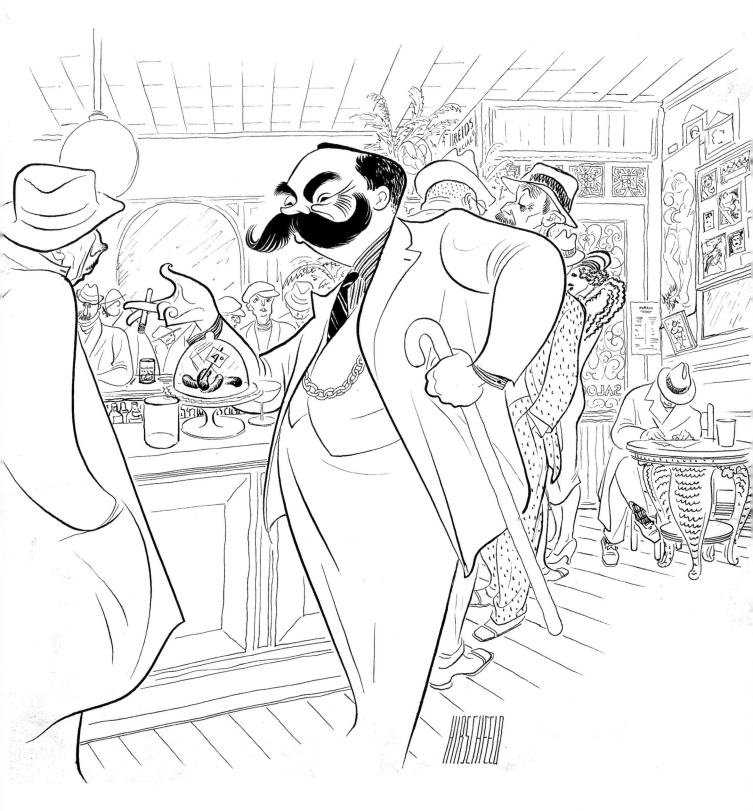

FRENCH PUB

Daily Express, London, 1936

EBONY JOINT

Jocelyn Augustus Bingham as 'Frisco';
Daily Express, London, 1936

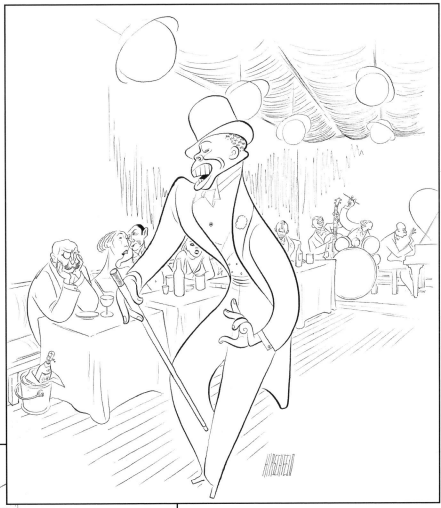

HARRY CRADDOCK
OF THE SAVOY

Inventor of the White Lady;
Daily Express, London, 1936

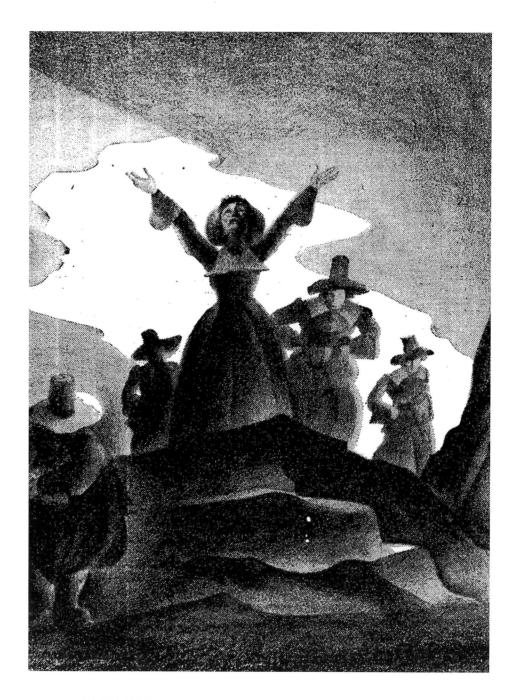

HIGH TOR

by Maxwell Anderson; directed by Guthrie McClintic;
actors: Peggy Ashcroft & cast; *NYT*, 1937

ART & INDUSTRY
Outside British Museum; lithograph; personal collection of Al Hirschfeld, 1931

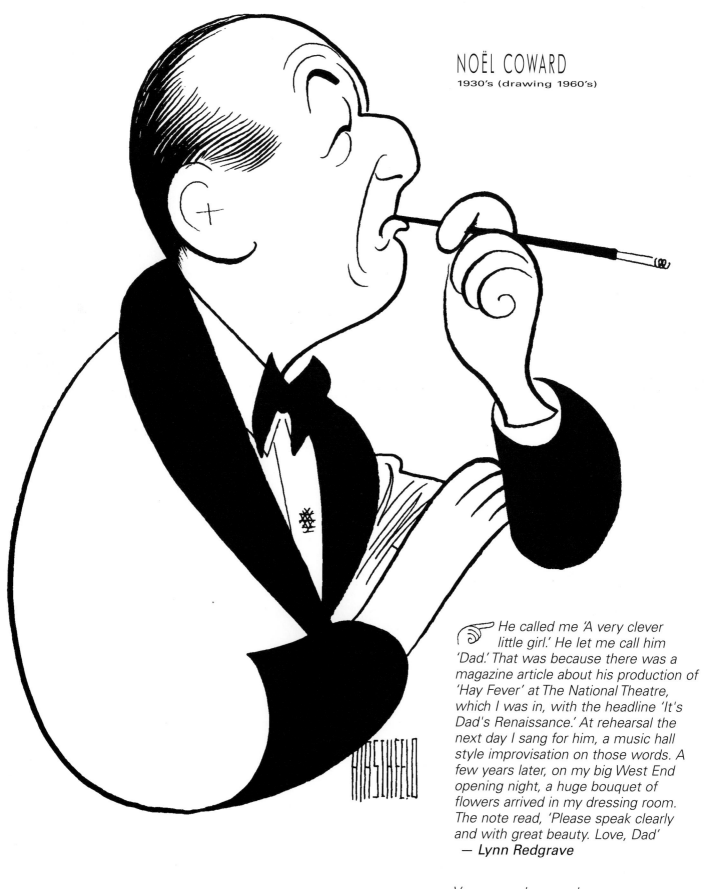

NOËL COWARD
1930's (drawing 1960's)

He called me 'A very clever little girl.' He let me call him 'Dad.' That was because there was a magazine article about his production of 'Hay Fever' at The National Theatre, which I was in, with the headline 'It's Dad's Renaissance.' At rehearsal the next day I sang for him, a music hall style improvisation on those words. A few years later, on my big West End opening night, a huge bouquet of flowers arrived in my dressing room. The note read, 'Please speak clearly and with great beauty. Love, Dad'
— Lynn Redgrave

Very, very clever and very, very cross. Hirschfeld, working like a Japanese master, depicts another.
— Simon Callow

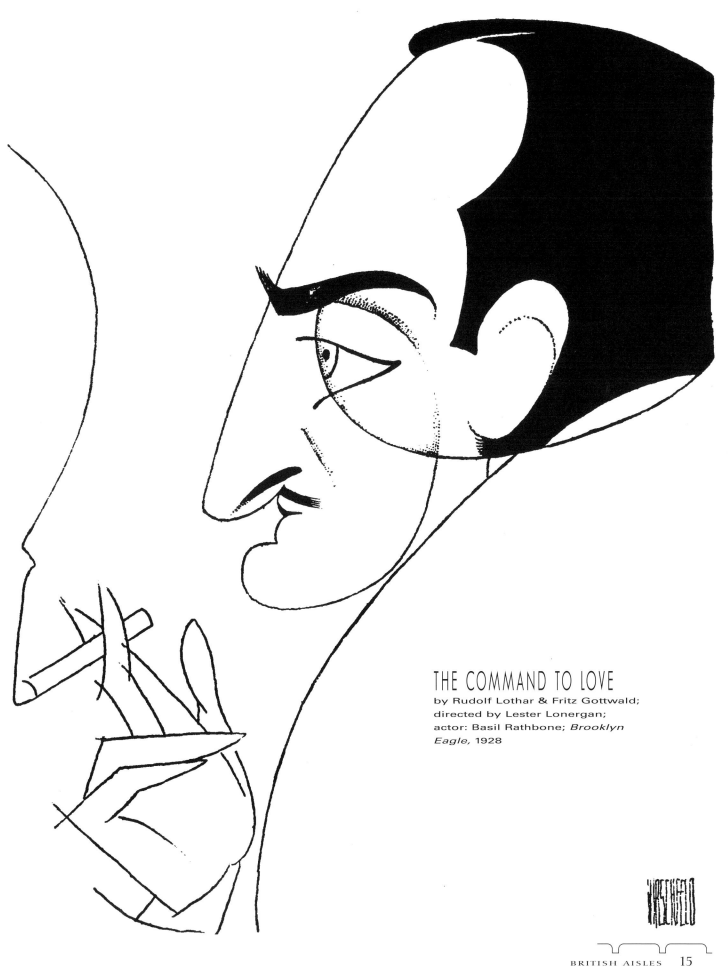

THE COMMAND TO LOVE
by Rudolf Lothar & Fritz Gottwald;
directed by Lester Lonergan;
actor: Basil Rathbone; *Brooklyn
Eagle,* 1928

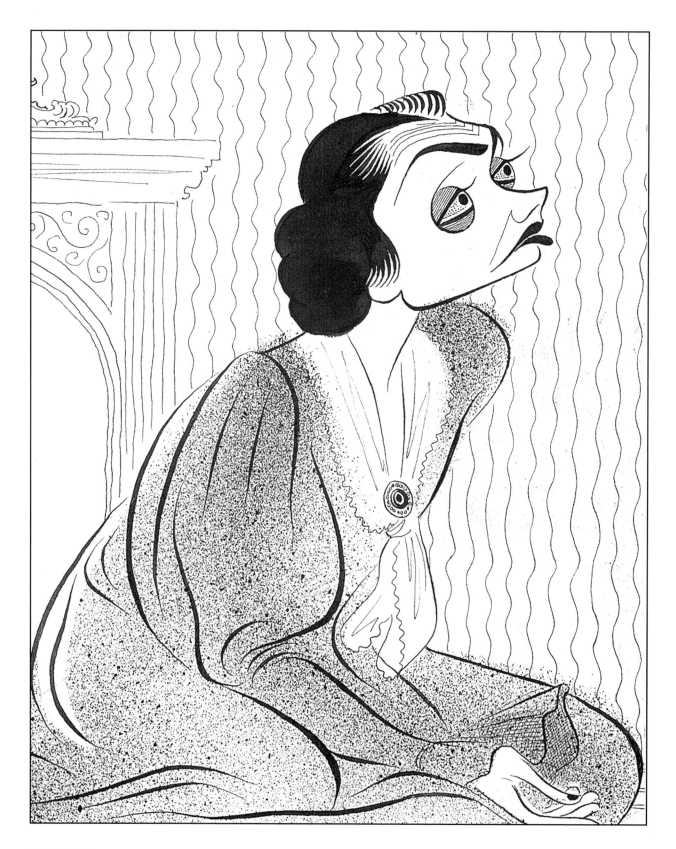

CANDIDA

by George Bernard Shaw; directed by Guthrie McClintic; actor: Katherine Cornell; detail of drawing, *Brooklyn Eagle,* 1936

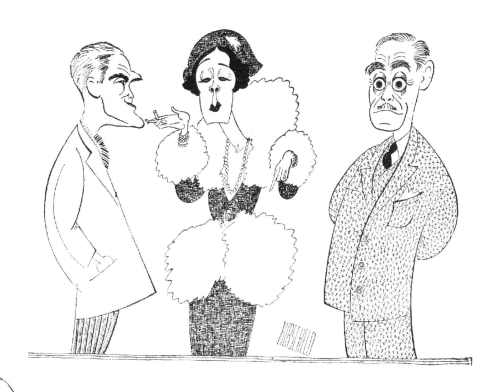

ART & MRS. BOTTLE

by Benn W. Levy; actors: Leon Quartermaine,
Jane Cowl & Walter Kingsford; *NYT,* 1930

☞ *Jane Cowl was a major star of her time as
much so in her day as Katharine Hepburn
was in hers. With a tip of her finger and a nod,
she could convey an innate sense of snobbery.
Look closely at the drawing — did Hirschfeld spell
his name wrong? — Mel Gussow*

SAINT JOAN

Katherine Cornell; *NY Herald Tribune,* 1936

SET TO MUSIC

Sketches, music, and lyrics by Noël Coward; directed by Noël Coward; actor: Beatrice Lillie; NY Herald Tribune, 1939

Hirschfeld was much needed as a recorder of moments in the theatre that are often talked of but not easy to reconstruct. One such is the impact of Beatrice Lillie, an actress whose incomparable vitality and unpredictable wit made her a legend in her lifetime. When she made a sensation in Noël Coward's 1939 'Set to Music,' Hirschfeld was able to present her on a single sheet of paper as a schoolgirl, a party girl, a sorority pet and 'a lady spy.' To a remarkable degree, these drawings do not date. — *John Russell*

THE PRINCE OF WALES TURNS HIS BACK ON THE THRONE

New Masses cover, 1937

Not one of his best, I fear! The pound note gets in the way. It compromises the drawing in a rather offensive way and denies Al's precise observation of characteristic features. Looks more like the current Prince of Wales actually. — *Ralph Steadman*

This was a cover I did for the 'New Masses,' which served as an outlet for my political drawings or anything too hot to be handled by the mainstream New York papers. I was fairly far Left back then. I wanted the viewer to witness the Prince of Wales turning himself into the Duke of Windsor under the intense spotlight of the grand world stage. The most obvious effect is how the English pound character £ lent itself to his highness' likeness. The bird atop the scepter is uttering its own protest. I never had it in me to be a real go-for-the-throat political cartoonist, but I did care passionately about politics. — *Al Hirschfeld*

KNIGHTS OF SONG

Book by Glendon Allvine, based on a story about Gilbert & Sullivan by G. Allvine & Adele Gutman Nathan;
directed by Oscar Hammerstein II; actors: Nigel Bruce, John Moore, Reginald Bach & Natalie Hall;
NY Herald Tribune, 1938

ALFRED HITCHCOCK

on the set of *Sabotage*; with producer Ivor Montagu; observed by the artist
at Shepherd's Bush Film Studio outside London; *NY Herald Tribune,* 1937

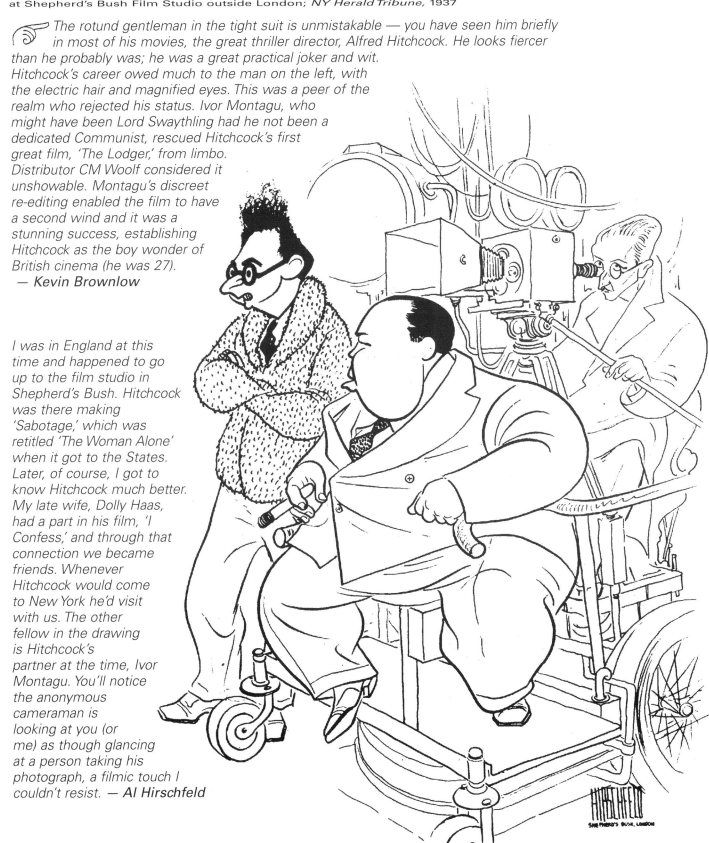

The rotund gentleman in the tight suit is unmistakable — you have seen him briefly in most of his movies, the great thriller director, Alfred Hitchcock. He looks fiercer than he probably was; he was a great practical joker and wit. Hitchcock's career owed much to the man on the left, with the electric hair and magnified eyes. This was a peer of the realm who rejected his status. Ivor Montagu, who might have been Lord Swaythling had he not been a dedicated Communist, rescued Hitchcock's first great film, 'The Lodger,' from limbo. Distributor CM Woolf considered it unshowable. Montagu's discreet re-editing enabled the film to have a second wind and it was a stunning success, establishing Hitchcock as the boy wonder of British cinema (he was 27).
— Kevin Brownlow

I was in England at this time and happened to go up to the film studio in Shepherd's Bush. Hitchcock was there making 'Sabotage,' which was retitled 'The Woman Alone' when it got to the States. Later, of course, I got to know Hitchcock much better. My late wife, Dolly Haas, had a part in his film, 'I Confess,' and through that connection we became friends. Whenever Hitchcock would come to New York he'd visit with us. The other fellow in the drawing is Hitchcock's partner at the time, Ivor Montagu. You'll notice the anonymous cameraman is looking at you (or me) as though glancing at a person taking his photograph, a filmic touch I couldn't resist. — Al Hirschfeld

THE D'OYLY CARTE COMPANY PREPARE TO OFFER A NEW SEASON
NYT, 1936

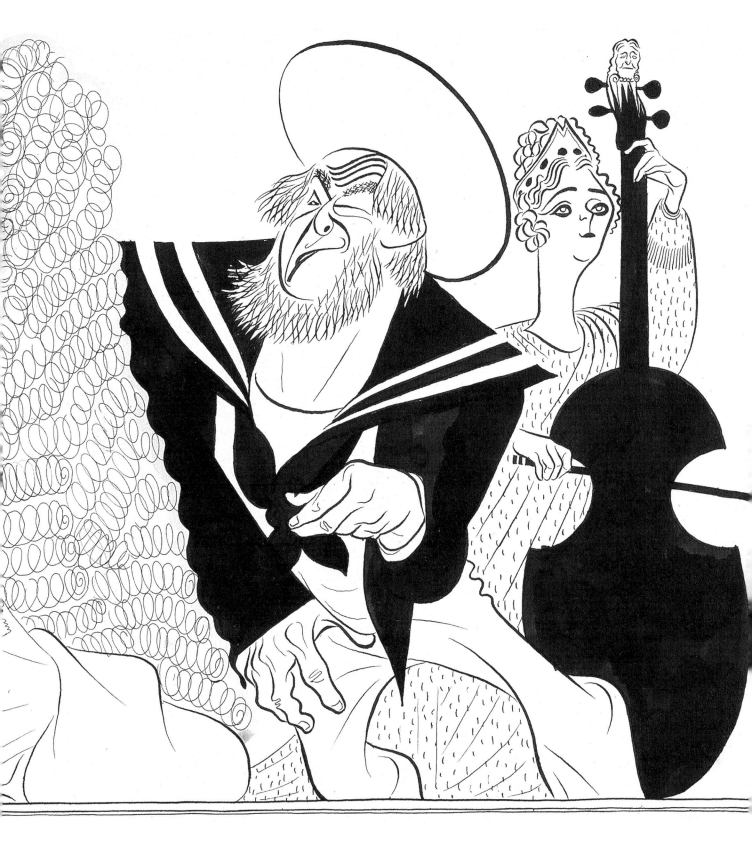

Pictured: Marjorie Eyre in *The Mikado*; Sydney Granville in *The Pirates of Penzance*; Martyn Green in *The Gondoliers*; Darrell Fancourt in *H.M.S. Pinafore*; Evelyn Gardner in *Patience*

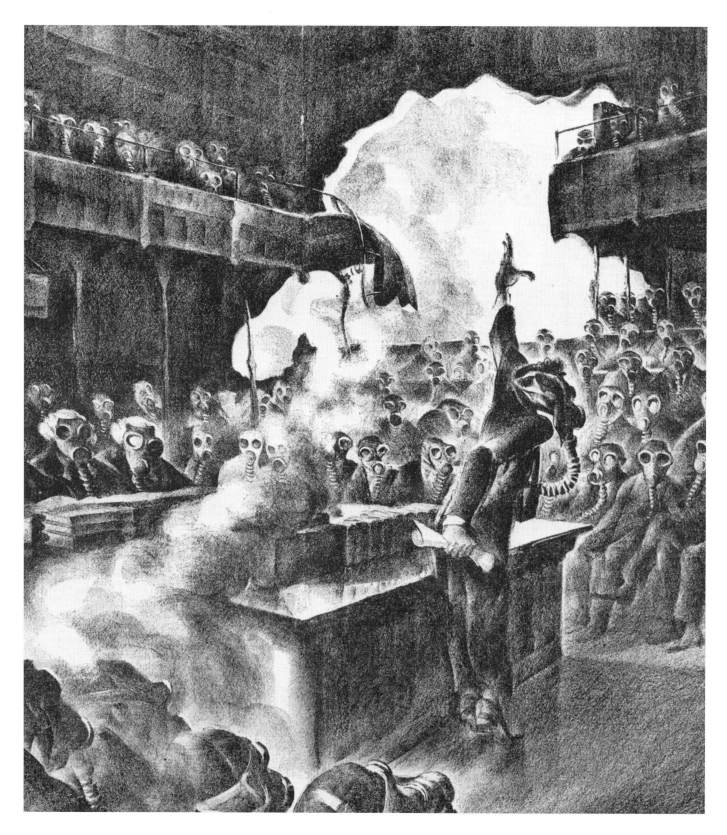

PEACE IN OUR TIME

Neville Chamberlain; detail of lithograph, *New Masses*, 1939

This is an extremely fine picture and idea, worthy of Gustav Doré and Honoré Daumier. It looks like a lithograph. It is the first of its kind I have seen of his. Excellent! — *Ralph Steadman*

world books

Market Place : Amazon US

Order No : 002-6491670-6897868

Ship Method : Standard

Order Date : 2011-07-13

Email : wllx8vzcl56k105@marketplace.amazon.com

Items : 1

Qty	Item	Locator	SKU
1	Hirschfeld's British Aisles [Paperback] by Hirschfeld, Al ISBN : 1557836744	MULTI E-086-04-06	RY

WORLD OF BOOKS USA , 4281 Express Lane , Suite L3647 , Sarasota , Florida,34238,U.S.A

Email:sales@worldofbooks.com

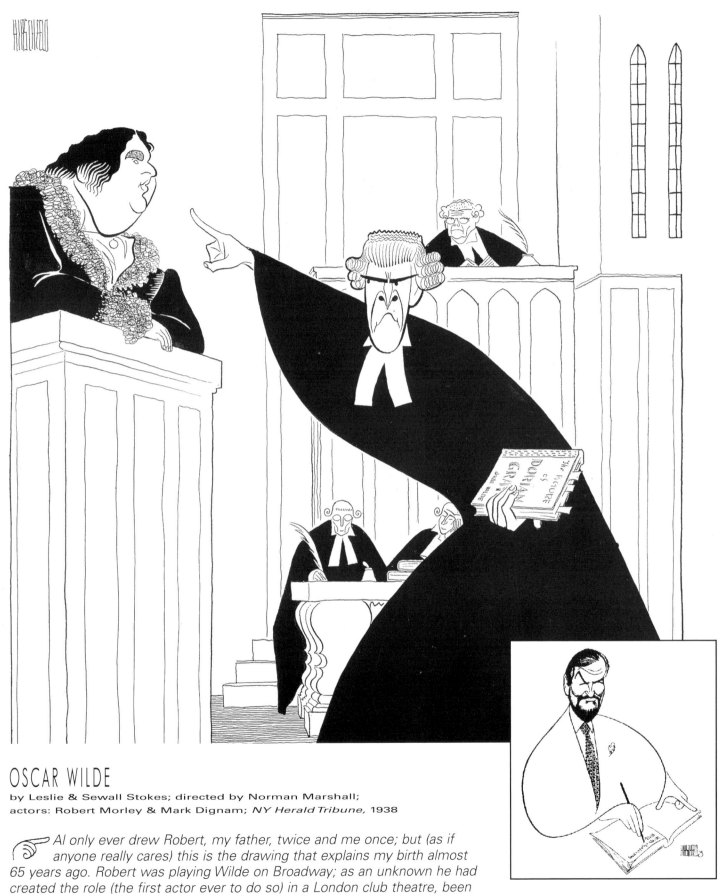

OSCAR WILDE

by Leslie & Sewall Stokes; directed by Norman Marshall;
actors: Robert Morley & Mark Dignam; *NY Herald Tribune,* 1938

Al only ever drew Robert, my father, twice and me once; but (as if anyone really cares) this is the drawing that explains my birth almost 65 years ago. Robert was playing Wilde on Broadway; as an unknown he had created the role (the first actor ever to do so) in a London club theatre, been spotted by an MGM talent scout, gone out to Hollywood to make 'Marie Antoinette' and then repeated his 'Oscar' on Broadway. The actor playing Lord Alfred Douglas, John Buckmaster, asked Pa if on his return to London he would look up his sister Joan. Robert did, married her, and she was my mother, dying at 94 only this year. 'I told you to meet her,' wired Johnnie on their wedding day, 'not necessarily to marry her.' — **Sheridan Morley**

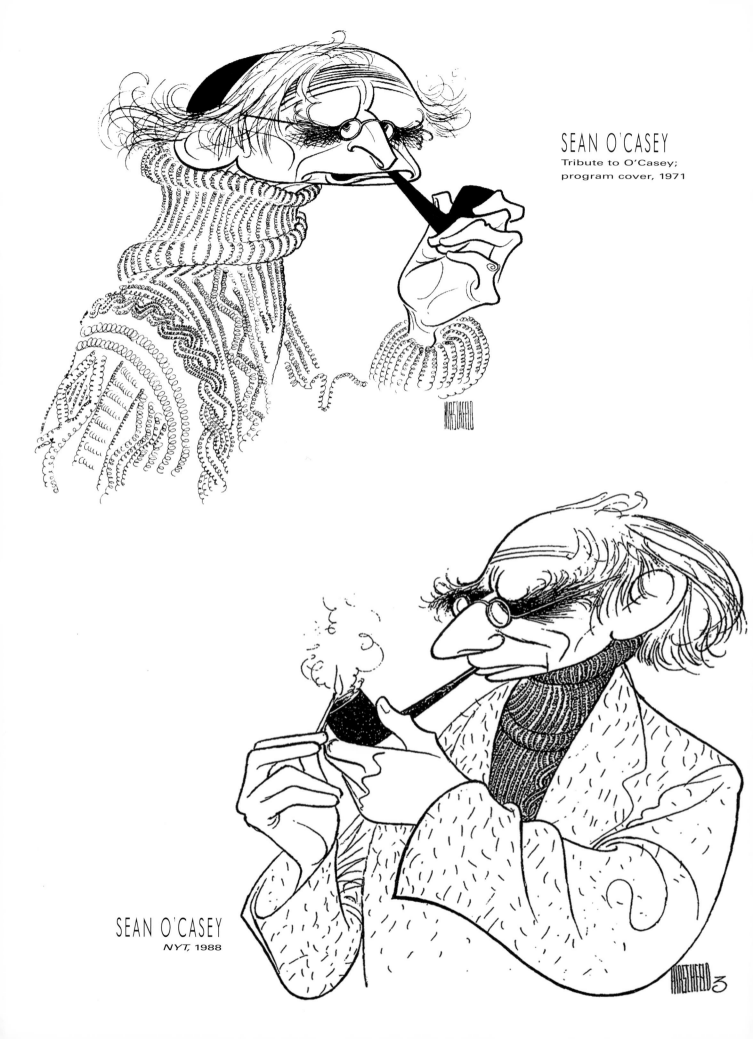

SEAN O'CASEY
Tribute to O'Casey;
program cover, 1971

SEAN O'CASEY
NYT, 1988

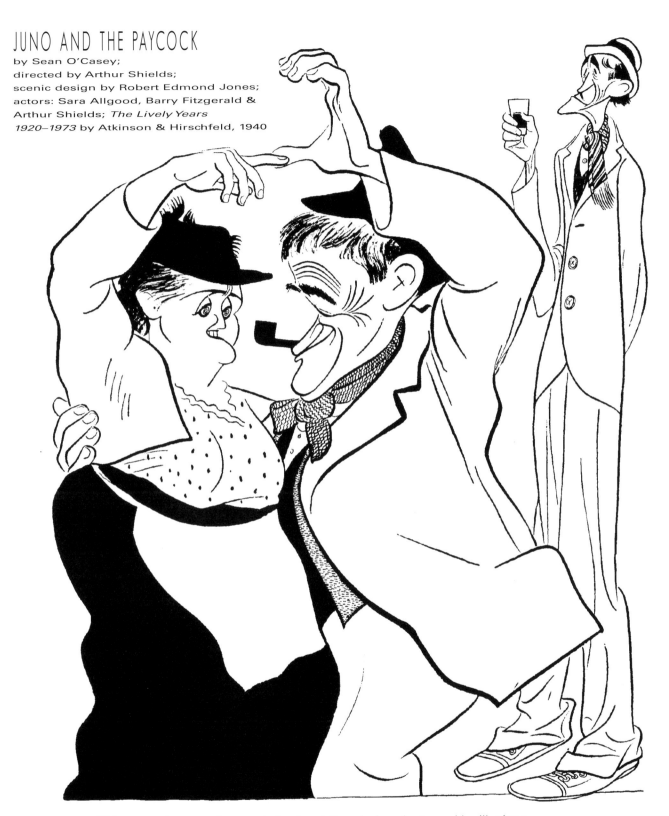

JUNO AND THE PAYCOCK

by Sean O'Casey;
directed by Arthur Shields;
scenic design by Robert Edmond Jones;
actors: Sara Allgood, Barry Fitzgerald &
Arthur Shields; *The Lively Years
1920–1973* by Atkinson & Hirschfeld, 1940

☞ *This marvelous tragi-comedy is about lives being destroyed by illusions, most of them fueled by drink. It lends itself to a certain amount of welly in the acting department, which is certainly what it's getting here. Sara Allgood had first played Juno at the première sixteen years before, since when neither she nor her performance seem to have got any smaller. The actor playing Joxer Daly, on the right, seems too decrepit and uninvolved: the whole point of the part is the man's malign conviviality. — Nicholas Wright*

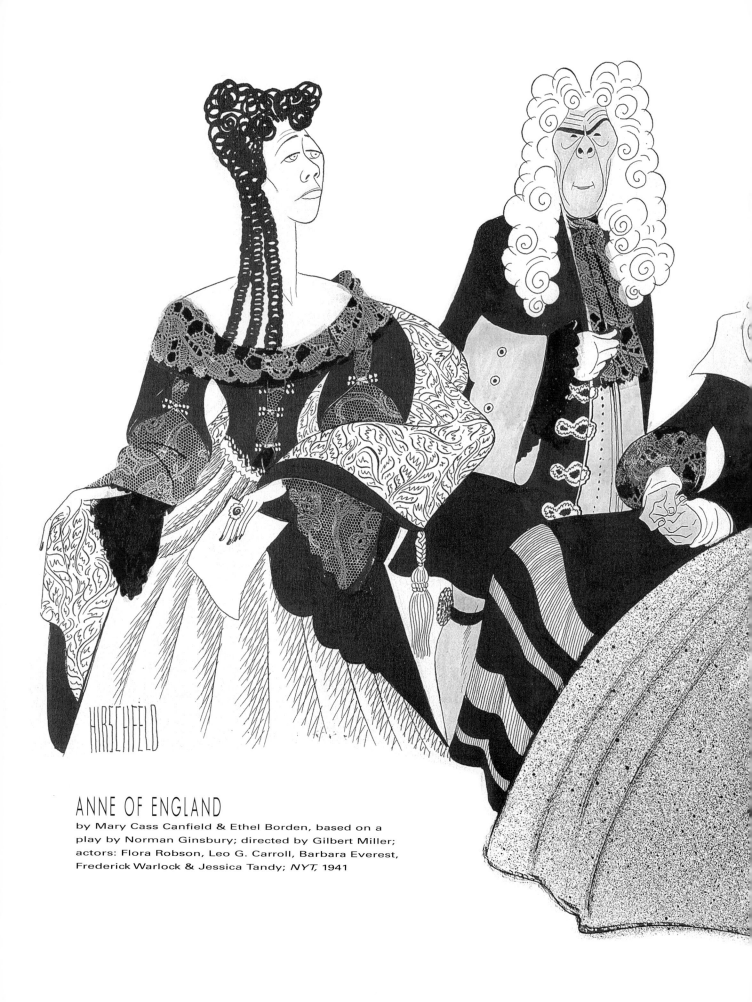

ANNE OF ENGLAND

by Mary Cass Canfield & Ethel Borden, based on a
play by Norman Ginsbury; directed by Gilbert Miller;
actors: Flora Robson, Leo G. Carroll, Barbara Everest,
Frederick Warlock & Jessica Tandy; *NYT,* 1941

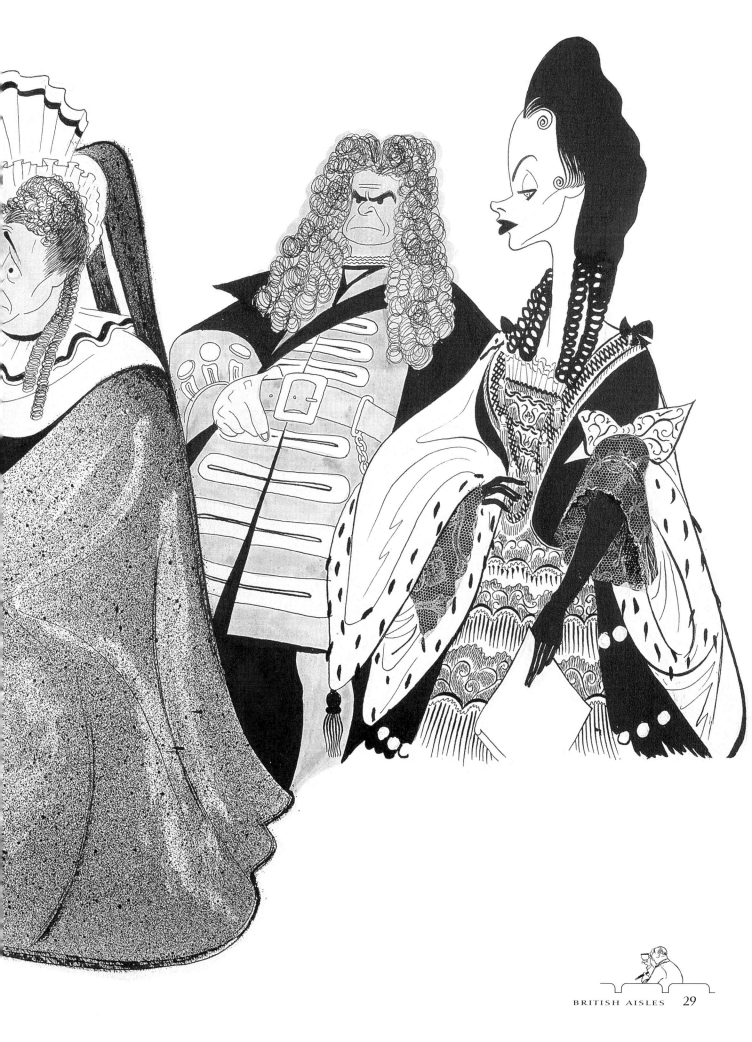

BLITHE SPIRIT

by Noël Coward; directed by John C. Wilson; actors: Clifton Webb, Mildred Natwick,
Leonore Corbett & Peggy Wood; detail of drawing, *NYT,* 1941

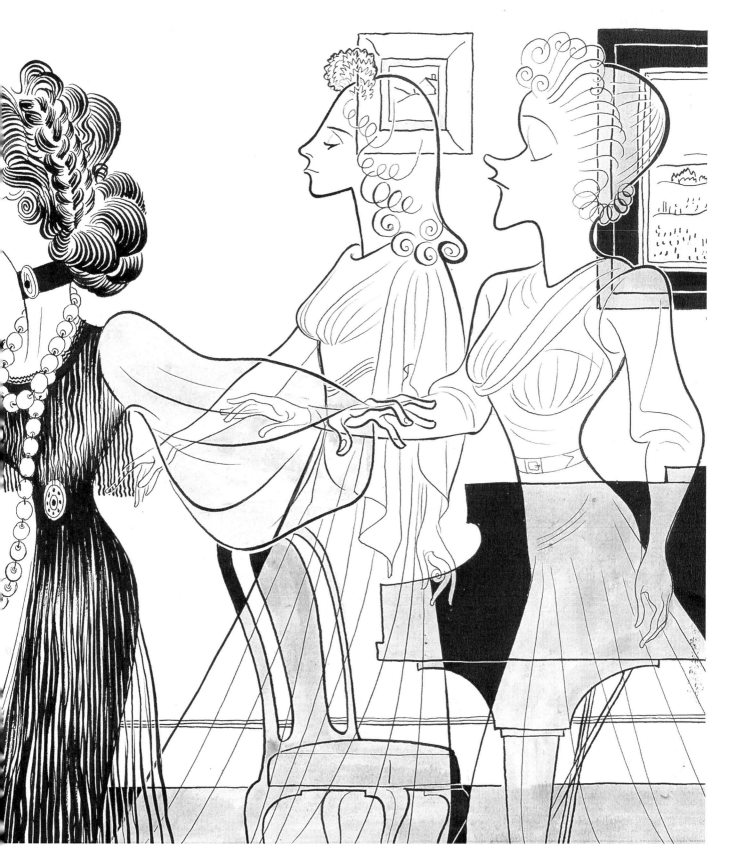

☞ *Extraordinary that Coward chose to write a play about the dead visiting the living in Britain in 1941. Beyond the comedy there is something oddly moving about 'Blithe Spirit,' the same quick throb of emotion that lies behind all of Noël Coward's best work. Mildred Natwick seems awfully thin for Mme Arcati, but then anyone would after Margaret Rutherford.* — **Simon Callow**

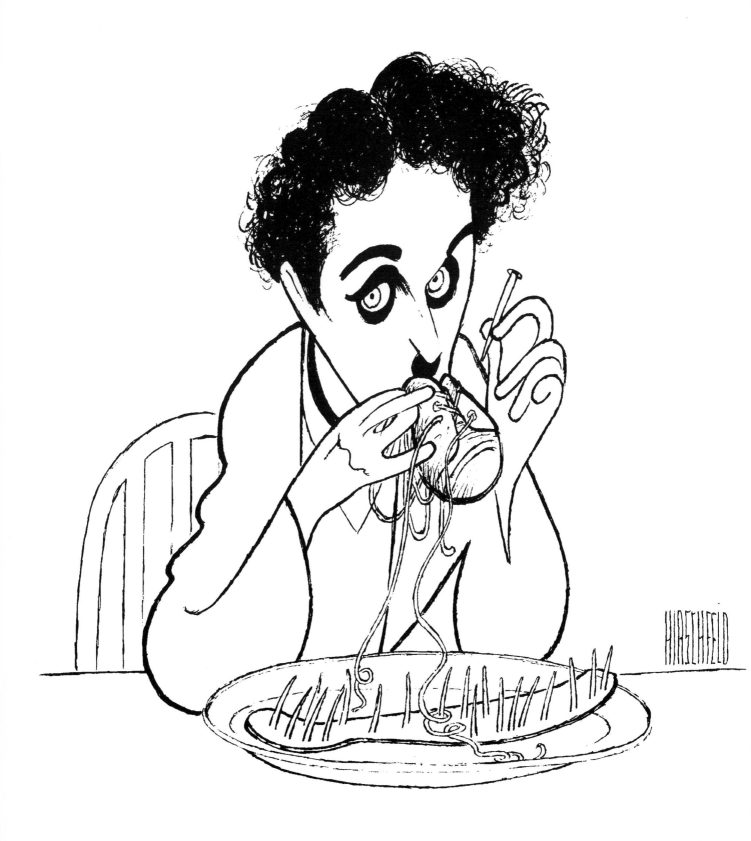

THE GOLD RUSH
Directed & written by Charlie Chaplin; actor: Charlie Chaplin; 1925 (drawing MF, 1989)

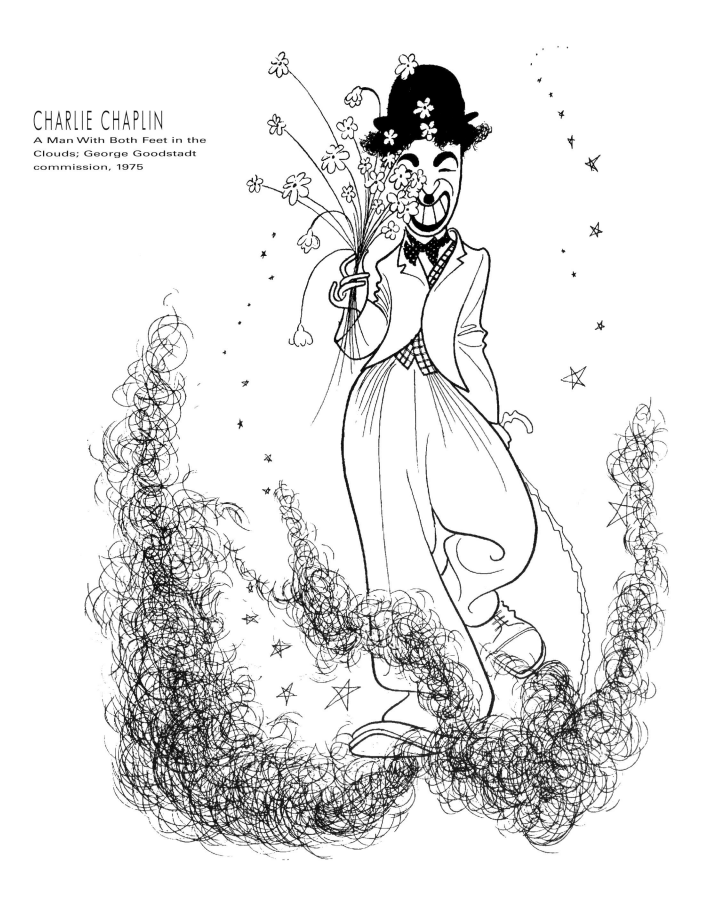

CHARLIE CHAPLIN

A Man With Both Feet in the
Clouds; George Goodstadt
commission, 1975

The apotheosis of the Little Tramp, Charlie, one of Hirschfeld's favorite subjects and an old friend, is looking more than usually Oriental as he ascends heavenward. Not borne by winged cherubs or in some gilded chariot, he shuffles through the empyrean in a pair of hand-me-down boots with a nosegay plucked from a nearby hedgerow. Seemingly an obituary tribute, the drawing was in fact made in the great actor's lifetime. — Barry Humphries

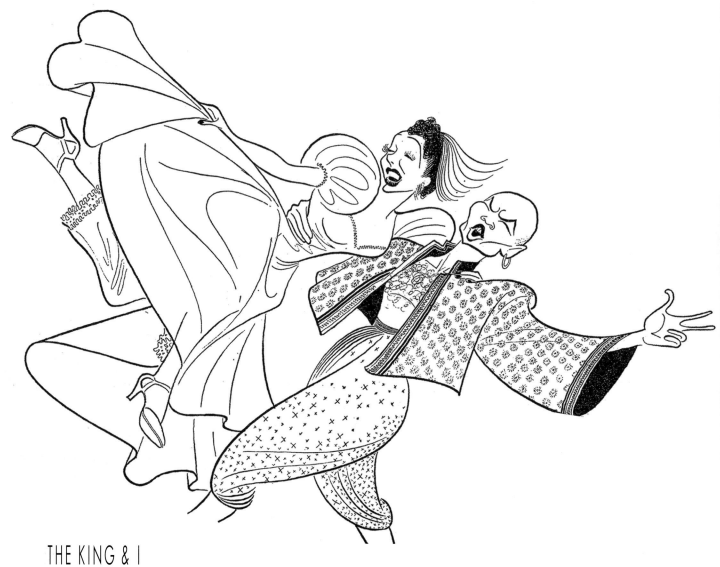

THE KING & I

Book & lyrics by Oscar Hammerstein II (Tony Award); music by Richard Rodgers
(Tony Award); directed by John van Druten; costumes by Irene Sharaff (Tony Award);
actors: Gertrude Lawrence (Tony Award) & Yul Brynner (Tony Award); detail of drawing, *NYT*, 1951

To the triumphant and stirring song 'Shall We Dance,' the reserved king of Siam commands the
lovely English teacher, 'You teach me!' They cautiously move towards each other, a seismic
choreographic shift representing bi-polar geography, opposite philosophy, and warring social and reli-
gious convictions. The king demands the schoolteacher's hand and in their steely linkage the couple
swing into a dance of incredible intensity. Hirschfeld's drawing is filled with the joyful romantic freedom
that neither character displayed, or dreamt possible, until that moment when they touched. The
abandon of Gertrude Lawrence's body and Yul Brynner's hold on her waist are captured here in one
of Hirschfeld's greatest Romantic drawings. — *Louise Kerz Hirschfeld*

LADY IN THE DARK

by Moss Hart; music & orchestration by Kurt Weill; lyrics by Ira Gershwin;
directed by Moss Hart; production & lighting design by Hassard Short; scenic design by Harry Horner;
costume design by Irene Sharaff; gowns by Hattie Carnegie; actor: Gertrude Lawrence;
detail of drawing, *NYT*, 1941

*Arguably the greatest of all Gertrude Lawrence's non-Coward roles, possibly excepting her Anna
Leonowens in 'The King and I'; but sadly she never got to play it in Britain, and despite a breathtaking
book and score (by Moss Hart, Kurt Weill and Ira Gershwin, no less), it has never been well staged in
London. We seem to have been defeated by its still revolutionary mix of dream-fantasy and psychiatry: the
show was ahead of its time, and is still of ours some sixty years later.* — *Sheridan Morley*

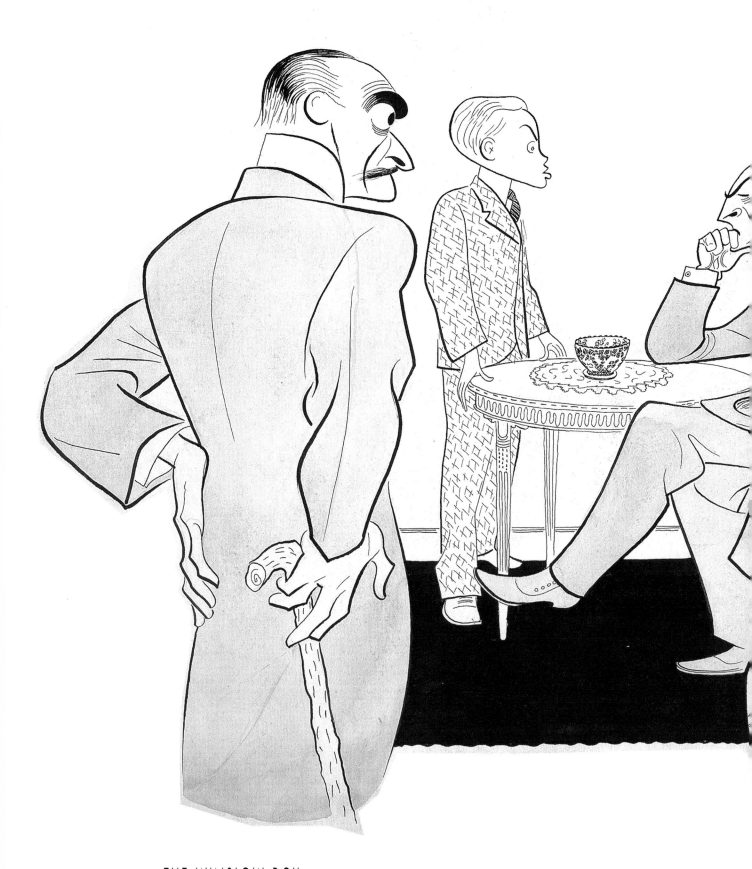

THE WINSLOW BOY
by Terence Rattigan; directed by Glen Byam Shaw; actors: Alan Webb, Michael Newell, Frank Allenby, Madge Compton & Valerie White; *NYT,* 1947

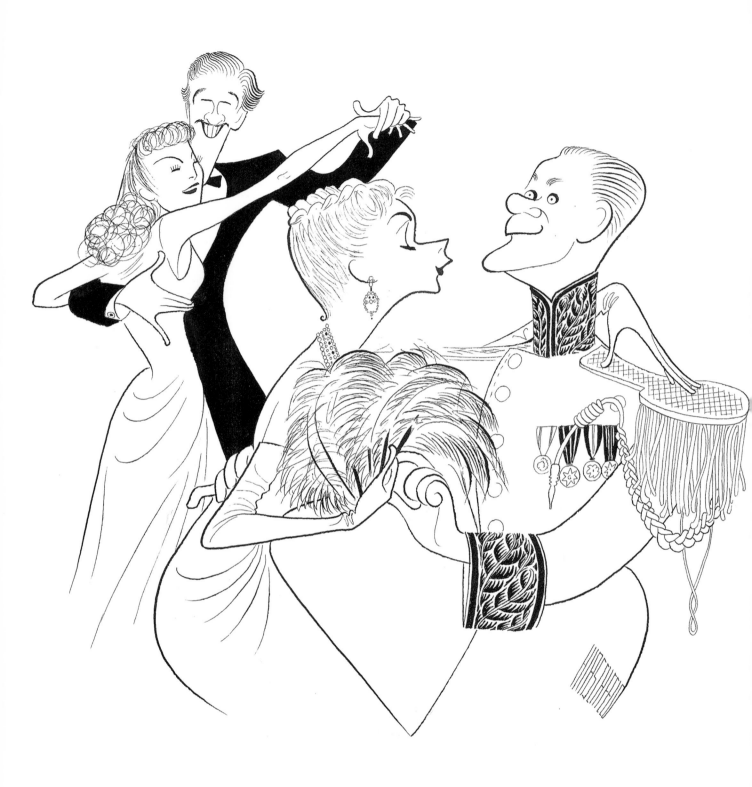

THE KING AND MRS. CANDLE

by Sumner Locke Elliott; directed by Arthur Penn; actors: Irene Manning, Richard Haydon,
Joan Greenwood & Cyril Ritchard; Philco Television Playhouse; *NYT,* 1955

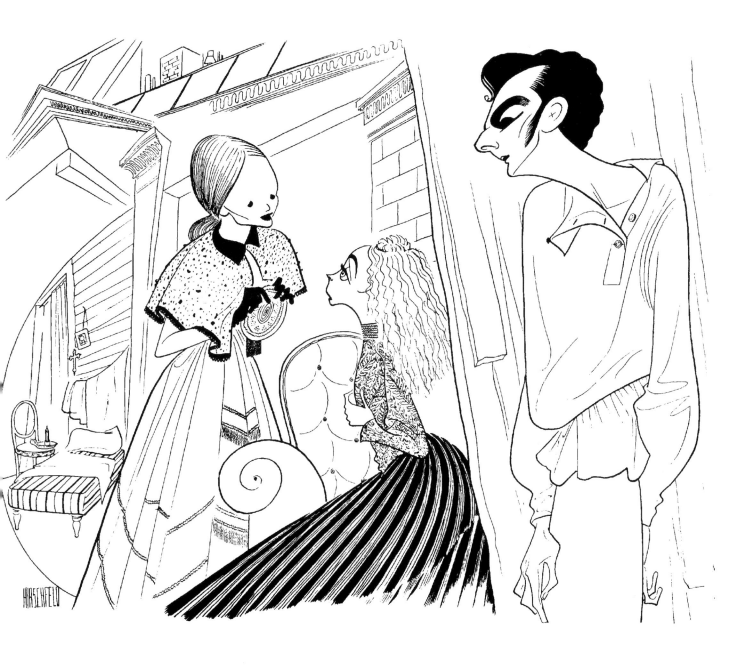

CRIME AND PUNISHMENT

Dramatized by Rodney Ackland, based on book by F. M. Dostoyevsky;
directed by Theodore Komisarievsky; actors: Dolly Haas, Lillian Gish & John Gielgud; *NYT,* 1947

☞ *'Crime and Punishment' was a serious dramatic choice buoyed by John Gielgud and Lillian Gish with director Theodore Komisarievsky, but it also served to be a surprisingly long-running dramatic success (much of it attributed to Dolly Haas). The play gave New Yorkers an early taste of what made Dolly Haas's rise meteoric in Europe.* — *Mel Gussow*

THE LINDEN TREE

by J.B. Priestley;
directed by George Schaefer;
scenic design by Peter Wolf;
actors: Una O'Connor &
Boris Karloff; *NYT,* 1948

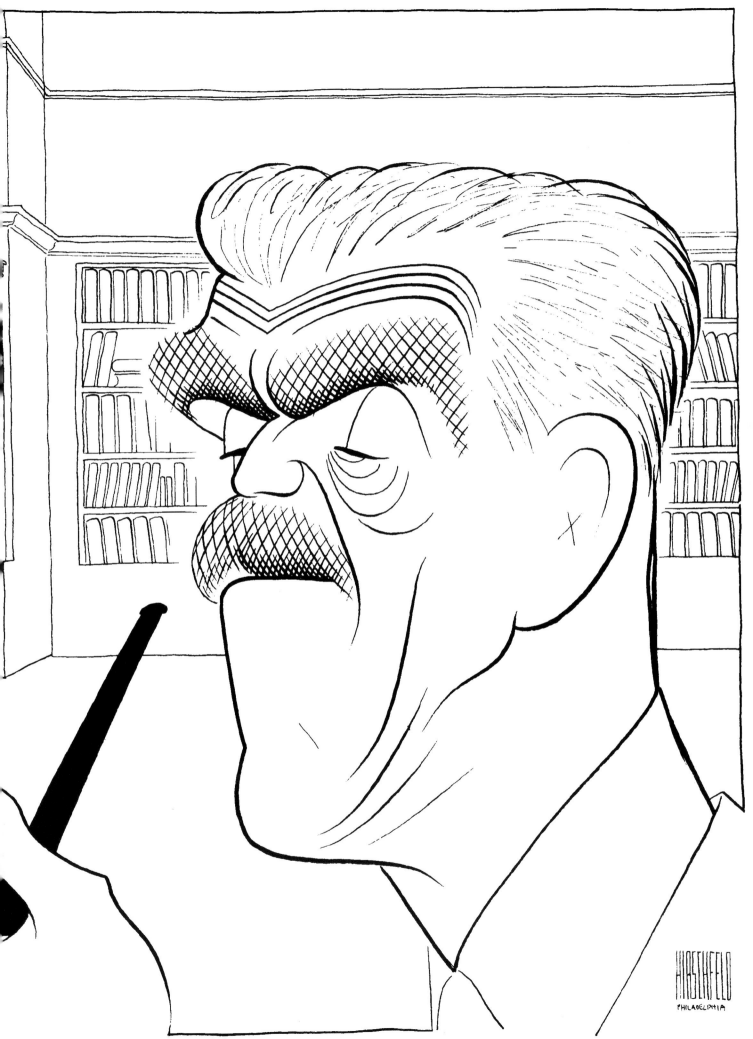

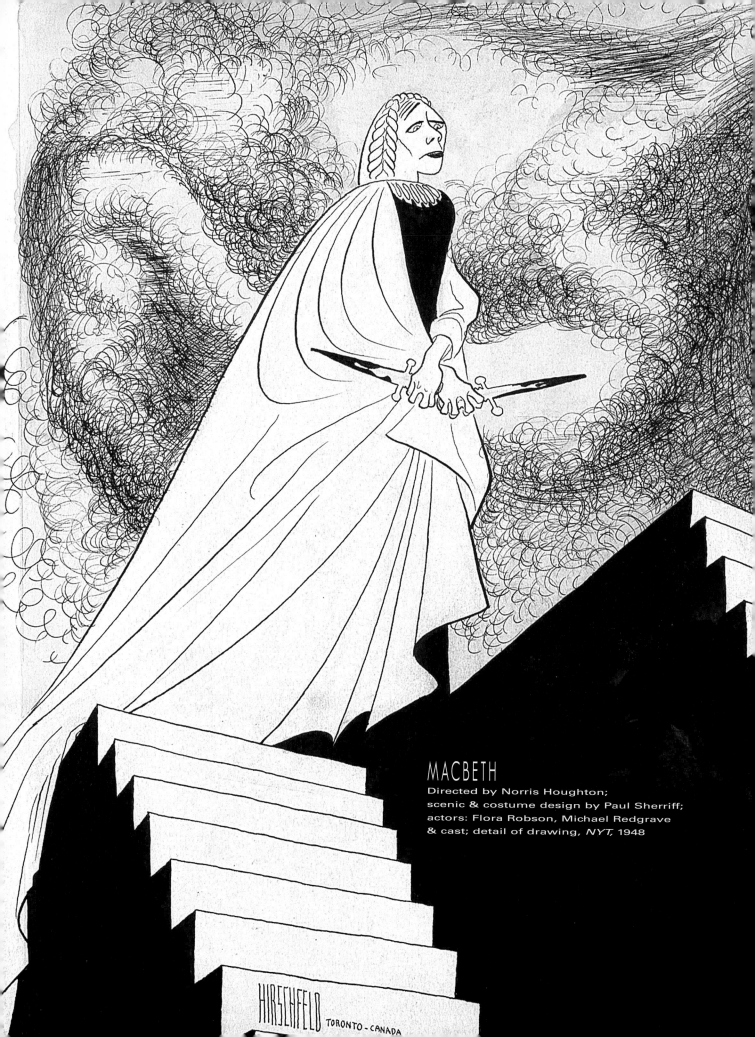

MACBETH
Directed by Norris Houghton;
scenic & costume design by Paul Sherriff;
actors: Flora Robson, Michael Redgrave
& cast; detail of drawing, *NYT*, 1948

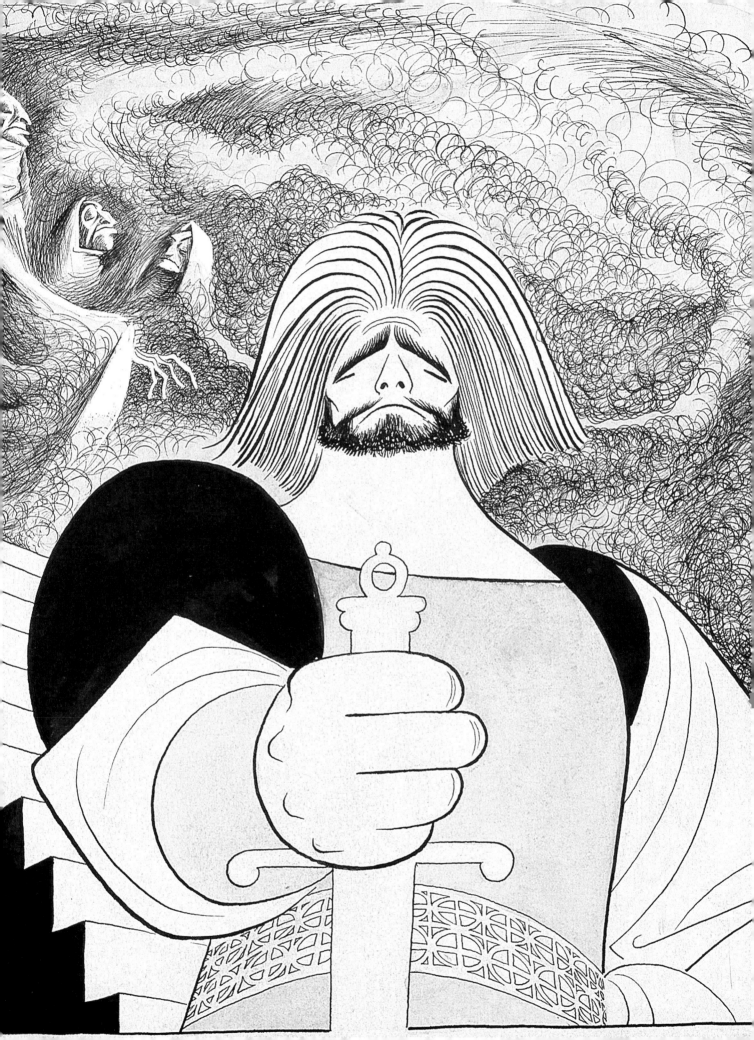

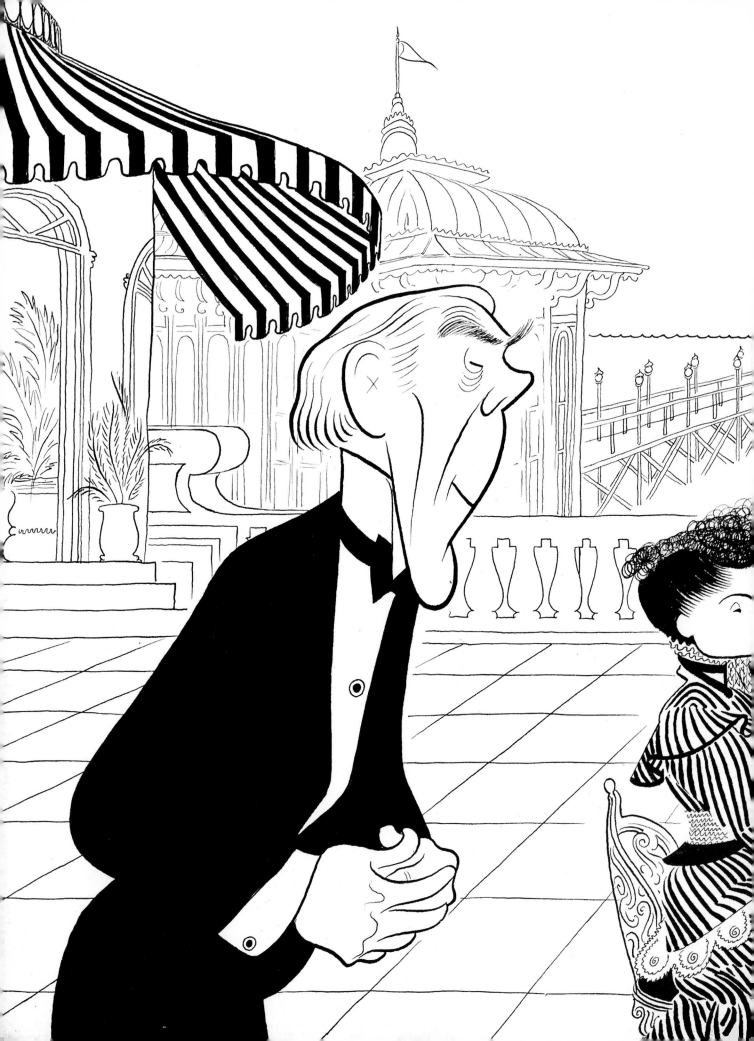

YOU NEVER CAN TELL

by George Bernard Shaw; directed by Peter Ashmore;
scenic & costume design by Stewart Chaney;
actors: Leo G. Carroll, Faith Brook, Tom Helmore, Frieda Inescort,
Patricia Kirkland, Walter Hudd, Nigel Stock, Ralph Forbes;
detail of drawing, *NYT,* 1948

*Leo G. Carroll is by far the biggest presence in this drawing
for the very good reason he has by far the best part. As the
waiter, he will glide around and upstage of the dinner table, serving
up all the tasty lines to colleagues obliged to look down
at their plates.* — *Michael Blakemore*

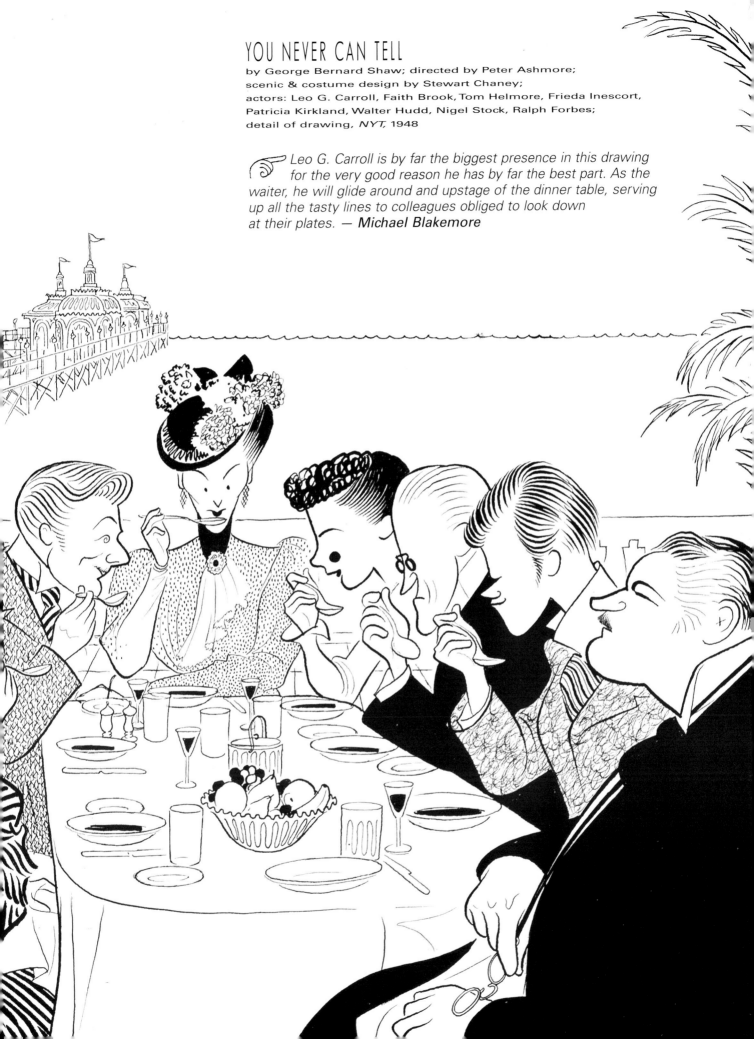

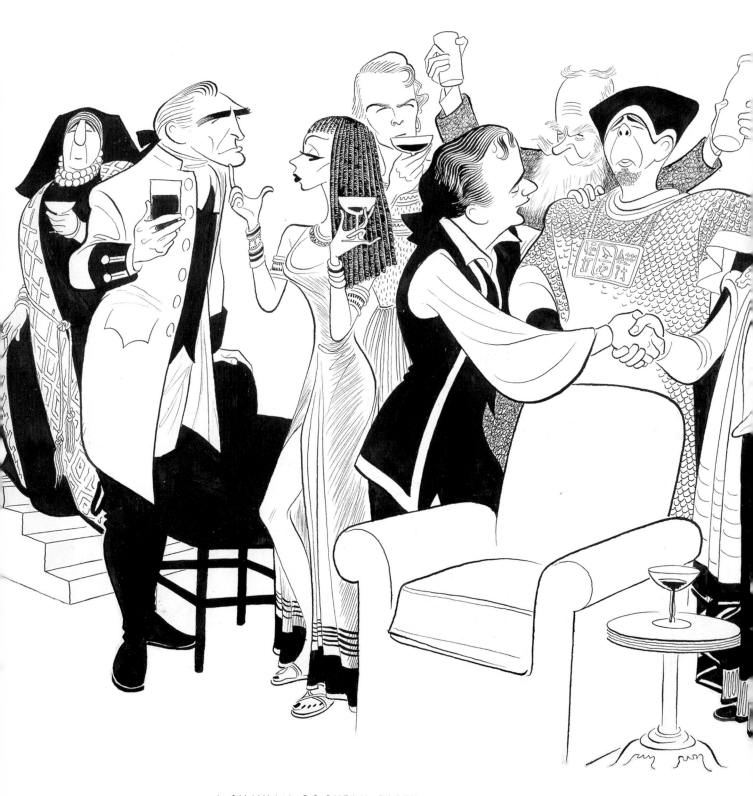

A SHAVIAN COCKTAIL PARTY

The Devil's Disciple & *Caesar and Cleopatra*; by George Bernard Shaw;
directed by Margaret Webster & Cedric Hardwick; actors: Bertha Belmore, Victor
Jory, Lili Palmer, John Buckmaster, Maurice Evans, Bernard Shaw, Nicholas Joy,
Arthur Treacher, Ivan Simpson, Marsha Hunt, Cedric Hardwick, Ralph Forbes &
Dennis King; *NYT*, 1950

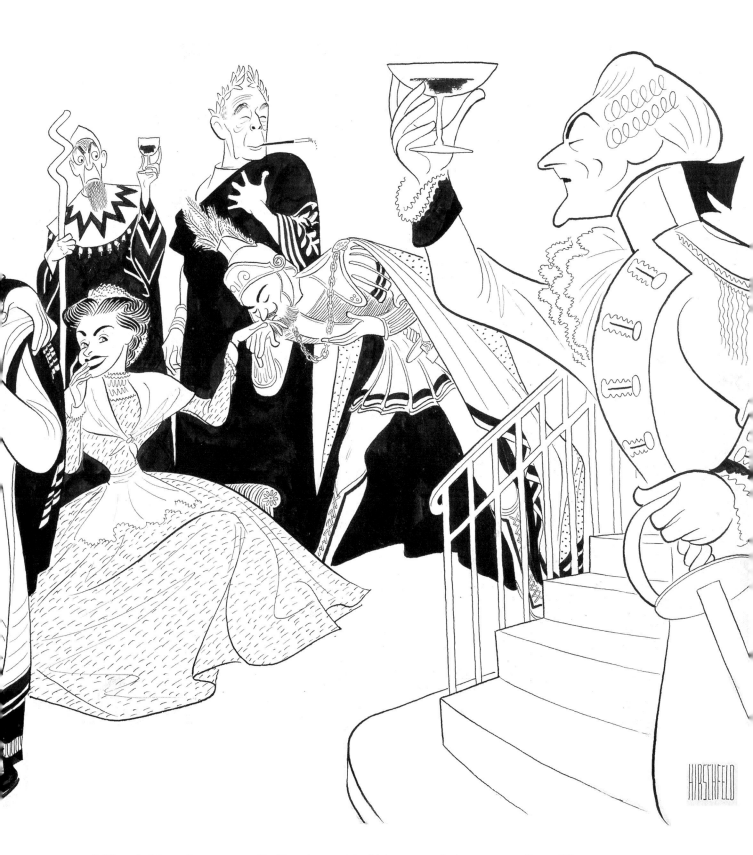

☞ *Shaw's idea of a toast: milk. But the swirl of his massed characters tells a different story. Neither play represented here has been done for years on either side of the Atlantic. We deny ourselves a lot of pleasure by giving up on a writer whose ideas sometimes seem to undermine his mastery. Not on stage, though: only in the study. In the theatre, where they belong, they scintillate with a superb cheeky vitality. And actors do awfully well by them.* — **Simon Callow**

AMERICANS IN LONDON

Holiday, 1952

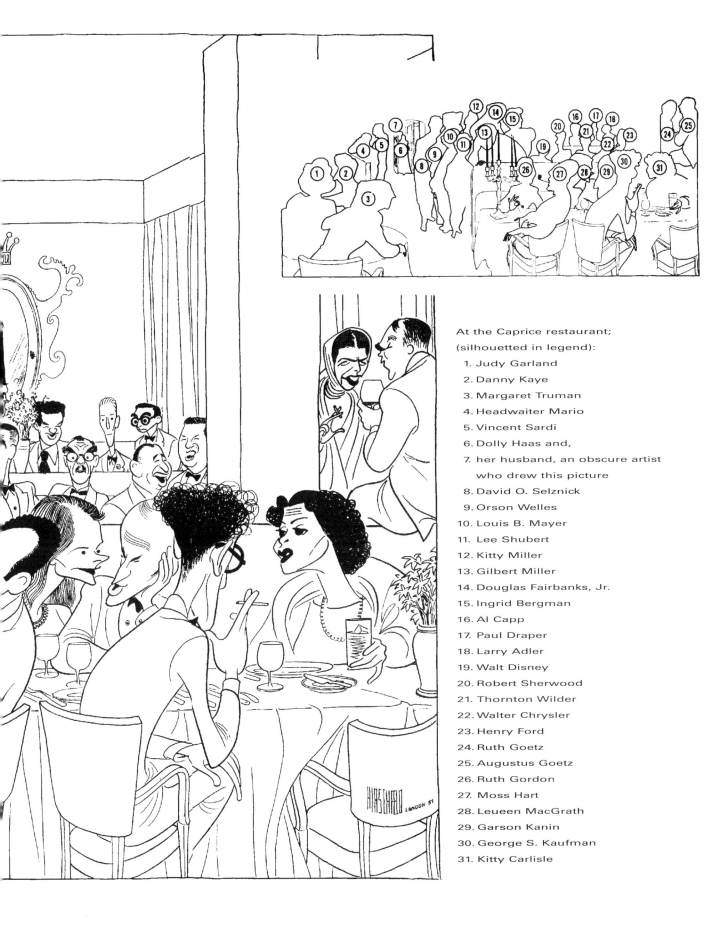

At the Caprice restaurant;
(silhouetted in legend):

1. Judy Garland
2. Danny Kaye
3. Margaret Truman
4. Headwaiter Mario
5. Vincent Sardi
6. Dolly Haas and,
7. her husband, an obscure artist who drew this picture
8. David O. Selznick
9. Orson Welles
10. Louis B. Mayer
11. Lee Shubert
12. Kitty Miller
13. Gilbert Miller
14. Douglas Fairbanks, Jr.
15. Ingrid Bergman
16. Al Capp
17. Paul Draper
18. Larry Adler
19. Walt Disney
20. Robert Sherwood
21. Thornton Wilder
22. Walter Chrysler
23. Henry Ford
24. Ruth Goetz
25. Augustus Goetz
26. Ruth Gordon
27. Moss Hart
28. Leueen MacGrath
29. Garson Kanin
30. George S. Kaufman
31. Kitty Carlisle

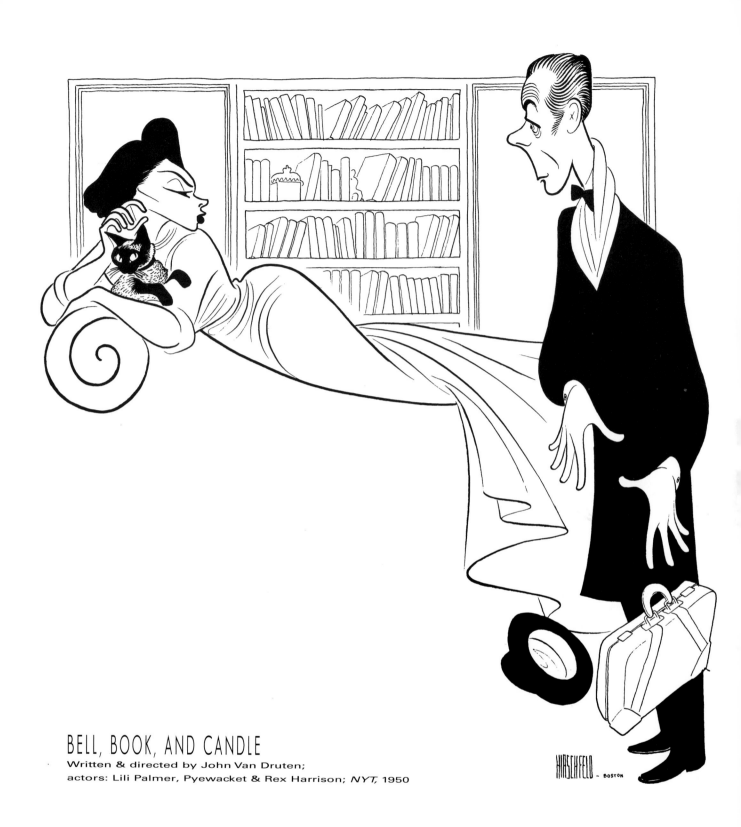

BELL, BOOK, AND CANDLE
Written & directed by John Van Druten;
actors: Lili Palmer, Pyewacket & Rex Harrison; *NYT,* 1950

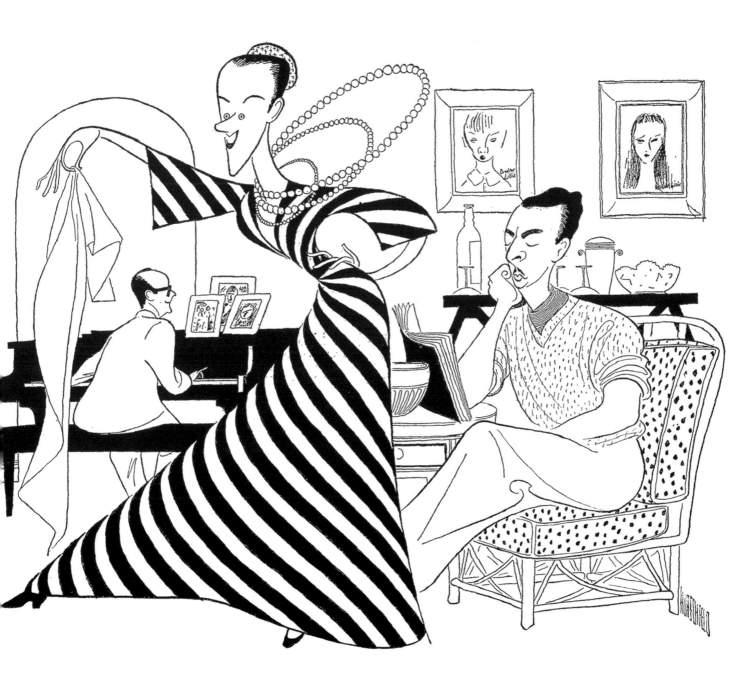

AN EVENING WITH BEATRICE LILLIE
Featuring 'Three Little Fishies' by Saxie Dowell, 'Zither' by Budd McCreery;
directed by Edward Duryea Dowling; scenic design by Rolf Gerard;
actors: Beatrice Lillie (Tony Award) &, Reginald Gardiner; *NYT,* 1952

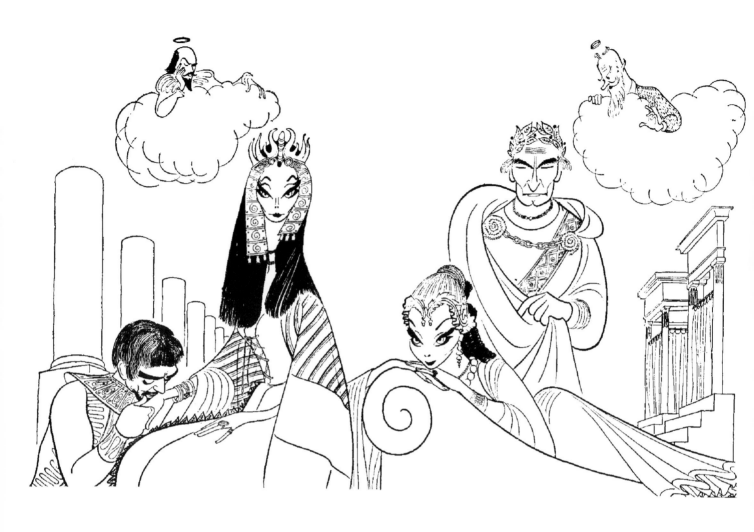

ANTONY & CLEOPATRA & CAESAR & CLEOPATRA

by George Bernard Shaw & Shakespeare; directed by Michael Benthall;
actors: Laurence Olivier & Vivien Leigh; *NYT,* 1951

☞ *Here, Hirschfeld has expertly caught the feline faux-demure likeness of Vivien Leigh as I saw her*
display it in Shaw's crafty Roman escapade. Watching her in 'Antony,' I was less happy. It is finally
my favorite dramatic text; its closing scenes, I am certain, contain the most sublime English ever
composed for the stage. I recall even now that Leigh did much better as an enchantress in Cleopatra's
teasing Shavian moments than with the monumental verbal wonders of that unmatchable Shakespearian
climax. — **Sir Peter Shaffer**

PETER PAN

by James M. Barrie; directed by John Burrell; actors: Jean Arthur & Boris Karloff; *NYT,* 1950

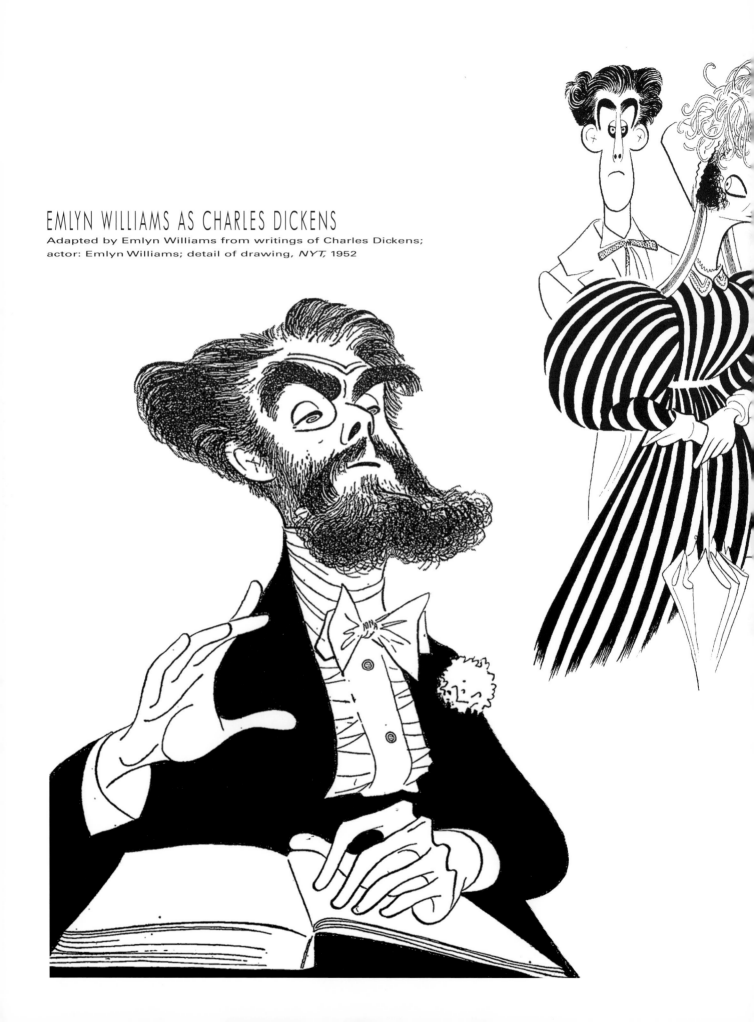

EMLYN WILLIAMS AS CHARLES DICKENS

Adapted by Emlyn Williams from writings of Charles Dickens;
actor: Emlyn Williams; detail of drawing, *NYT,* 1952

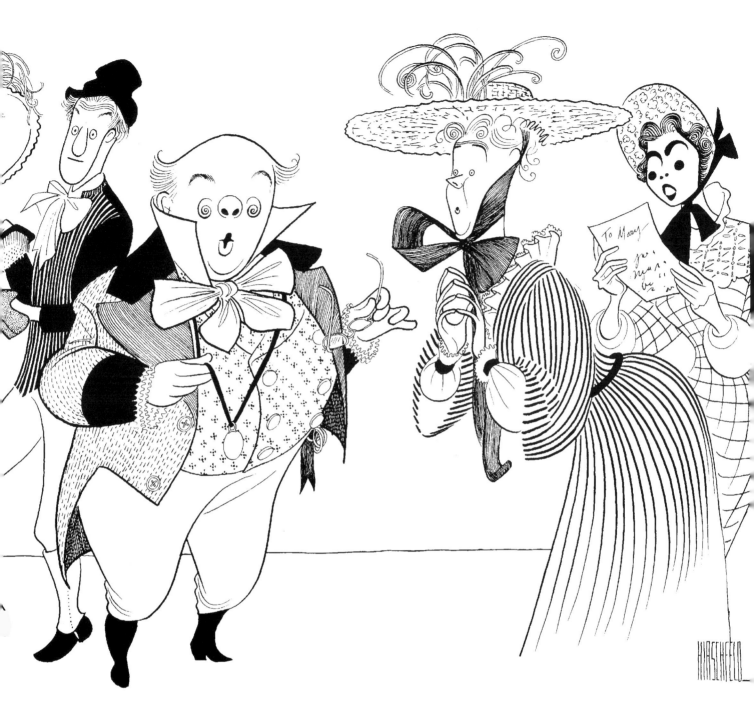

MR. PICKWICK
by Stanley Young, based on *The Pickwick Papers* by Charles Dickens;
directed by John Burrell; actors: Nigel Green, Estelle Winwood, Clive Revill,
George Howe, Nydia Westman & Sarah Marshall; *NYT,* 1952

CHARLES LAUGHTON
ca. 1940's

☞ *England's finest film actor, still. Every inch of that odd body and that curious face expressing something, a thousand teeming impulses visible just beneath the surface. A voice all cellos and basses and the occasional thwack from the tympani sounding every implication of every word.* — **Simon Callow**

KING LEAR

Actor: Orson Welles; 1953

Two twisted ankles beneath that voluminous robe. The first night was played in a wheelchair, and he made his first entrance in it, smashing through the map of England which filled the stage. It was downhill all the way after that. — **Simon Callow**

JULIUS CAESAR

Actors: Leora Dana, Polly Rowles, Christopher Plummer, Jack Palance, Hurd Hatfield, Roddy Mcdowall & Raymond Massey; American Shakespeare Festival; *NYT,* **1955**

EDEN ROC HOTEL FLORIDA MURAL

Detail of one panel of five wall murals; l to r: Duke of Windsor, Eleanor Roosevelt,
Duchess of Windsor, Bette Davis, Winston Churchill, President Dwight D. Eisenhower
& Justice Felix Frankfurter; detail of drawing, 1955

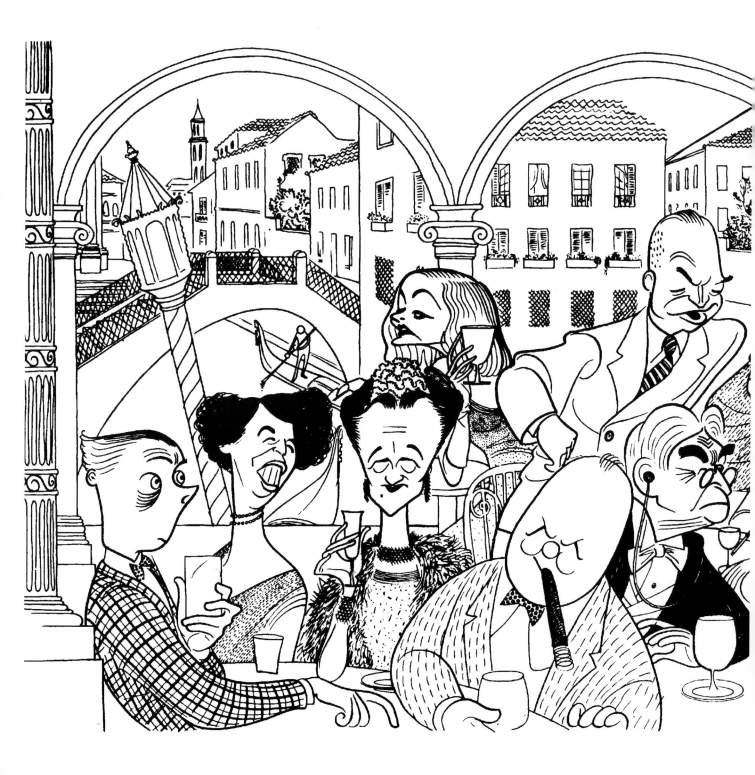

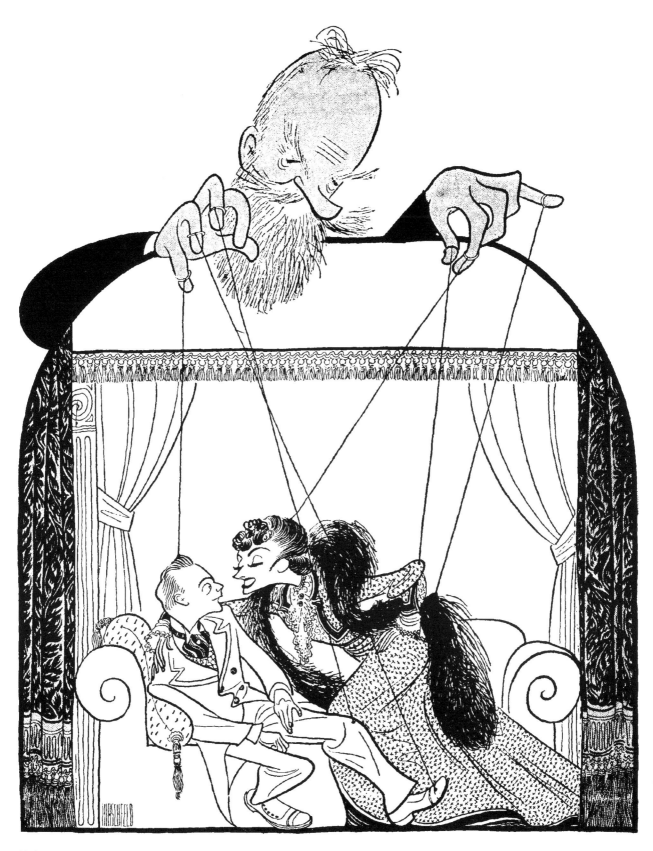

MAN & SUPERMAN

by George Bernard Shaw; directed by Maurice Evans & George Schaefer;
actors: Maurice Evans & Frances Rowe; *NYT,* 1947

Shaw is indeed the real superman, hovering godlike over his characters, who merely do his bidding. Maurice Evans is one of those actors whose almost universal and virtually infallible success are a little elusive to posterity. Good acting manners seems to have been the point, but it's a little hard to get excited by that, retrospectively. — **Simon Callow**

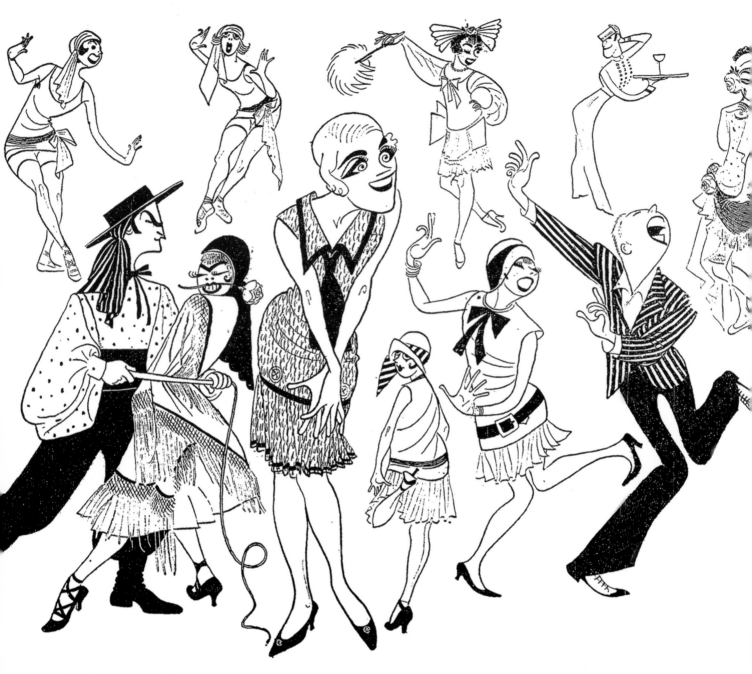

THE BOY FRIEND

by Sandy Wilson; directed by Cy Feuer; actor:
Julie Andrews in her 100th performance (Tony Award); *NYT,* 1955

I believe this was the first drawing that Hirschfeld ever did of me. (I made my Broadway debut in 'The Boy Friend.') I've been told that I'm the lucky person who has the honour of being represented the most by Hirschfeld — some thirty-four times, I believe, and I'm very proud of that. The study evokes many memories. The joy that emanated from this little show, the energy. The incredible eye makeup we girls were made to apply — complete with beaded wax on the lashes. And the girdles we wore about our bosoms in order to keep us uniformly flat and à la mode.
— Julie Andrews

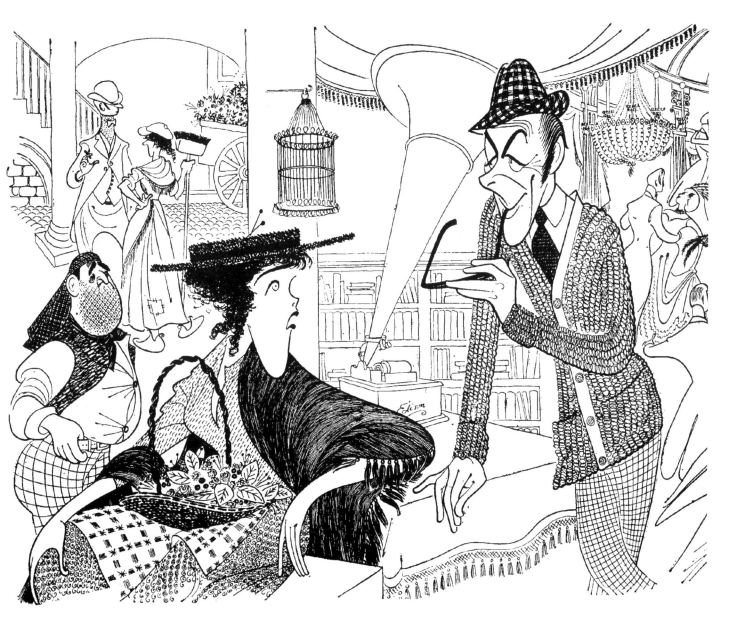

MY FAIR LADY

(Tony Award)

Adapted from *Pygmalion* by George Bernard Shaw; book & lyrics by Alan Jay Lerner;
music by Frederick Loewe; directed by Moss Hart (Tony Award); production design by Oliver Smith (Tony Award);
costume design by Cecil Beaton (Tony Award); actors: Stanley Holloway, Julie Andrews,
Rex Harrison (Tony Award) & cast; detail of drawing, *NYT*, 1956

☞ *As a thank you for Alan J. Lerner directing my smash hit 1979 revival of his 'Fair Lady' I introduced him to my delightful Eliza, Liz Robertson. They immediately fell in love, she became his next Fair Lady and they got themselves to the church in double quick time.* — **Sir Cameron Mackintosh**

A dream assignment appeared to me one day in 1988. I was to prepare the historical groundwork for a BBC television series entitled 'From Offenbach to Andrew Lloyd Webber.' During a sound check, the auditorium at UCLA was empty except for three people. Alone on stage, she sang, 'I Could Have Danced All Night,' that incomparable soprano voice ringing out to the last row. Reflexively I turned away; waves of emotion poured from me. Julie Andrews was singing that number as if at a command performance in Prince Albert Hall — all for a theatre historian and two sound technicians clutching our clipboards in southern California. The musical about the girl whose life would change forever and the man who coached her transformation came flooding back. And once more, as in 1956, I was Eliza's confidante at the Grand Ball. Al Hirschfeld captures here the pivotal moment when Professor Higgins takes on the challenge of a cockney flower girl with no clue as to the lessons she would have in store for him. — **Louise Kerz Hirschfeld**

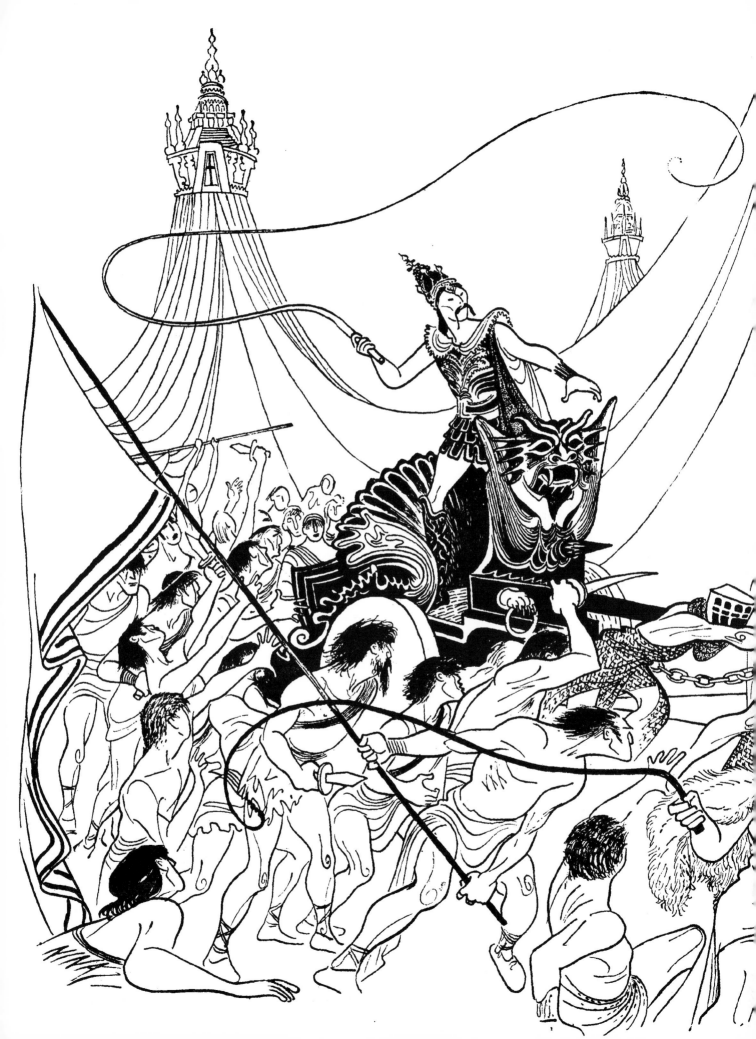

TAMBURLAINE THE GREAT

by Christopher Marlowe; book adapted by
Tyrone Guthrie & Donald Wolffit; directed by
Tyrone Guthrie; scenic & costume design by
Leslie Hurry; actors: Anthony Quayle & cast; *NYT,* 1956

HIRSCHFELD •TORONTO, CANADA

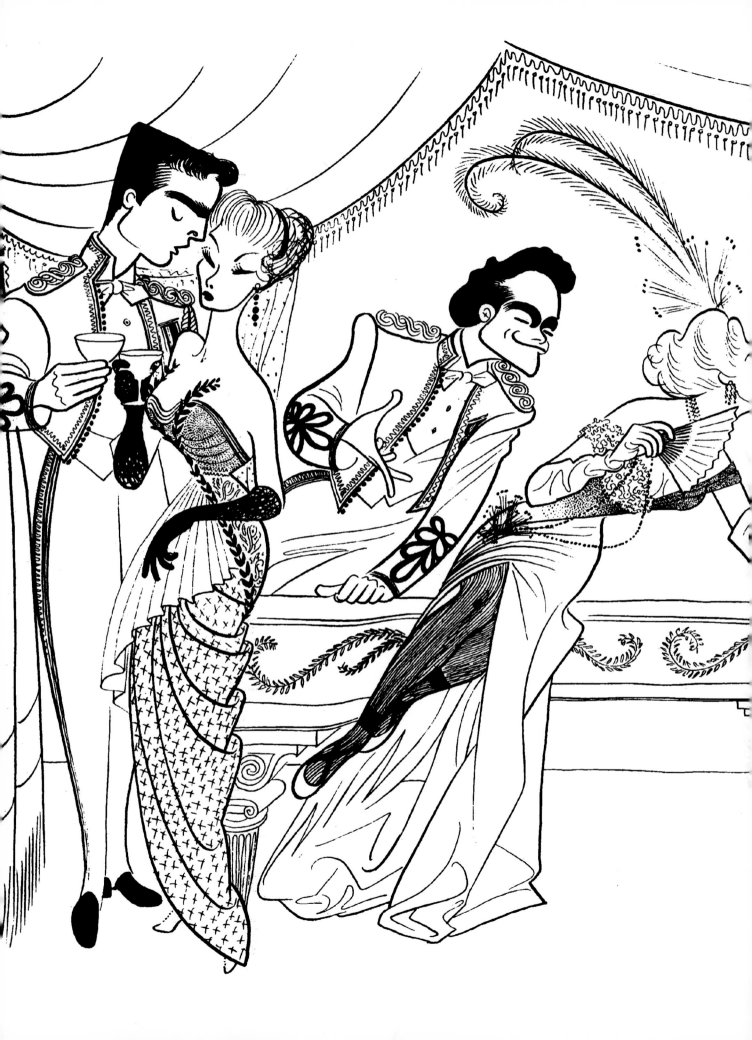

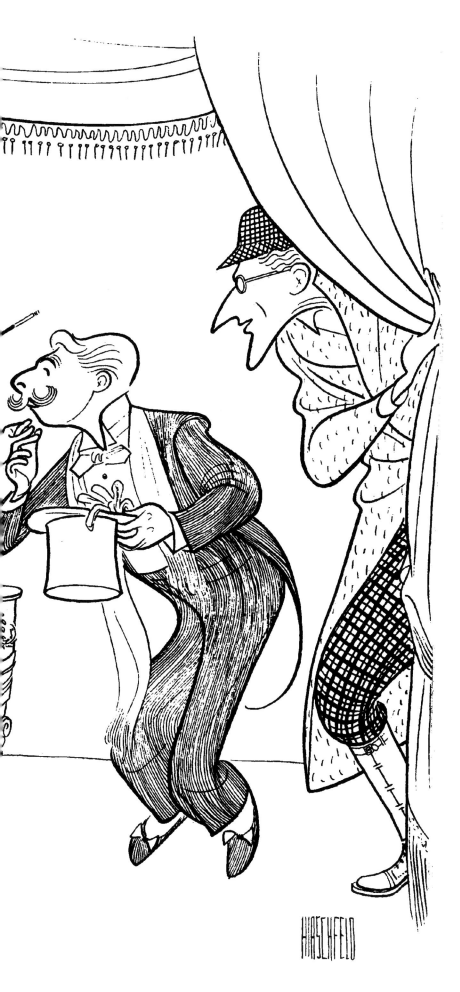

TROILUS & CRESSIDA

**Produced by the Old Vic Company;
directed by Tyrone Guthrie;
actors: Jeremy Brett,
Rosemary Harris, Ronald Allen,
Coral Browne, Paul Rogers &
John Neville; *NYT*, 1956**

☞ *Though attempted as early
as 1927, modern dress
Shakespeare had its signal success in
London in 1956 when Tyrone Guthrie
staged 'Troilus and Cressida.' Using not
only Edwardian dress but Edwardian
manners and accessories, Guthrie was
prodigal with stage-pictures, which
Hirschfeld seized to perfection.*
— John Russell

MAN IN THE GLASS BOOTH

by Robert Shaw; directed by Harold Pinter; actor: Donald Pleasance; *NYT,* 1968

☞ *This was one of those plays that fakes significance by lassoing in some major event and daring us to say, 'Hey! Put that back! It's public property!' I saw it in London and it gave me ataxia. Who was the 'man,' exactly? Eichmann, presumably, given the booth. Then why wasn't he called Eichmann? Or was he partly Eichmann and partly fictional? But how much of each? Somewhere towards the end, Donald Pleasance got very animated and started accusing us all of something or other. From this point on, the mood of the audience was guiltily reverent, and the play was a great success. — Nicholas Wright*

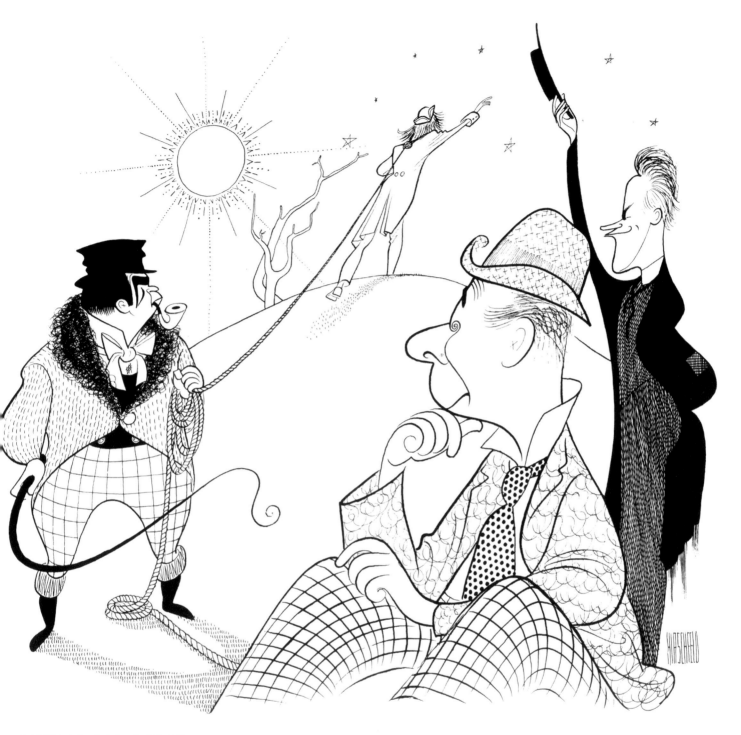

WAITING FOR GODOT

by Samuel Beckett; directed by Herbert Berghof;
actors: Kurt Kasznar, Alvin Epstein, Bert Lahr, E.G. Marshall; *NYT,* 1956

Beckett thought this production was 'very wrong and dreadful' and it's certainly true that the costumes are horrid. They scream 'Aren't we funny!' just like the background screams 'Yes, and arty too!' But Bert Lahr must have been fantastic. Beckett is best played by melancholy clowns of great finesse: Lahr, Max Wall, Buster Keaton. Comedians of the second rank need not apply. Beckett's comment on the play's Broadway success is enchanting in its bafflement and contains a profound truth about all theatre: 'There is something queer about this play, I don't know exactly what, that worms its way into people whether they like it or not.' — *Nicholas Wright*

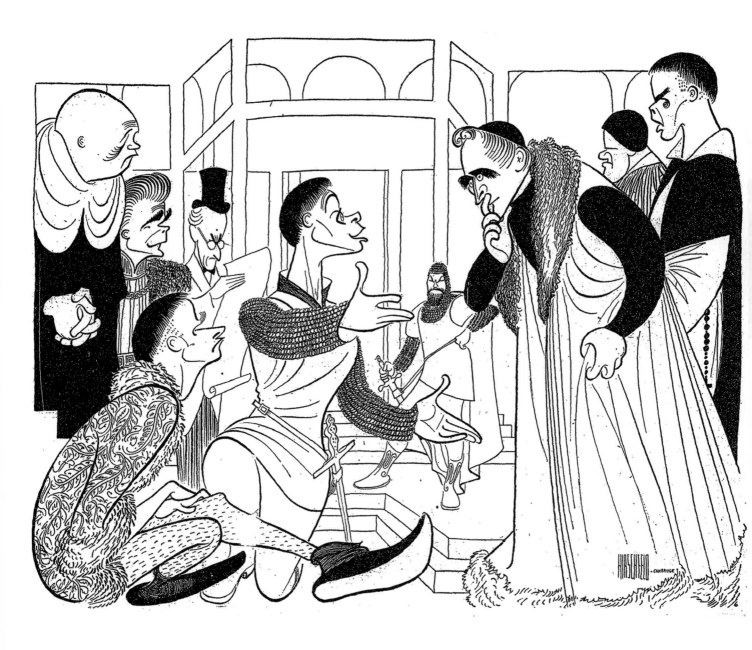

SAINT JOAN

by George Bernard Shaw; directed by Albert Marre; scenic & lighting design by Klaus Holm;
actors: Siobhan McKenna, Thayer David, Kent Smith, Arch Johnson, Ian Keith, Frederick Tozere,
Dick Moore & Michael Wager (seated); *NYT,* 1956

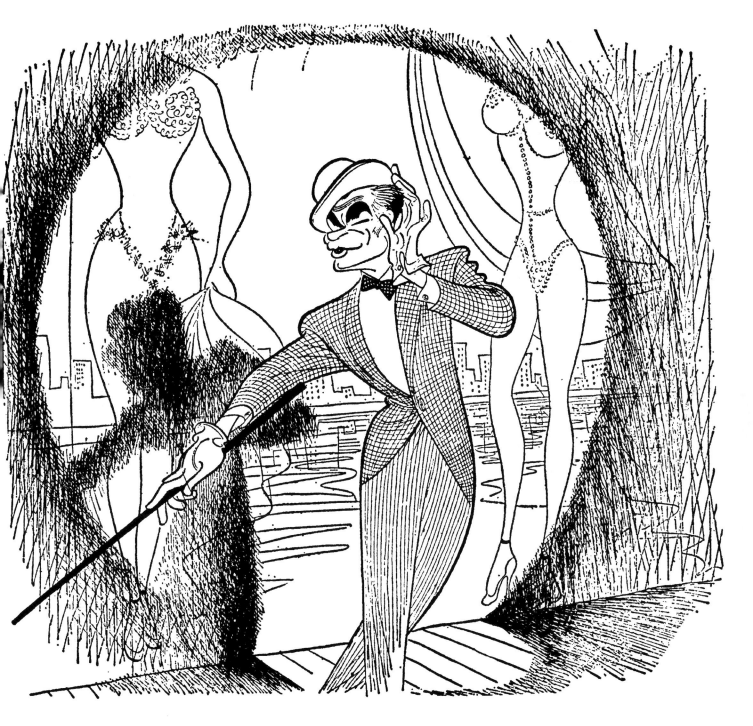

THE ENTERTAINER

by John Osborne; directed by Tony Richardson; actor: Laurence Olivier; *NYT,* 1958

☞ *Here is Laurence Olivier in the role of John Osborne's Archie Rice, a role in which he scaled the
peaks of his profession. Olivier must have closely studied some of the surviving Music Hall
performers at the Metropolitan Theatre, Edgeware Road — notably, Max Miller, Osborne's prototype for
the character. The seediness of British vaudeville in its decline was seen by Osborne as a metaphor for
modern Britain. It was a measure of Olivier's genius and courage that he could strut the stage telling with
tremendous zest a series of awful gags that relentlessly fell flat. Within a few years of this production, the
Metropolitan Theatre — the final refuge of the British Music Hall — was demolished in favor of the M-4,
the six-lane motorway leading to industrial South Wales. The audience cringes at the tawdry spectacle but
is not untouched by this threadbare remnant of popular theatre, inexorably threatened by that sword of
Damocles: Television. — Barry Humphries*

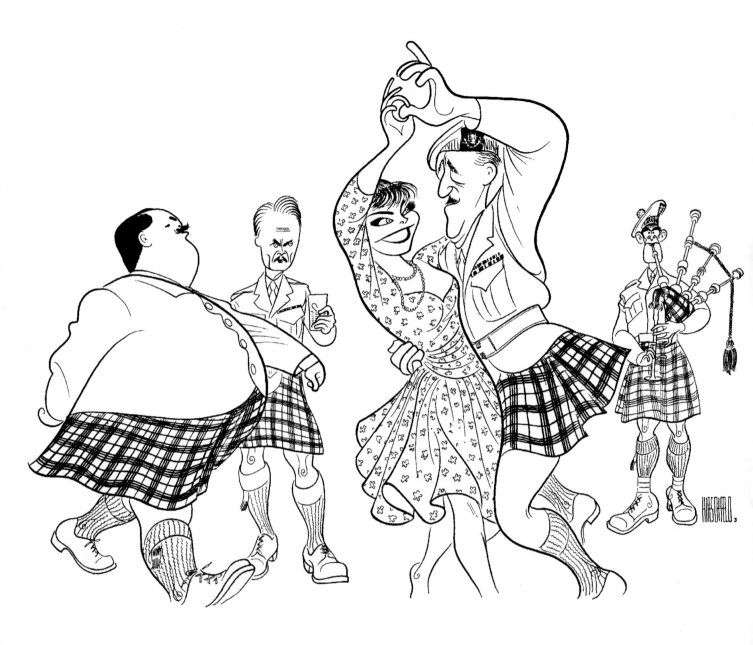

TUNES OF GLORY

Screenplay (and novel) by James Kennaway; directed by Ronald Neame;
actors: Alec Guinness and Susannah York dance before Gordon Jackson,
John Mills & John Fraser; United Artists promotion, 1960

THE APPLE CART

by George Bernard Shaw; directed by George Schaefer;
actors: Maurice Evans & Signe Hasso; *NYT,* 1956

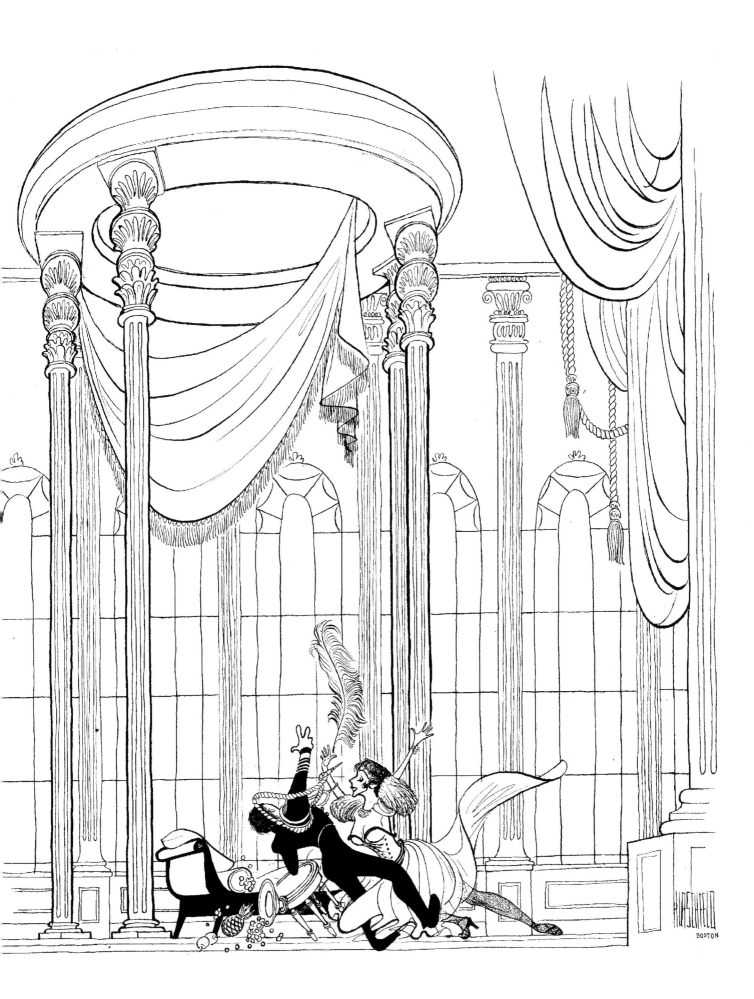

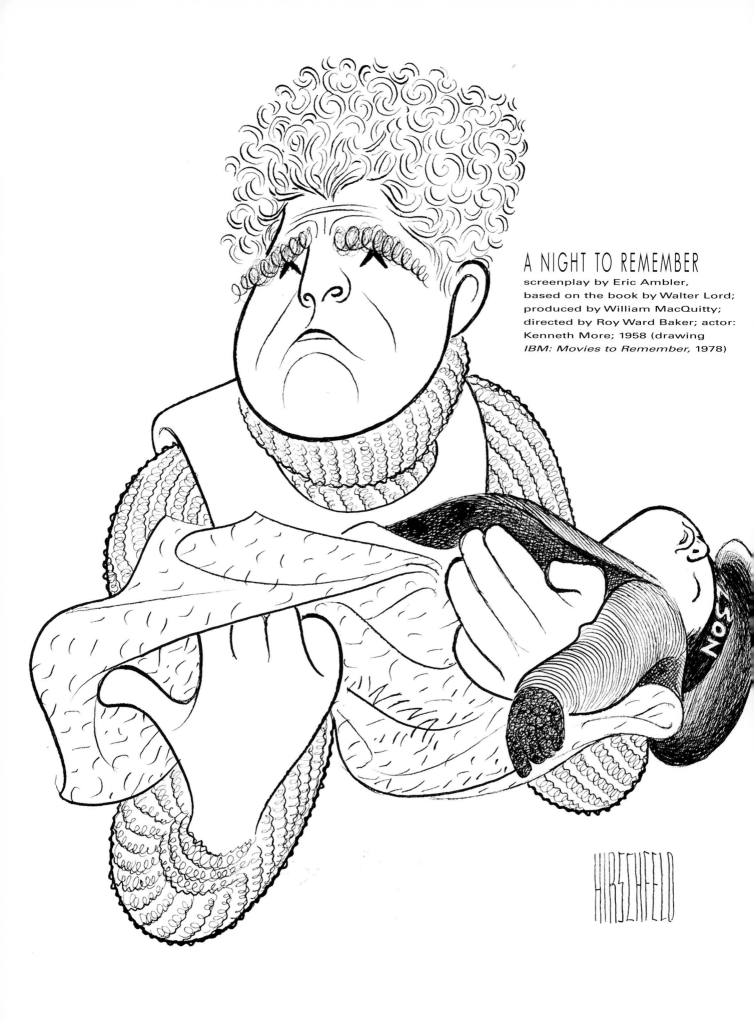

A NIGHT TO REMEMBER
screenplay by Eric Ambler,
based on the book by Walter Lord;
produced by William MacQuitty;
directed by Roy Ward Baker; actor:
Kenneth More; 1958 (drawing
IBM: Movies to Remember, 1978)

THE CRUEL SEA

Screenplay by Eric Ambler, based on the book by Nicholas Monsarrat; directed by Charles Frend; actor: Jack Hawkins; 1953 (drawing *IBM: Movies to Remember,* 1978)

John G. quivering with wit, a mask behind a mask. The lost art of high comedy. Elegance, fun, an unerring instinct for beauty, speed of thought, tears brimming in voice and eye. And ever upward, as the drawing so perfectly suggests, buoyant, elevated, champagne on legs. — **Simon Callow**

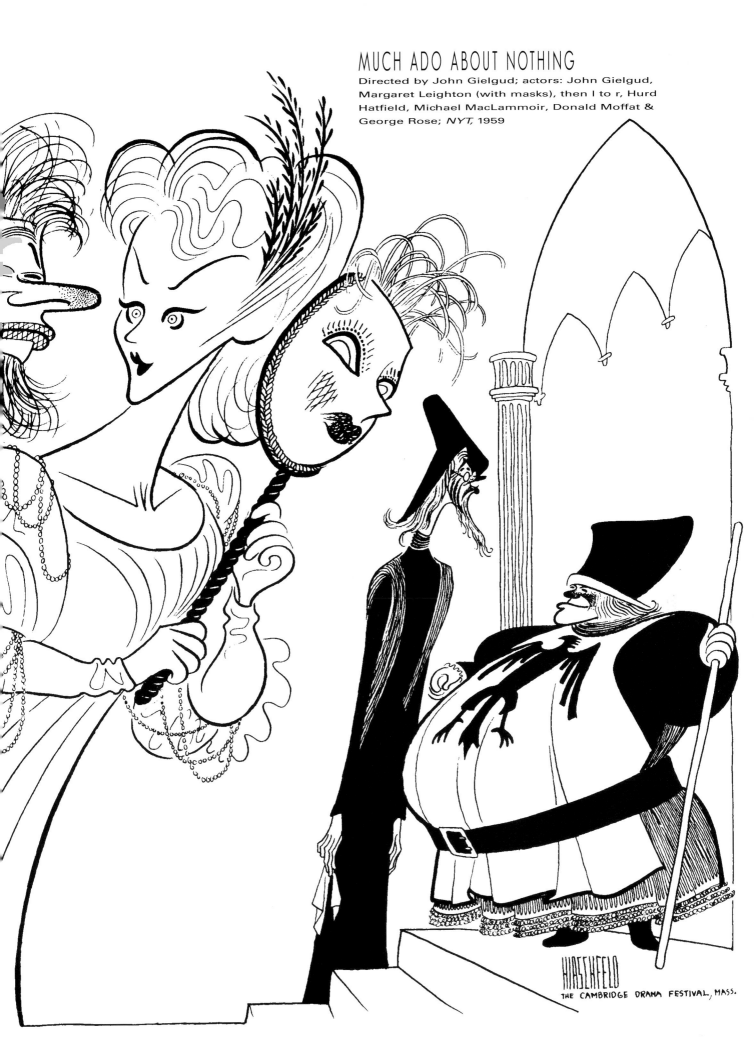

MUCH ADO ABOUT NOTHING
Directed by John Gielgud; actors: John Gielgud,
Margaret Leighton (with masks), then l to r, Hurd
Hatfield, Michael MacLammoir, Donald Moffat &
George Rose; *NYT*, 1959

A TASTE OF HONEY

by Shelagh Delaney; directed by Tony Richardson & George Devine; production design by Oliver Smith; costume design by Dorothy Jeakins; actors: Angela Lansbury & Joan Plowright (Tony Award); 1960 (drawing *The Lively Years,* 1973)

In my early days I aspired to be both Angela and Joan. Comical, tragical, musical, pastoral…! On my first night in New York in 1966, I went to see 'Mame.' People used to say I looked like Angela. Of course I was flattered. I went round to meet her afterwards. Warm, welcoming. 'People say you look like me,' she said. And Joan Plowright's work at The Royal Court, at The National Theatre. Her Sonia with my father in 'Uncle Vanya,' her St. Joan. 'Light your fires!' I'll never forget that cry. I wish I'd seen this 'Taste of Honey.' — **Lynn Redgrave**

SEPARATE TABLES

by Terence Rattigan; directed by Peter Glenville;
actors: Margaret Leighton (Tony Award) & Eric Portman; *NYT,* 1957

Sad, lonely, so, so British. Tea. With milk poured first of course. Cocktails. Always. Alcoholics? No, no! Of course not! Social drinkers. Sherry, port, cognac. Lace handkerchiefs tucked in cardigan sleeves. Chilly, tidy houses. Damp. Cramped. Brave smiles. No tears. Alone. Together, but alone. Lies like truth. Masked. Naked. Appearances are everything. — **Lynn Redgrave**

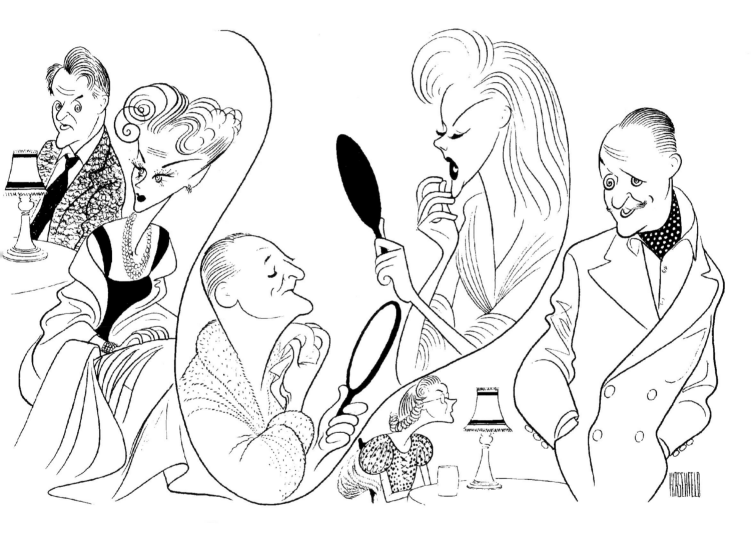

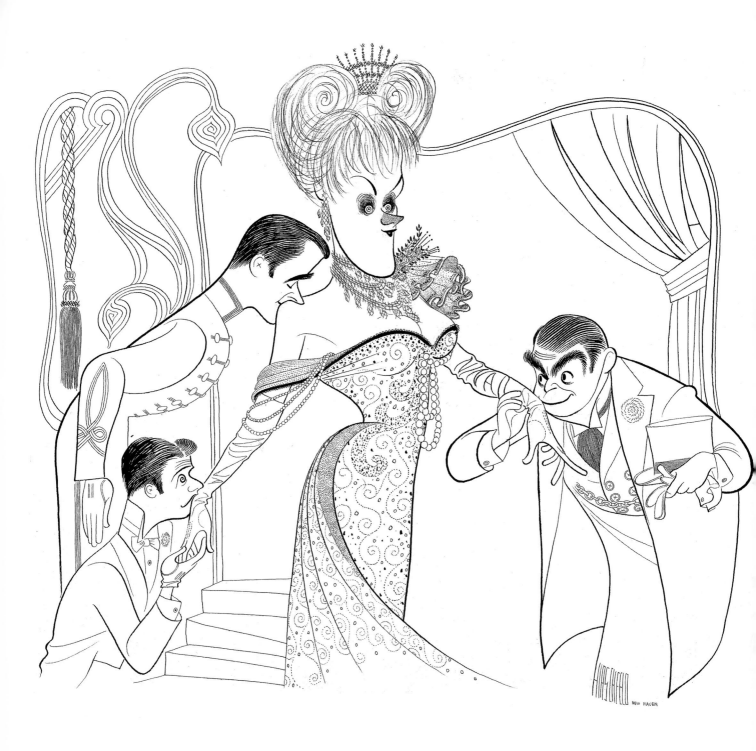

LOOK AFTER LULU

by Noël Coward, based on *Occupe-toi d'Amelie* by Georges Feydeau;
directed by Cyril Ritchard; scenic & costume design by Cecil Beaton;
actors: Roddy Mcdowall, George Baker, Tammy Grimes, Kurt Kasznar; *NYT,* 1959

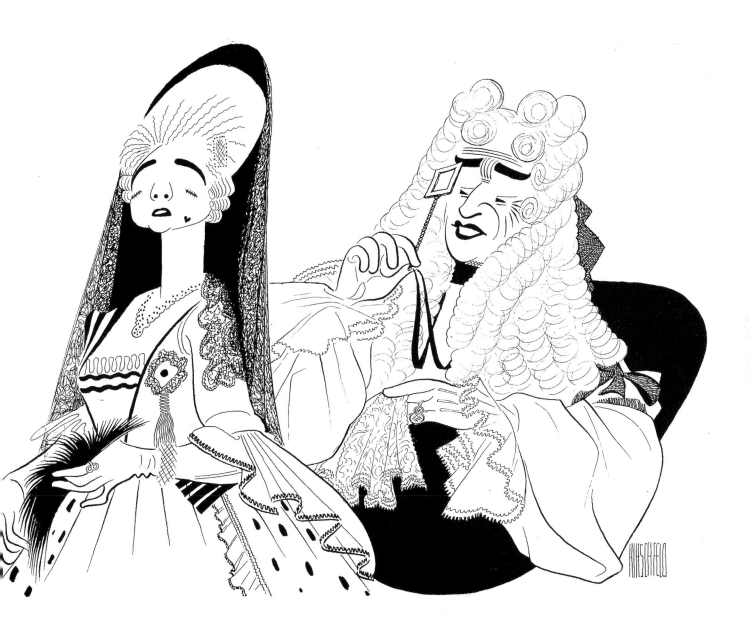

THE GONDOLIERS

Produced by D'Oyly Carte Opera Company; written by W. S. Gilbert; music by Sir Arthur Sullivan;
staged by Anna Bethell; scenic & costume design by Charles Ricketts;
actors: Ella Halman & Martyn Green; *NYT,* 1948

THE VISIT

by Friedrich Duerrenmatt; book adapted by Maurice Valency; directed by Peter Brook;
production design by Teo Otto; Miss Fontanne's clothes by Castillo;
actors: Lynn Fontanne & Alfred Lunt; *NYT,* 1958

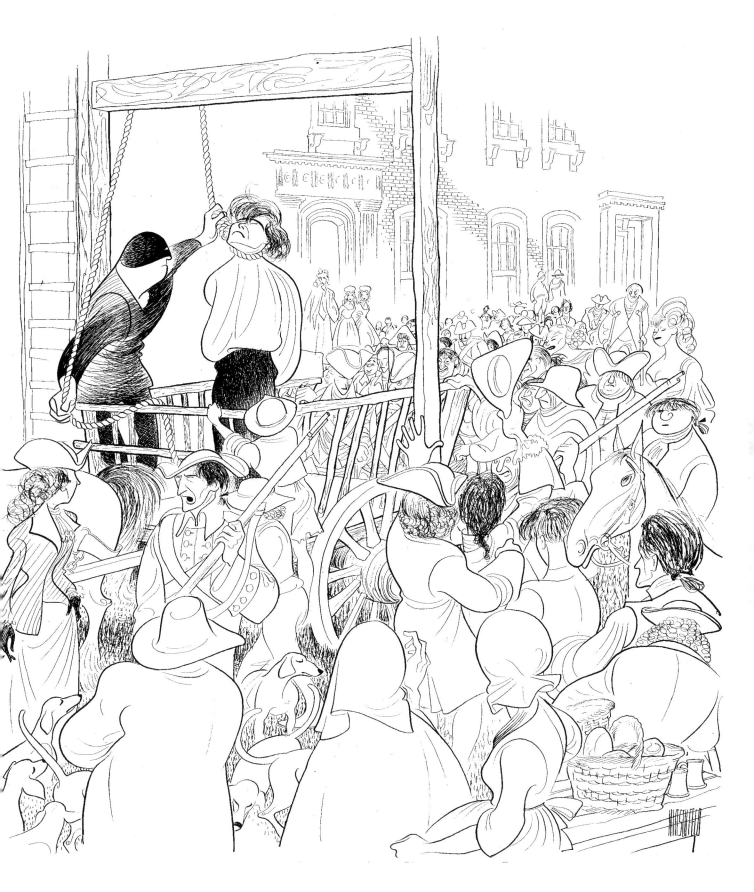

TOM JONES

Screenplay by John Osborne, based on the novel by Henry Fielding;
directed by Tony Richardson; actor: Albert Finney; United Artists promotion, 1963

THE FIGHTING COCK

by Jean Anouilh; directed by Peter Brook; actors: Arthur Treacher, Rex Harrison, Natasha Parry, Roddy Mcdowall, Gerald Hiken, Alan MacNaughton & Jane Lillig; *NYT*, 1959

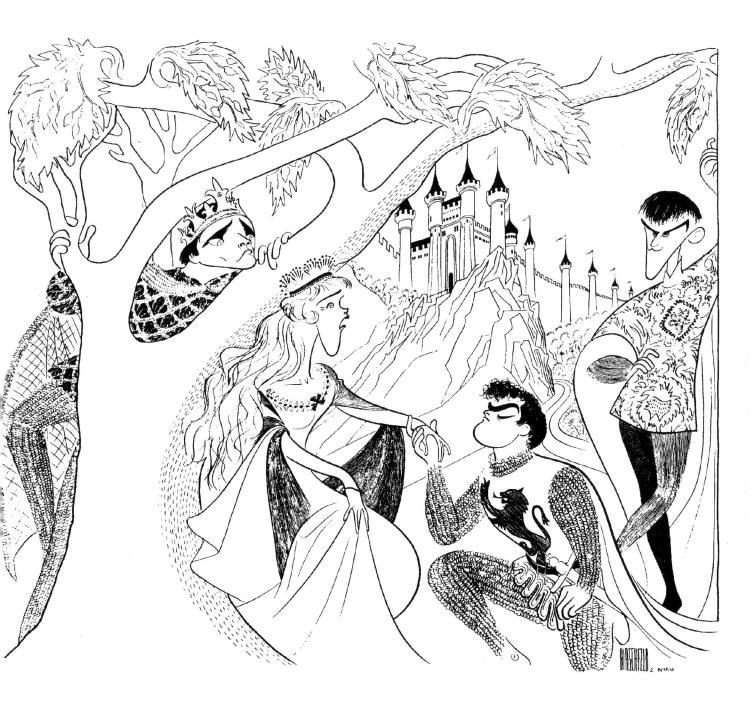

CAMELOT

Produced by Alan Jay Lerner, Frederick Loewe & Moss Hart; based on *The Once and Future King*
by T. H. White; book & lyrics by A.J. Lerner; music by F. Loewe; directed by Moss Hart;
scenic design by Oliver Smith (Tony Award); costume design by Adrian & Tony Duquette (Tony Awards);
actors: Richard Burton (Tony Award), Julie Andrews, Robert Goulet & Roddy Mcdowall; *NYT,* 1960

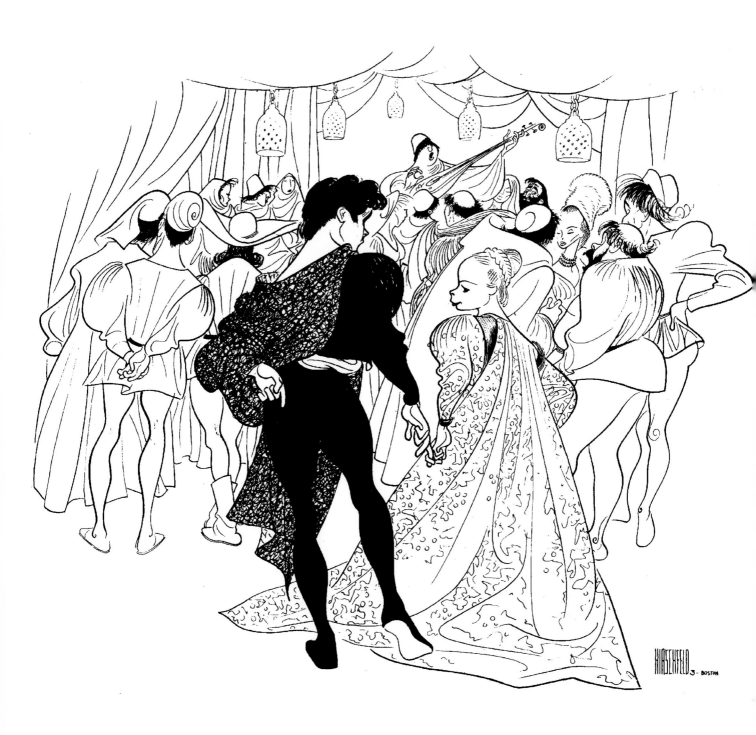

ROMEO AND JULIET

Production by Old Vic; directed & designed by Franco Zeffirelli;
actors: John Stride & Joanna Dunham; *NYT,* 1962

☞ *My mother, Rachel Kempson, played Juliet at Stratford-upon-Avon in 1934. It was her favorite role. As she aged she could no longer memorize new roles. But Juliet… I remember one hot sultry day in a garden near Malibu. A benefit. Dressed in white, she was assisted onto the stage. She had to hold the back of a chair to steady herself. An 85-year-old woman. And then she began. She launched into Juliet's 'potion' speech. She was fourteen. She was in love. She was afraid. She was Juliet. No one in that garden will ever forget her.* **— Lynn Redgrave**

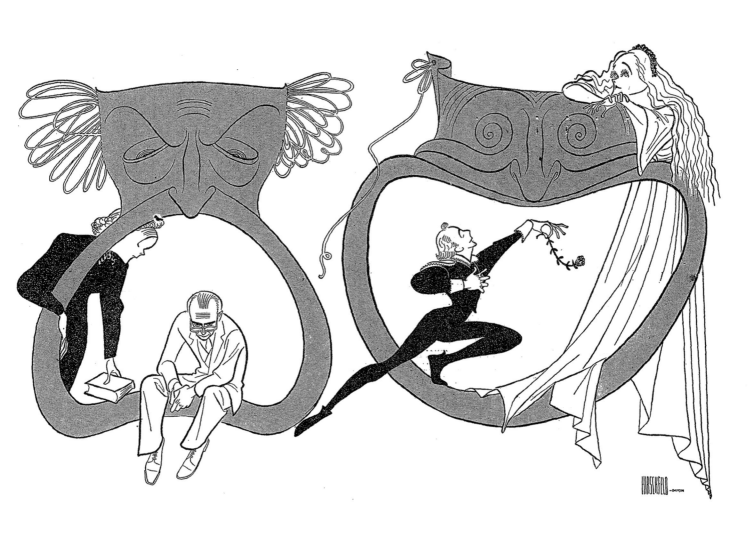

THE BROWNING VERSION/HARLEQUINADE

by Terence Rattigan; directed by Peter Glenville; actors: Edna Best & Maurice Evans; *NYT,* 1949

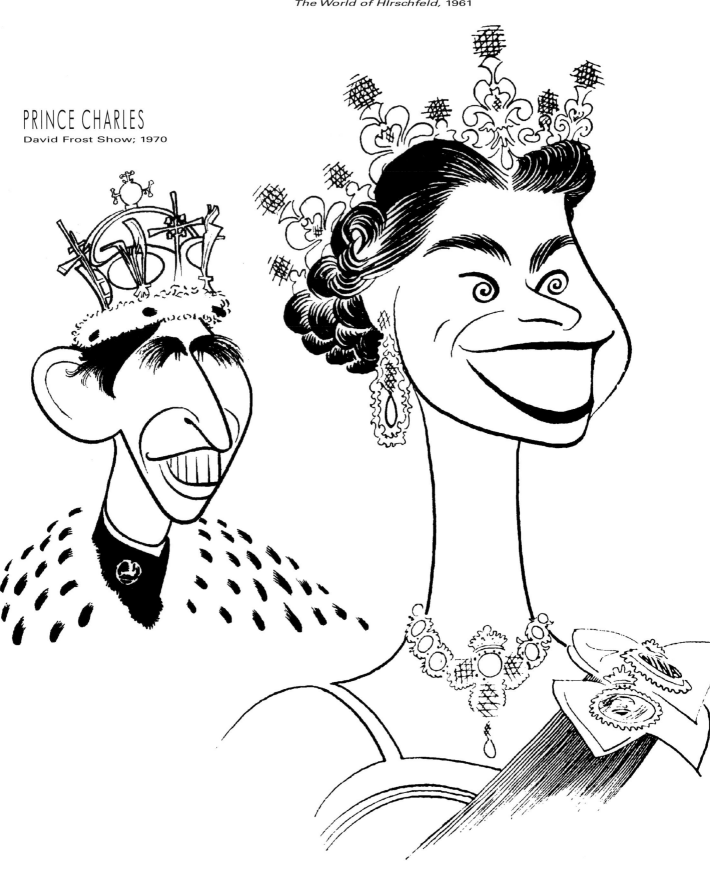

PRINCESS MARGARET
The World of Hirschfeld, 1961

PRINCE CHARLES
David Frost Show; 1970

CATHLEEN NESBITT

My Fair Lady; book & lyrics by Alan Jay Lerner,
based on *Pygmalion* by George Bernard Shaw;
music by Frederick Loewe; directed by Patrick Garland;
scenic design by Oliver Smith;
costume design by Cecil Beaton; NYT, 1981

THE HOLLOW CROWN

Shakespeare excerpts presented by Sir Michael Redgrave; *NYT*, 1974

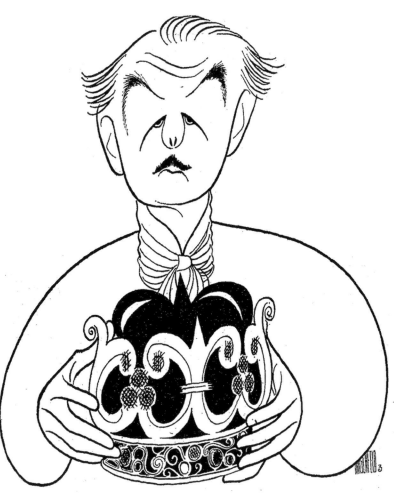

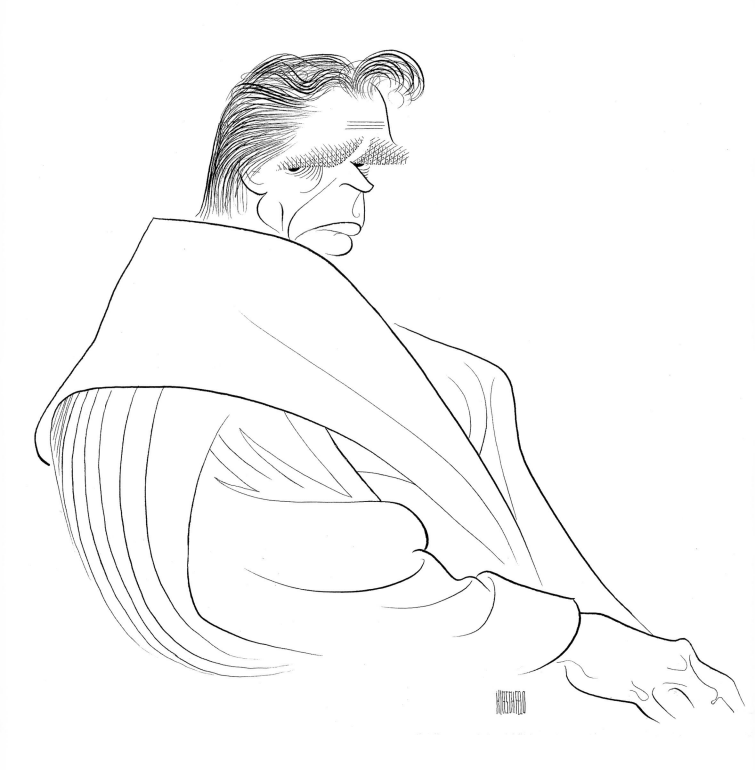

A MAN FOR ALL SEASONS
by Robert Bolt (Tony Award); directed by Noël Willman (Tony Award);
actor: Paul Scofield (Tony Award); *NYT,* 1962

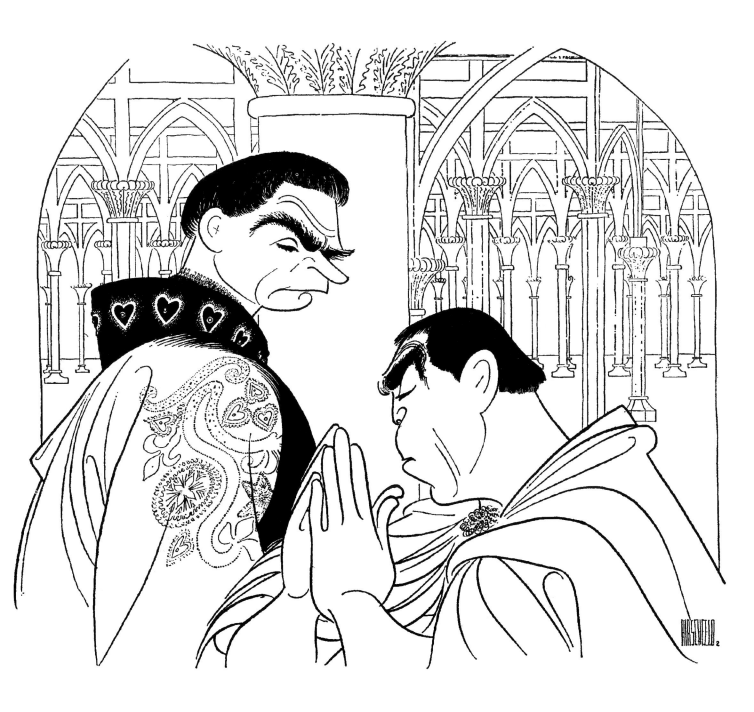

BECKET

(Tony Award)

by Jean Anouilh; directed by Peter Glenville; scenic design by Oliver Smith (Tony Award);
costume design by Motley (Tony Award); actors: Laurence Olivier & Anthony Quinn; *NYT,* 1960

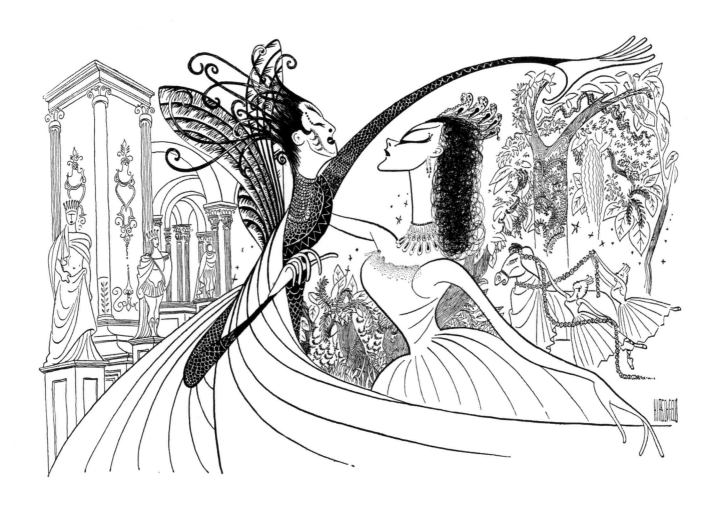

A MIDSUMMER NIGHT'S DREAM
Ballet; dancers: Robert Helpmann & Moira Shearer; *NYT*, 1954

☞ *Nobody stands like this! — even when they are dancing. Overcome by his obvious admiration for Beardsley, Hirschfeld has allowed the drawing to become a decorative pattern.* — **Ralph Steadman**

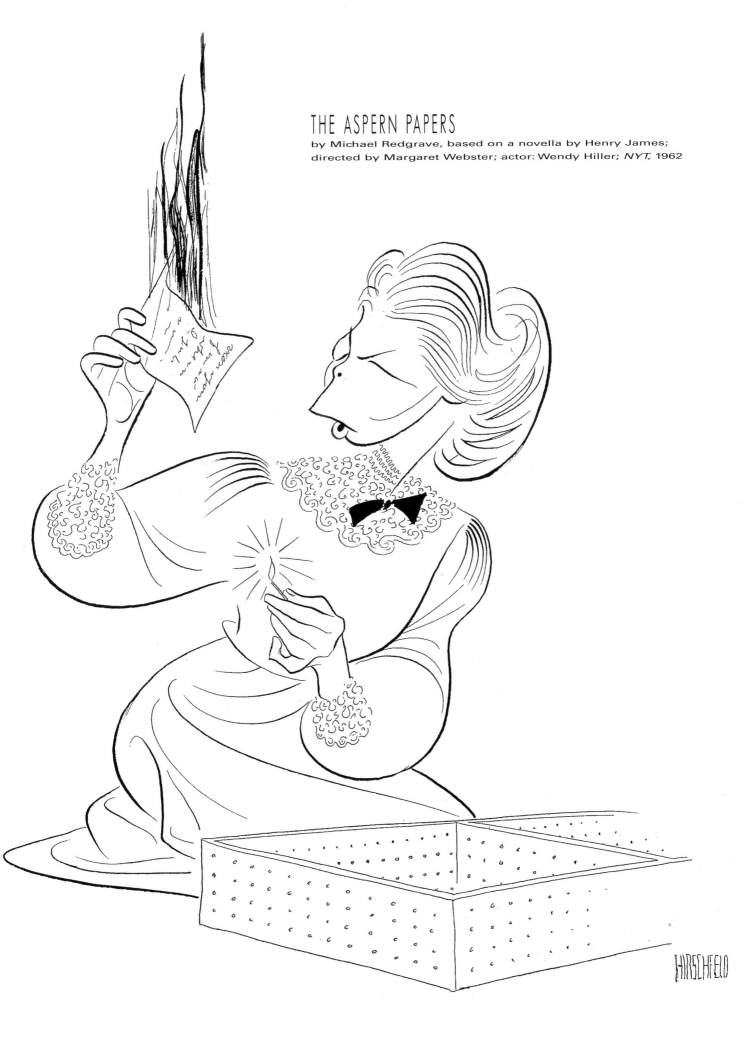

THE ASPERN PAPERS
by Michael Redgrave, based on a novella by Henry James;
directed by Margaret Webster; actor: Wendy Hiller; *NYT,* 1962

A PASSAGE TO INDIA

by Santha Rama Rau, based on the book by E.M. Forster; directed by Donald McWhinnie; actors: Zia Moyheddin, Anne Meacham, Eric Portman & Gladys Cooper; detail of drawing, *NYT*, 1962

☞ *The playwright, Santha Rama Rau, did very much the same kind of job on Forster as Ruth Prawer Jhabvala was to do in later years for Merchant/Ivory: elegant and slightly pointless. Zia Moyheddin, seen here on Broadway, had played Dr. Aziz in London with a less starry cast. We see him here opposite three big guns. Gladys Cooper had by now settled in Hollywood, where she played a succession of grandes dames, most notably Bette Davis' mother in 'Now Voyager.' Eric Portman was an extremely fine actor but a heavy drinker, which is perhaps why he's clinging so tightly onto Dame Gladys.* — Nicholas Wright

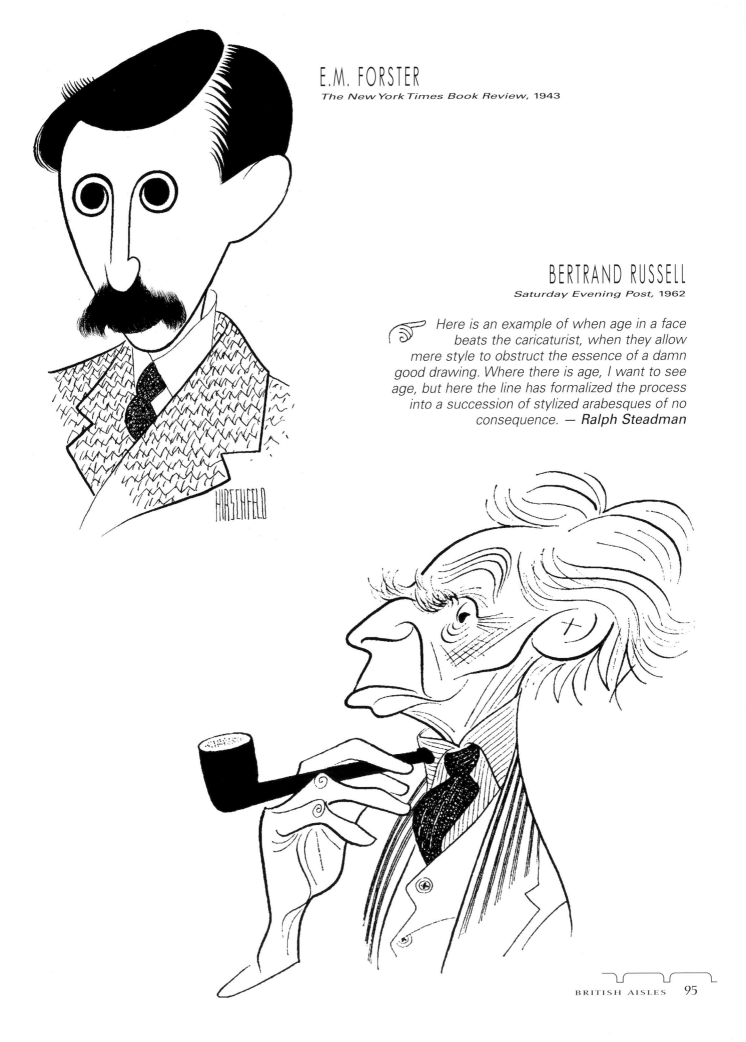

E.M. FORSTER
The New York Times Book Review, 1943

BERTRAND RUSSELL
Saturday Evening Post, 1962

Here is an example of when age in a face beats the caricaturist, when they allow mere style to obstruct the essence of a damn good drawing. Where there is age, I want to see age, but here the line has formalized the process into a succession of stylized arabesques of no consequence. — **Ralph Steadman**

MOUSE ON THE MOON

Screenplay by Michael Pertwee, based on the novel
by Leonard Wibberley; directed by Richard Lester;
actors: Terry-Thomas, Margaret Rutherford,
David Kossoff, Bernard Cribbins, Ron Moody; detail
of drawing, United Artists promotion, 1963

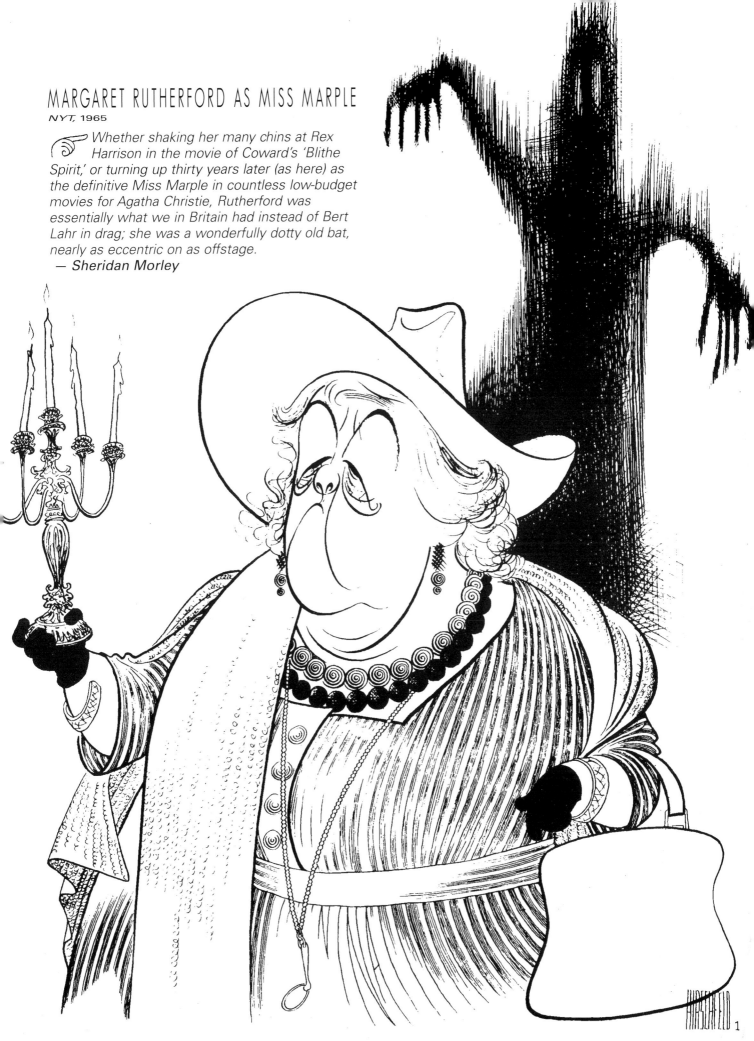

MARGARET RUTHERFORD AS MISS MARPLE

NYT, 1965

Whether shaking her many chins at Rex Harrison in the movie of Coward's 'Blithe Spirit,' or turning up thirty years later (as here) as the definitive Miss Marple in countless low-budget movies for Agatha Christie, Rutherford was essentially what we in Britain had instead of Bert Lahr in drag; she was a wonderfully dotty old bat, nearly as eccentric on as offstage.
— *Sheridan Morley*

1

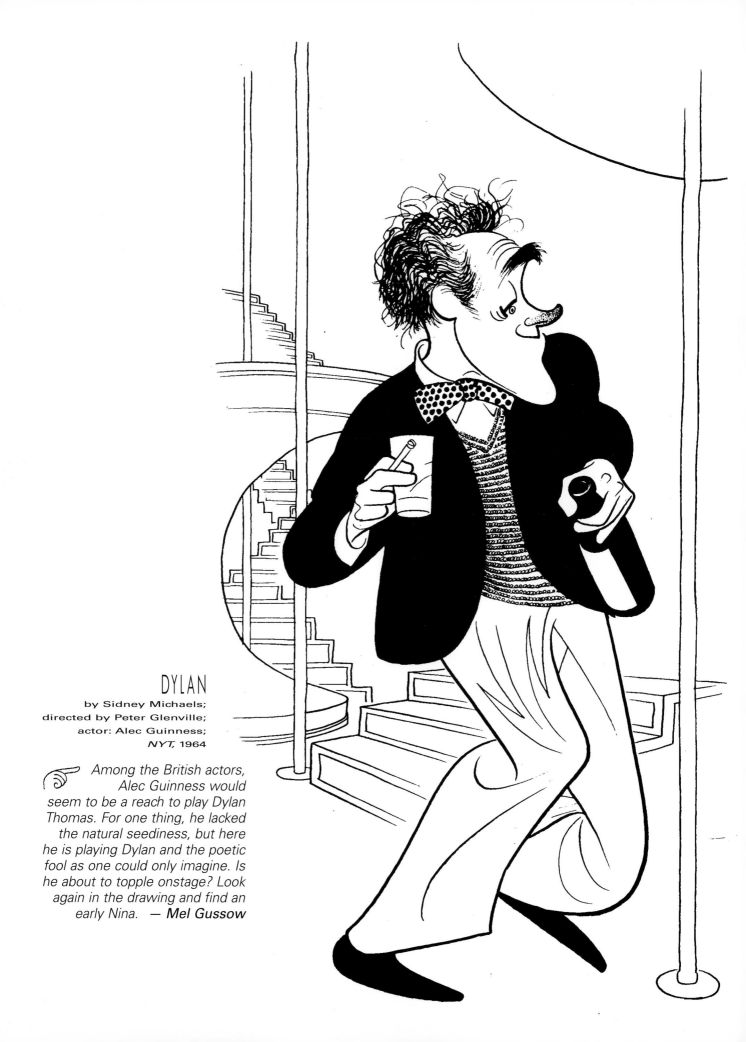

DYLAN
by Sidney Michaels;
directed by Peter Glenville;
actor: Alec Guinness;
NYT, 1964

Among the British actors,
Alec Guinness would
seem to be a reach to play Dylan
Thomas. For one thing, he lacked
the natural seediness, but here
he is playing Dylan and the poetic
fool as one could only imagine. Is
he about to topple onstage? Look
again in the drawing and find an
early Nina. — *Mel Gussow*

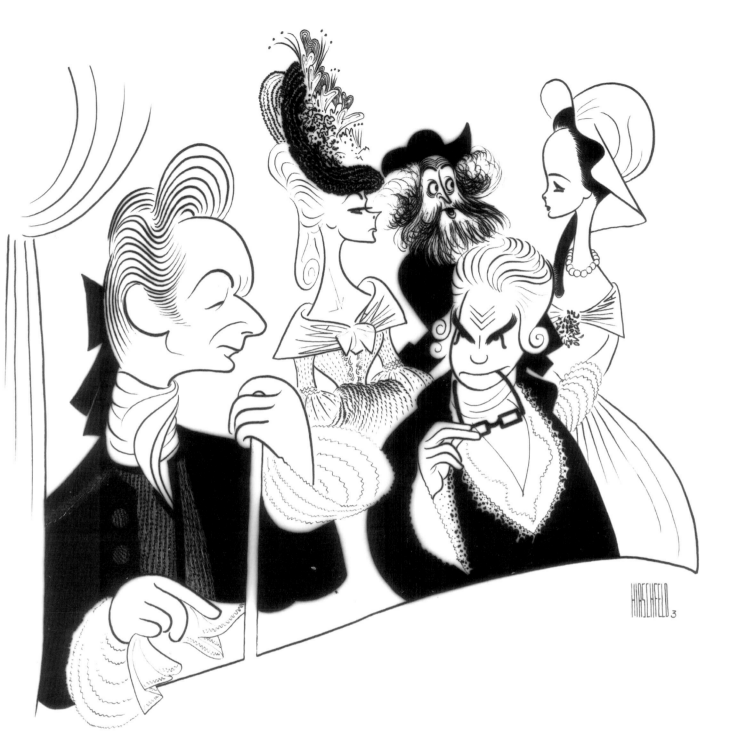

THE SCHOOL FOR SCANDAL

by R. B. Sheridan; directed by John Gielgud; actors: John Gielgud, Ralph Richardson,
Meriel Forbes, Laurence Naismith & Pinkie Johnstone; *First Nite*, 1963

The astonishing range of Hirschfeld's pictorial empathy can be savored at its very best by comparing the two 'side-by-side' impressions of Gielgud and Richardson (see page 131). In Sheridan's perfect comedy, you can see by a glance at the rococo lines of their portraits John's superbly sleek hypocrisy as Joseph Surface and Ralph's testy but true heart as Sir Peter Teazle. In Pinter's 'No Man's Land,' the artist catches with a fierce exactitude Richardson's alcohol-sodden and, above all, haunted introversion confronting the sponging dependency of Gielgud's seedy intellectual parasite. — Sir Peter Shaffer

BEYOND THE FRINGE

Book by Alan Bennett, Peter Cook,
Dudley Moore & Jonathan Miller;
directed by Alexander H. Cohen,
original London Production
directed by Eleanor Fazan;
scenic design by John Wyckham;
actors: Peter Cook (Tony Award),
Jonathan Miller (Tony Award),
Alan Bennett (Tony Award) &
Dudley Moore (Tony Award);
NYT, 1962

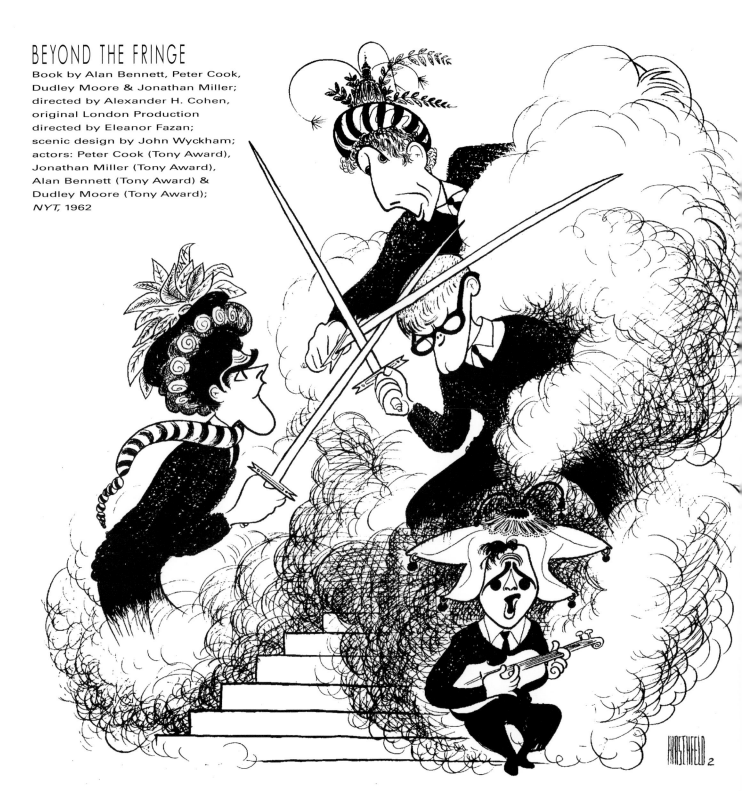

Recently arrived from Australia and performing in Lionel Bart's 'Oliver,' I attended the first performance of 'Beyond the Fringe.' I knew all the creators of this insouciant production for which, I suppose, the fashionable epithet of today would seem 'cutting edge.' There is a sadness for me in this brilliant composition as I reflect that only two members of this quartet are still living: Miller and Bennett still look very like Al's rendering of them nearly half a century ago. Having written and acted in my own satirical revues in Australia I saw the Fringe team as fellow spirits. When their show went to Broadway, Peter Cook auditioned for replacements and offered me his role, but the producers of 'Oliver' declined to release me. However, a friendship with Cook developed which lasted until his death in 1995. In the 60's Peter cast me and Dudley in his film 'Bedazzled,' directed by Stanley Donen. The movie was about the Seven Deadly Sins and my role was Envy — put that down to great casting. — *Barry Humphries*

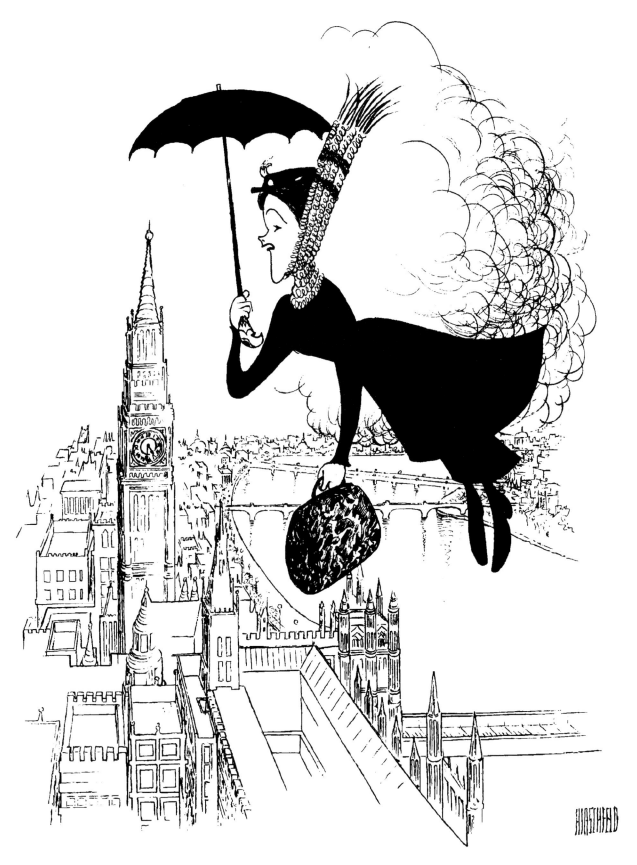

MARY POPPINS, FLYING OVER LONDON
Screenplay by Bill Walsh, based on a book by P. L. Travers;
music & lyrics by Richard M. Sherman & Robert B. Sherman;
directed by Robert Stevenson; costume design by Tony Walton;
actor: Julie Andrews (Oscar); 1964 (drawing Blake Edwards commission, 1990)

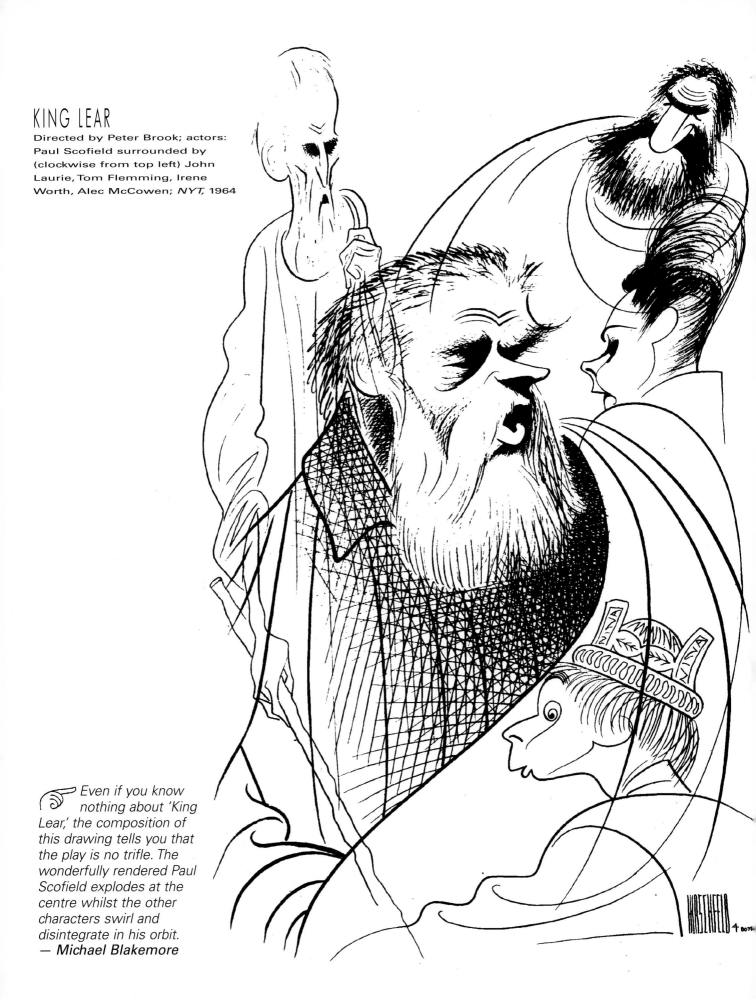

KING LEAR

Directed by Peter Brook; actors:
Paul Scofield surrounded by
(clockwise from top left) John
Laurie, Tom Flemming, Irene
Worth, Alec McCowen; *NYT*, 1964

*Even if you know
nothing about 'King
Lear,' the composition of
this drawing tells you that
the play is no trifle. The
wonderfully rendered Paul
Scofield explodes at the
centre whilst the other
characters swirl and
disintegrate in his orbit.*
— *Michael Blakemore*

PHOTO FINISH
by Peter Ustinov; directed by Ustinov & Nicholas Garland; actor: Peter Ustinov; *NYT*, 1963

☞ *Ustinov died last year looking not much older than he does in this drawing. He lived his life in reverse. As a young man he was precociously mature: an actor of weight, a movie-director to take notice of and, above all, the single playwright who seemed capable of reviving the great art of English comedy. As the years went by, his plays became less and less achieved. Meanwhile, his celebrity grew. He died famous for his wit and sparkle: the very model of the promising adolescent. Someone should re-discover his early plays.*
— *Nicholas Wright*

TINY ALICE

by Edward Albee; directed by Alan Schneider; scenic design by William Ritman; gowns by Mainbocher; actors: (r to l) John Gielgud, Irene Worth, John Heffernan, Eric Berry & William Hutt; *NYT,* 1964

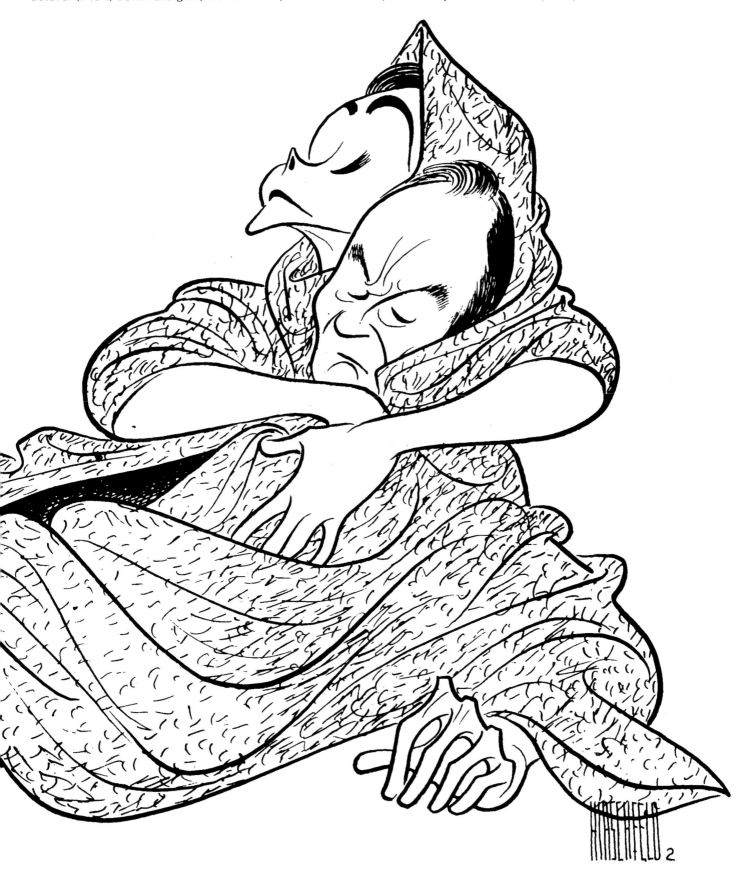

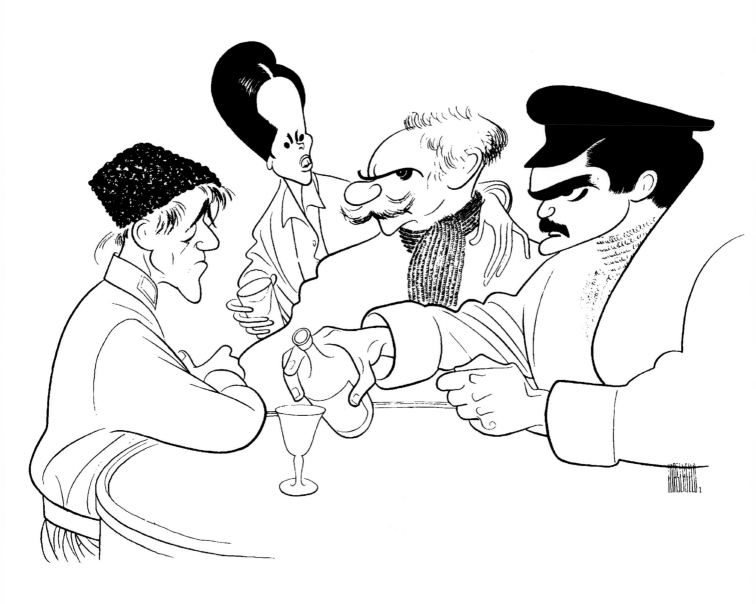

DR. ZHIVAGO

Screenplay by Robert Bolt, based on the book by Boris Pasternak; directed by David Lean;
actors: Alec Guinness, Geraldine Chaplin, Ralph Richardson & Omar Sharif; *NYT*, 1965

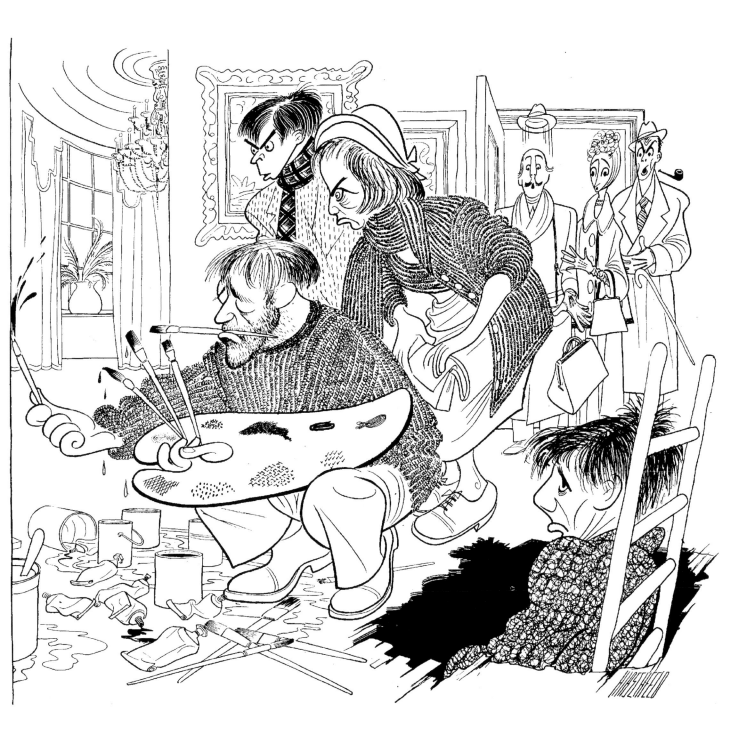

THE HORSE'S MOUTH

Screenplay by Alec Guinness, from the novel by Joyce Cary; directed by Ronald Neame; actors: Alec Guinness, Mike Morgan, Kay Walsh & Michael Gough; United Artists promotion, 1958

☞ *Hirschfeld had done his research for this drawing. In his youth, he traveled to the Soviet Union, drove through Persia, dined in Baghdad and lived for some months on the island of Bali. His watercolors and easel under his arm, he painted everything in sight. Back in New York, he hung out in the studios of his friends, Pollack, Keisler and Jenkins. He made a point of meeting artists who drank from many different palates.*

We don't know what's on his canvas, but the work obviously shocks everyone in sight. Alec Guinness is naturally oblivious to everything but the work under creation. Hirschfeld takes it all in and gives us back this marvelous portrait of the artist as hero. — **Louise Kerz Hirschfeld**

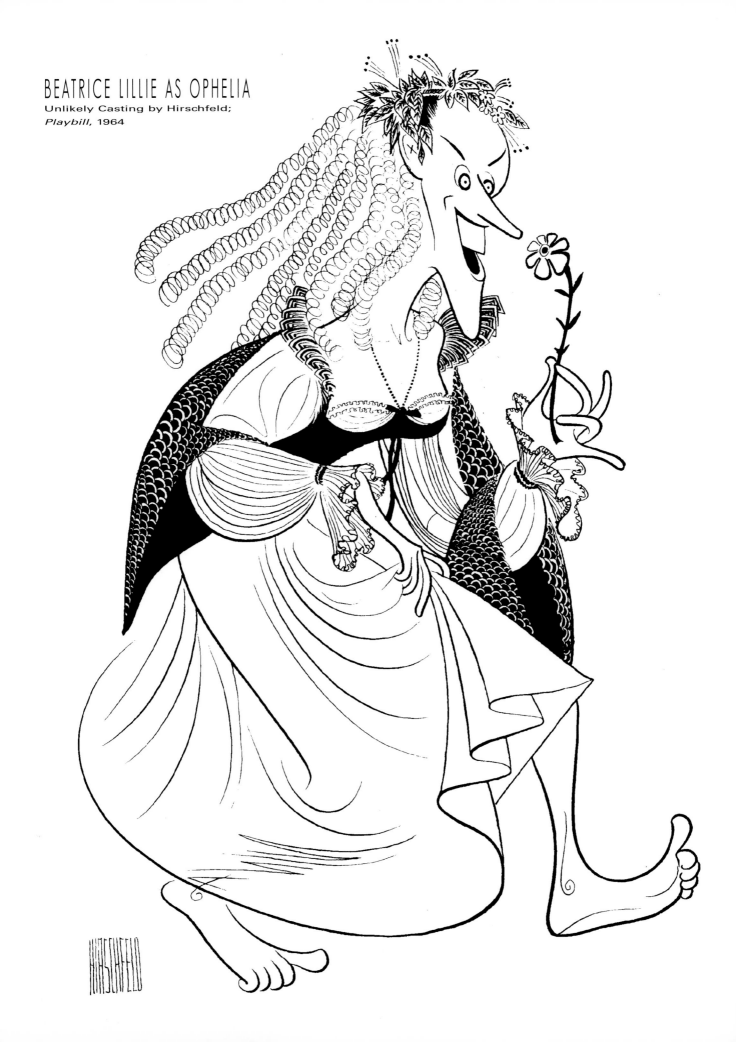

BEATRICE LILLIE AS OPHELIA
Unlikely Casting by Hirschfeld;
Playbill, 1964

JOHN GIELGUD IN TOBACCO ROAD
Unlikely Casting by Hirschfeld; *Playbill*, 1964

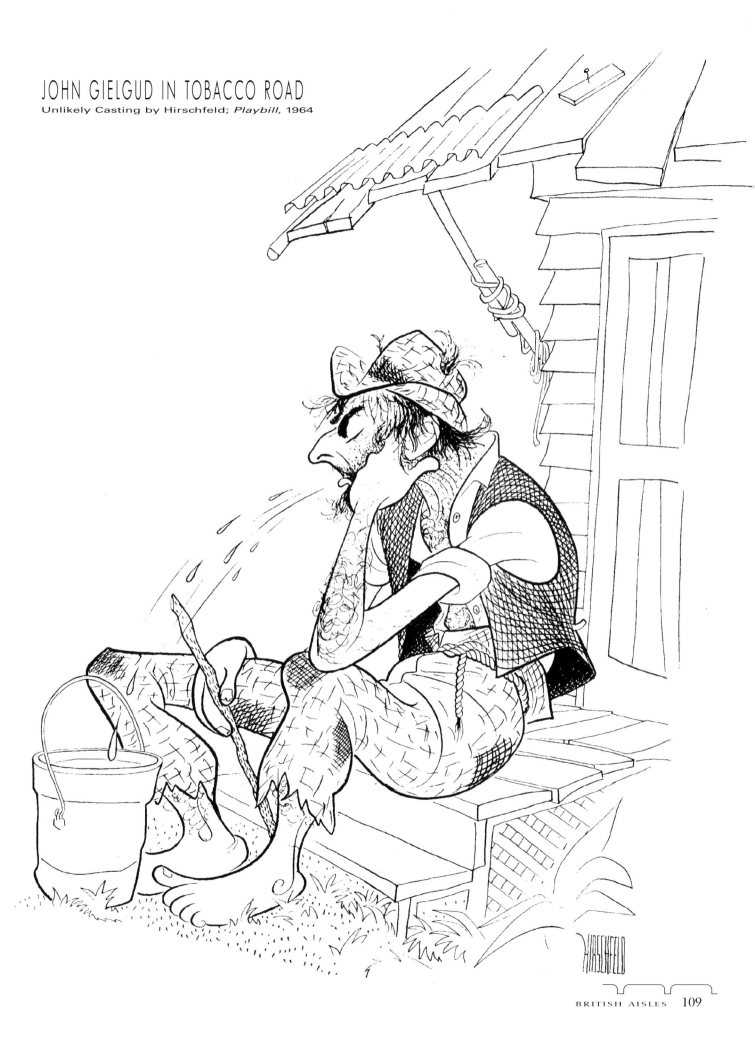

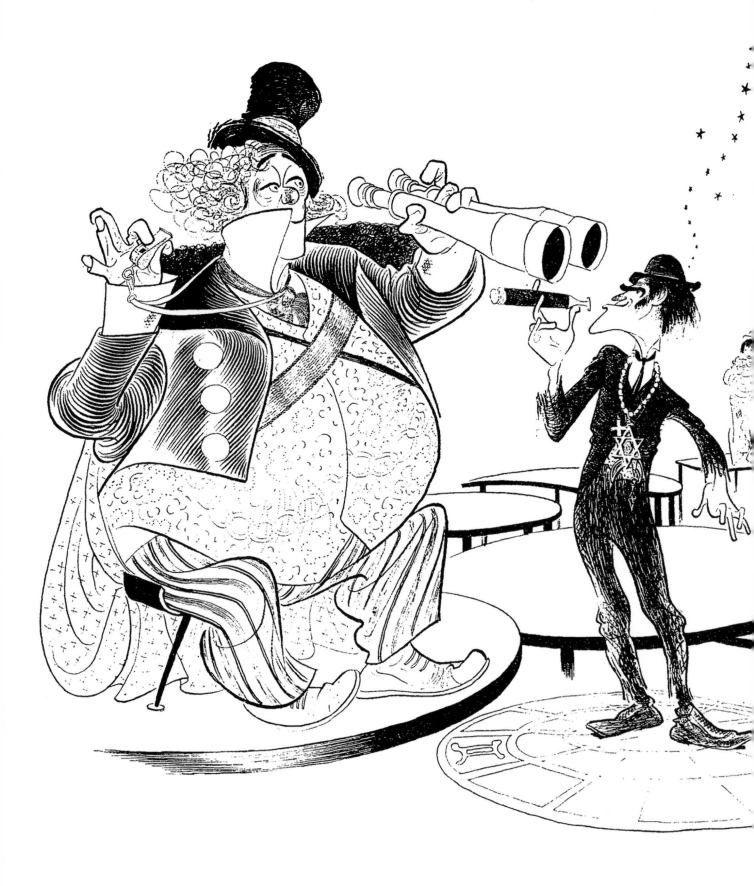

THE ROAR OF THE GREASEPAINT, THE SMELL OF THE CROWD
Book, lyrics & music by Leslie Bricusse & Anthony Newley; directed by Anthony Newley;
choreographed by Gillian Lynne; scenic design by Sean Kenny;
actors: Cyril Ritchard & Anthony Newley; detail of drawing, *NYT*, 1965

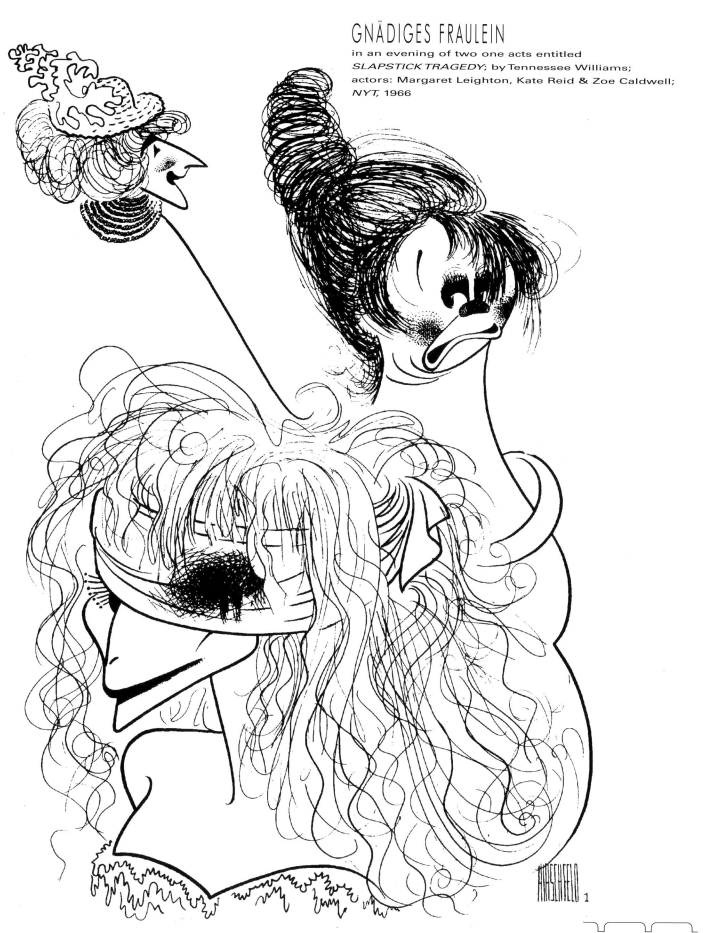

GNÄDIGES FRAULEIN
in an evening of two one acts entitled
SLAPSTICK TRAGEDY; by Tennessee Williams;
actors: Margaret Leighton, Kate Reid & Zoe Caldwell;
NYT, 1966

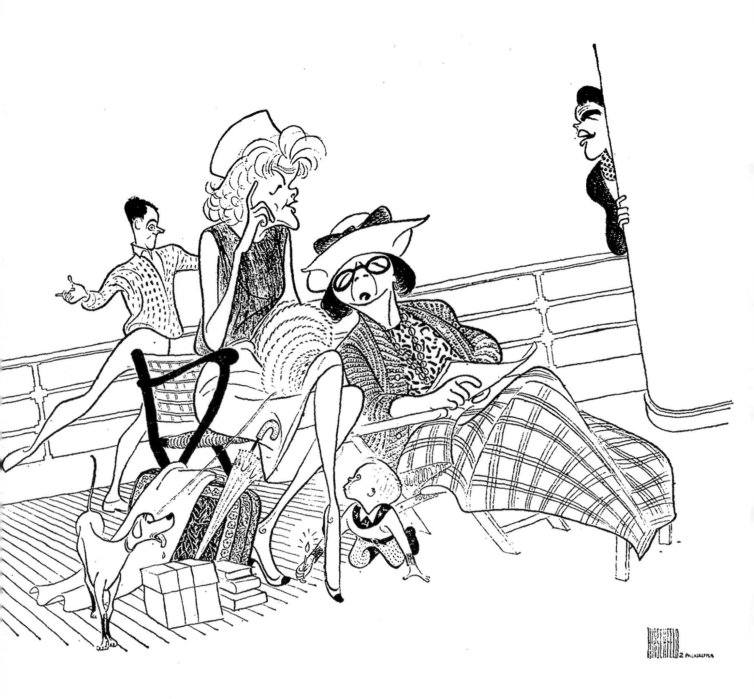

SAIL AWAY

Book, music & lyrics by Noël Coward; choreographed by Joe Layton;
actors: Grover Dale, Elaine Stritch, Alice Pearce, James Hurst & Paul O'Keefe; *NYT,* 1961

☞ *The last of Sir Noël Coward's many Broadway and West End solo-credit musicals (on 'Girl Who Came to Supper' he was only responsible for the score, and on 'High Spirits' not even that), this one was set on a cruise liner and made a star of Elaine Stritch, whose originally secondary role was expanded hugely on the road pre-New York, when it was reckoned that the original leading lady (Jean Fenn) was somewhat overly operatic.* — **Sheridan Morley**

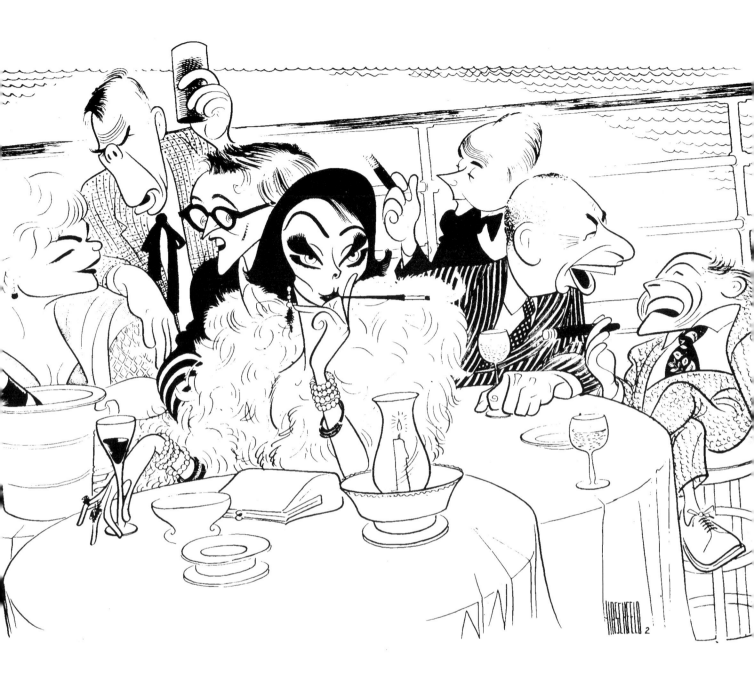

SHIP OF FOOLS
Screenplay by Abby Mann, based on the book by Katherine Anne Porter; directed by Stanley Kramer; actors: Simone Signoret, Lee Marvin, Oskar Werner, Vivien Leigh, Heinz Ruhmann, Jose Ferrer & Michael Dunn; *NYT,* 1965

This is an all-star movie, so everyone in the picture is working very hard to be as much of a star as anyone else. Vivien Leigh has the best idea. Say nothing, sit dead centre well to the front and bat your eyelashes straight to camera. — *Michael Blakemore*

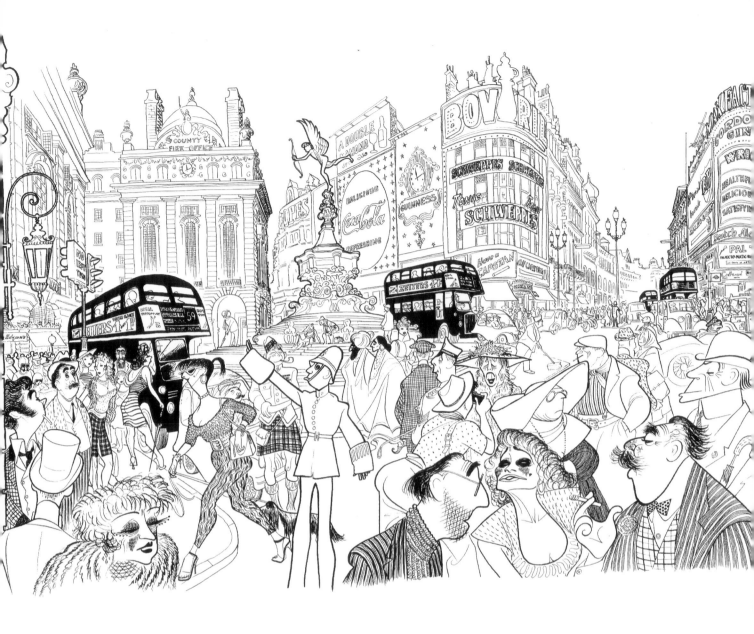

AT THE DROP OF A HAT

**Theatre curtain by Al Hirschfeld; music by Donald Swann; lyrics by Michael Flanders;
directed by Swann & Flanders; Alexander H. Cohen commission, 1956**

 There is no dirt in this drawing and it is far too specific. The policeman is hopelessly out of character. Some figures are recognizably typical but the top hat is a cliché. — **Ralph Steadman**

Producer Alexander H. Cohen hired me to design this curtain, depicting Piccadilly Circus. It was my only stab at stage designing, largely because it did not require joining the Stage Designers Union. To join the union at that time you had to recognize the difference between a great braguette and a G-String; also between a Tuscan pillar, an Ionic column and a Brass Rail. You also had to have five hundred dollars in cash. If you happened to pass the mental and financial tests and were accepted as a full-fledged 829 member, the logical consequence of your folly would be that you'd actually be given an assignment to design the sets for a new play. The probability of this extravagant set of assumptions ever happening was about as remote as the growth of a small hand behind your ear. — **Al Hirschfeld**

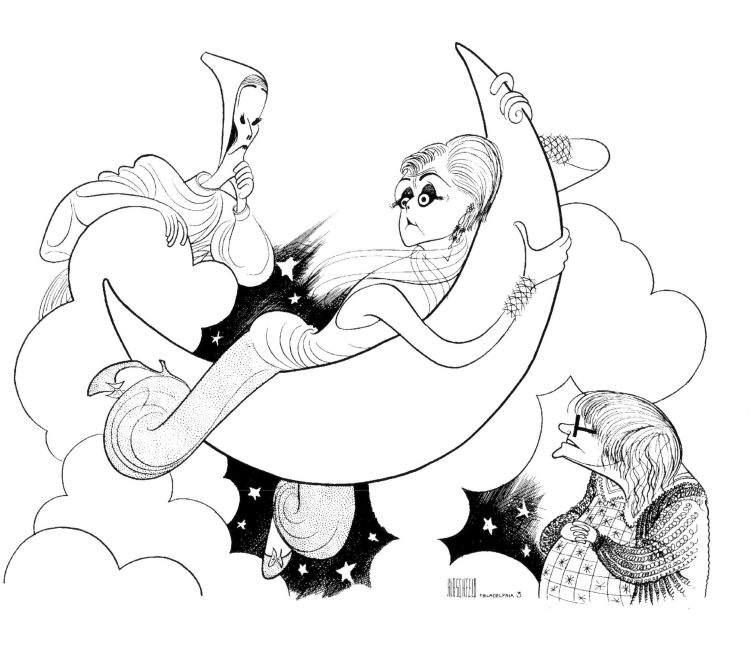

MAME

Book by Jerome Lawrence & Robert E. Lee; music & lyrics by Jerry Herman;
directed by Gene Saks; scenic design by William & Jean Eckart; actors: Beatrice Arthur
(Tony Award), Angela Lansbury (Tony Award) & Jane Connell; *NYT*, 1966

☞ *Angela Lansbury, whom I first glimpsed as a servant in 'The Old House,' is one of the
great indestructible stars of our time. Recently at a Stephen Sondheim gala she was
photographed with Dame Edna Everage, beside whom she appeared to be considerably
younger and possibly even better dressed. Her theatrical, television and film incarnations are
innumerable. Seeing Hirschfeld's drawing of the great Lansbury rather awkwardly and even
painfully airborne, I wish more than ever I had seen her as Mame.* — *Barry Humphries*

IVANOV

by Anton Chekhov; directed by John Gielgud;
actors: Roland Culver, Edward Atienza,
Vivien Leigh, John Gielgud, Jennifer Hilary,
Ethel Griffies, John Merivale &
Paula Laurence; *NYT,* 1966

*John (aka 'Jack') Merivale was
Vivien Leigh's lover in this last
act of her life, and a nicer or more
decent man would be hard to imagine.
He subscribed to the gentlemanly
school of acting of which Roland
Culver (seen on the left) was a master,
and he left one fine performance for
posterity in the 1958 Titanic movie, 'A
Night to Remember' as the passenger
who gallantly sends his wife ahead to
the lifeboats. 'I'll be fine, my darling,'
he assures her, knowing he won't.
Merivale had a lifelong connection
with beautiful actresses: his
stepmother was Gladys Cooper, he
was married to the Hollywood stunner
Jan Sterling and, after the death of
Vivien Leigh, he ended his days with
the idol of my teenage cinema-going,
Dinah Sheridan. — **Nicholas Wright**

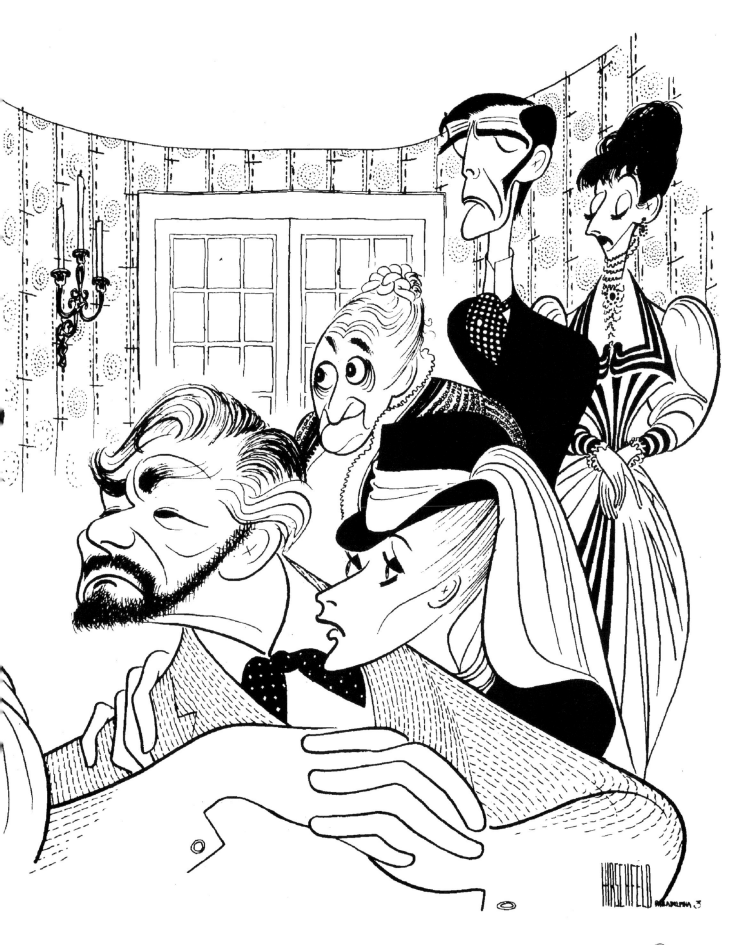

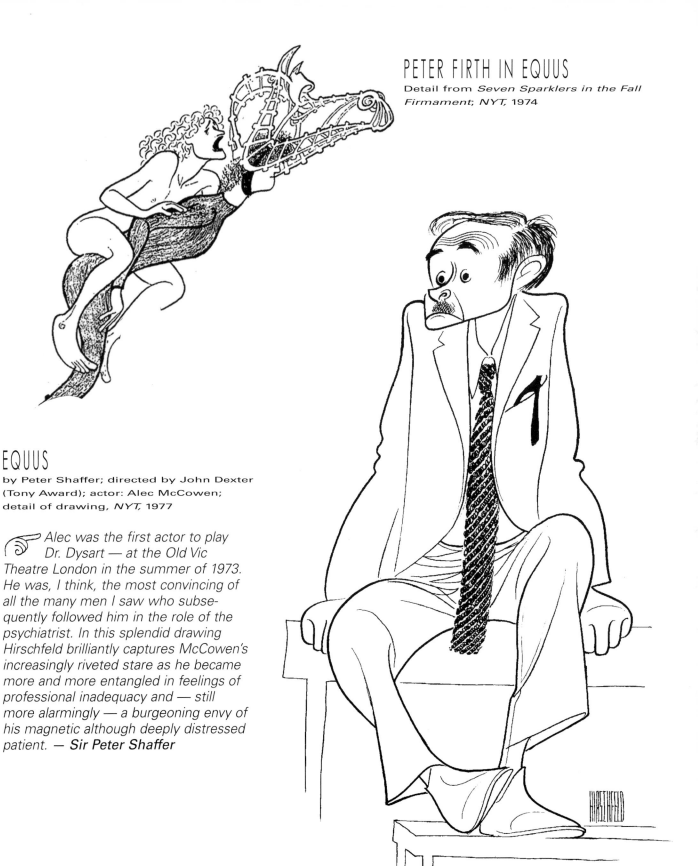

EQUUS

by Peter Shaffer; directed by John Dexter (Tony Award); actor: Alec McCowen; detail of drawing, *NYT,* 1977

Alec was the first actor to play Dr. Dysart — at the Old Vic Theatre London in the summer of 1973. He was, I think, the most convincing of all the many men I saw who subsequently followed him in the role of the psychiatrist. In this splendid drawing Hirschfeld brilliantly captures McCowen's increasingly riveted stare as he became more and more entangled in feelings of professional inadequacy and — still more alarmingly — a burgeoning envy of his magnetic although deeply distressed patient. — **Sir Peter Shaffer**

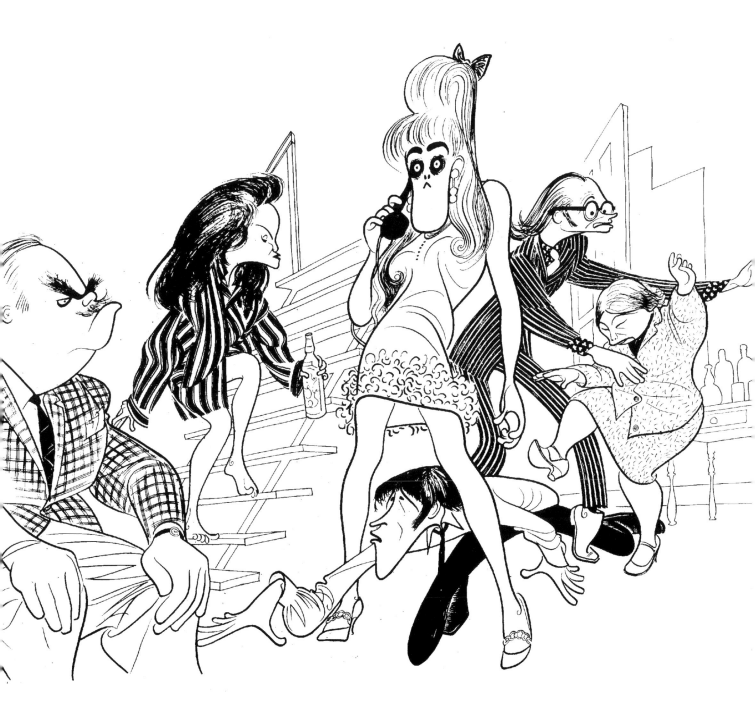

BLACK COMEDY

by Peter Shaffer; directed by John Dexter; actors: Peter Bull, Geraldine Page, Michael Crawford, Lynn Redgrave, Donald Madden, & cast; *NYT,* 1967

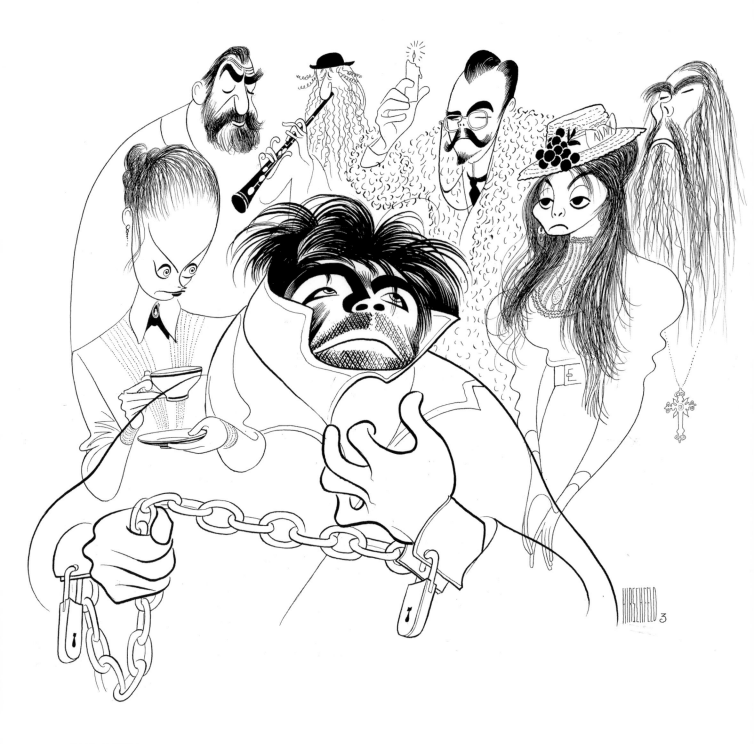

THE FIXER

**Screenplay by Dalton Trumbo, based on the novel by Bernard Malamud; directed by John Frankenheimer;
actors: Elizabeth Hartman, Hugh Griffith, Jack Gilford, Dirk Bogard, Georgia Brown, Ian Holm surround
Alan Bates; *NYT*, 1968**

FAR FROM THE MADDING CROWD

Screenplay by Frederic Raphael, based on Thomas Hardy's novel; directed by John Schlesinger;
actors: Alan Bates, Julie Christie, Peter Finch & Terence Stamp; *NYT*, 1967

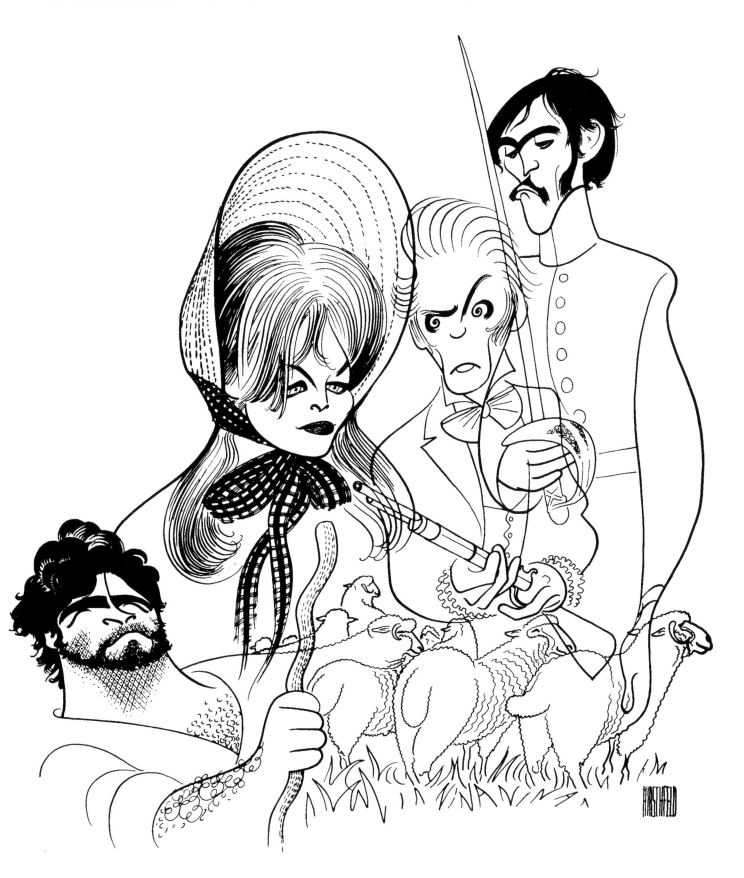

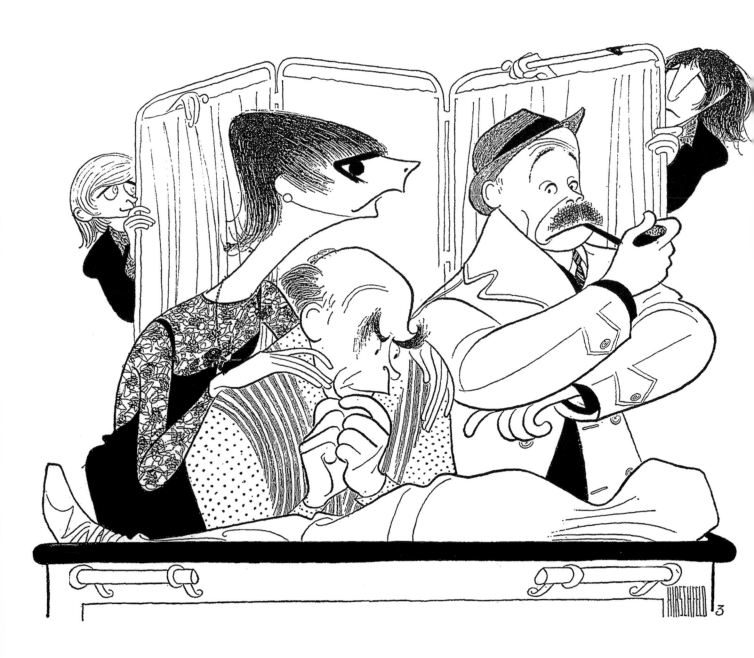

LOOT

by Joe Orton; directed by Derek Goldby; actors: Jack Hunter, Carole Shelley,
Liam Redmond, George Rose & Kenneth Cranham; *NYT,* 1968

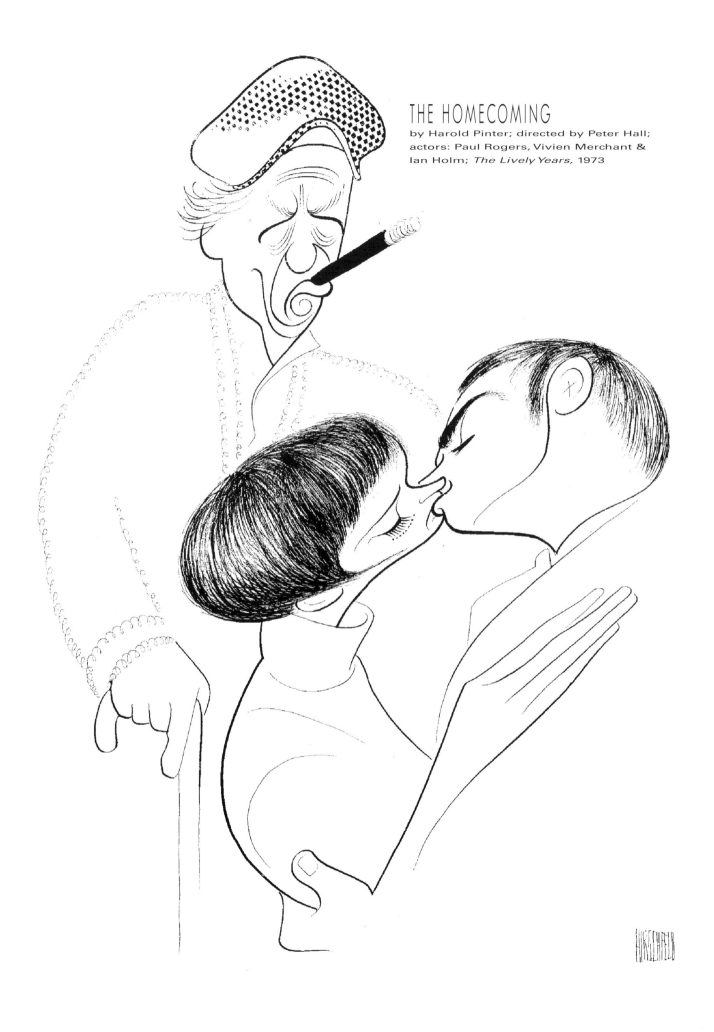

THE HOMECOMING
by Harold Pinter; directed by Peter Hall;
actors: Paul Rogers, Vivien Merchant &
Ian Holm; *The Lively Years,* 1973

VIVAT! VIVAT REGINA!

by Robert Bolt; directed by Peter Dews;
actors: Claire Bloom & Eileen Atkins; *NYT*, 1972

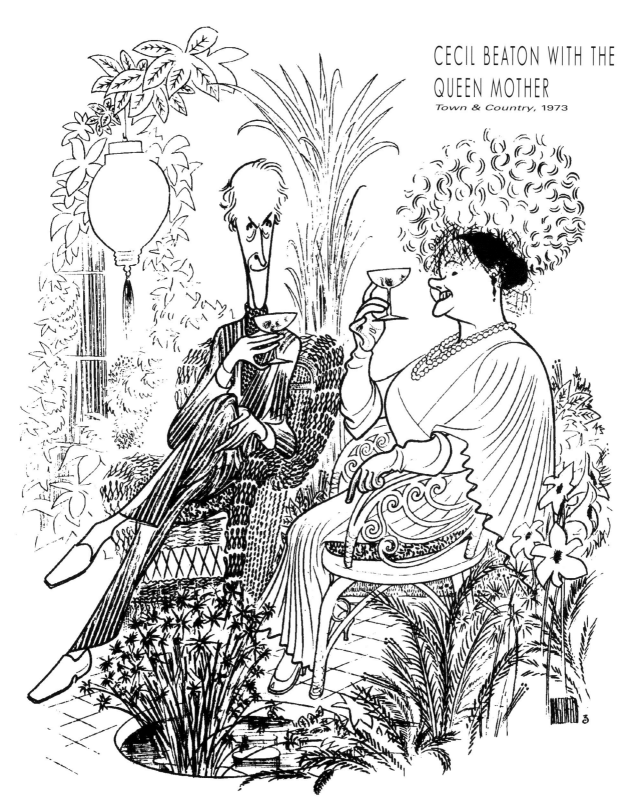

☞ *This is my absolute favorite Hirschfeld drawing. Cecil Beaton, court photographer, flanneur and
acclaimed designer of sets and costumes for 'My Fair Lady' is here seen in the role of Henry
Higgins in colloquy with Mrs. Higgins in her luxuriant conservatory. Mrs. Higgins is, of course, the Queen
Mother, the penultimate royal matriarch sipping some gin-based tincture. As a royal vignette it equals Max
Beerbohm's celebrated drawing of Alfred Lord Tennyson reading 'In Memoriam' to Queen Victoria. In
Hirschfeld's drawing the royal personage is gazing lovingly into her cocktail and Cecil, poised in a wicker
chair, has a beady eye on posterity. I once sat next to the Queen Mother at dinner during which she sotto
voce sang me a series of old fashioned and slightly naughty vaudeville songs. 'You might put some of
those into your next show, Mr. Humphries,' she advised. Cecil, always the courtier, is assuming an
appreciative expression as the Queen Mother teeters on the brink of song. — Barry Humphries*

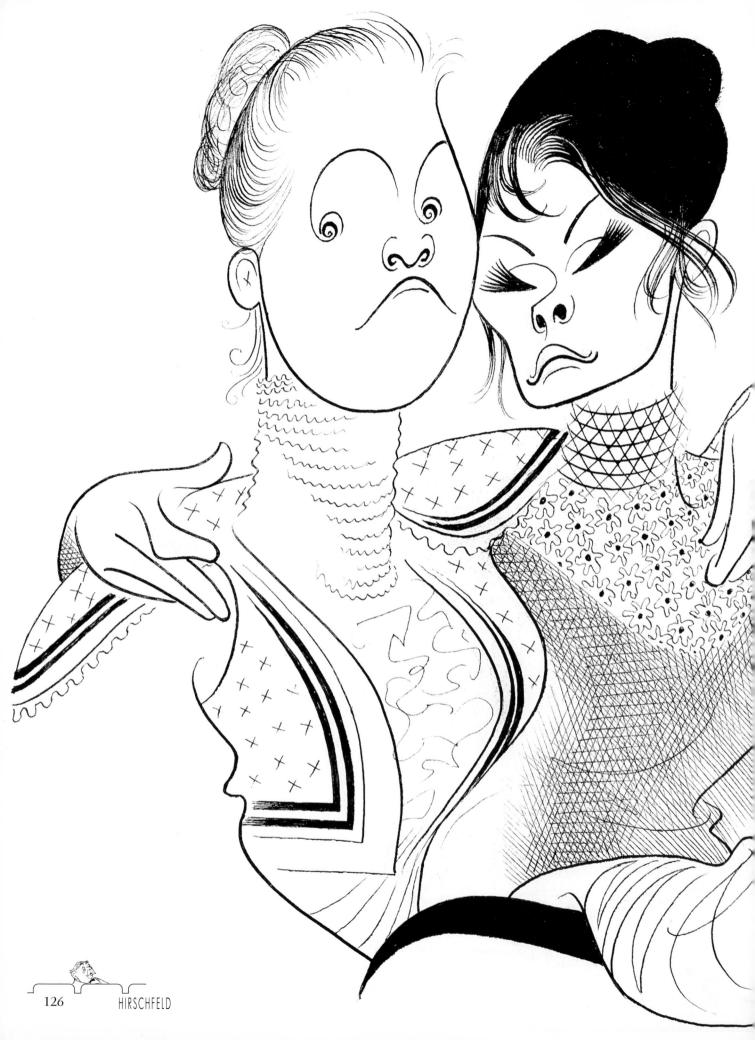

THREE SISTERS
Screenplay by Moura Budberg,
based on the play by Anton Chekhov;
directed by Cedric Messina;
actors: Eileen Atkins, Janet Suzman &
Michele Dotrice; Mobil Classic Theatre,
BBC/PBS, 1975

ULYSSES IN NIGHTTOWN

Dramatized by Marjorie Barkentin, from the novel *Ulysses* by James Joyce;
score by Peter Link; directed by Burgess Meredith; actor: Zero Mostel; NYT, 1973

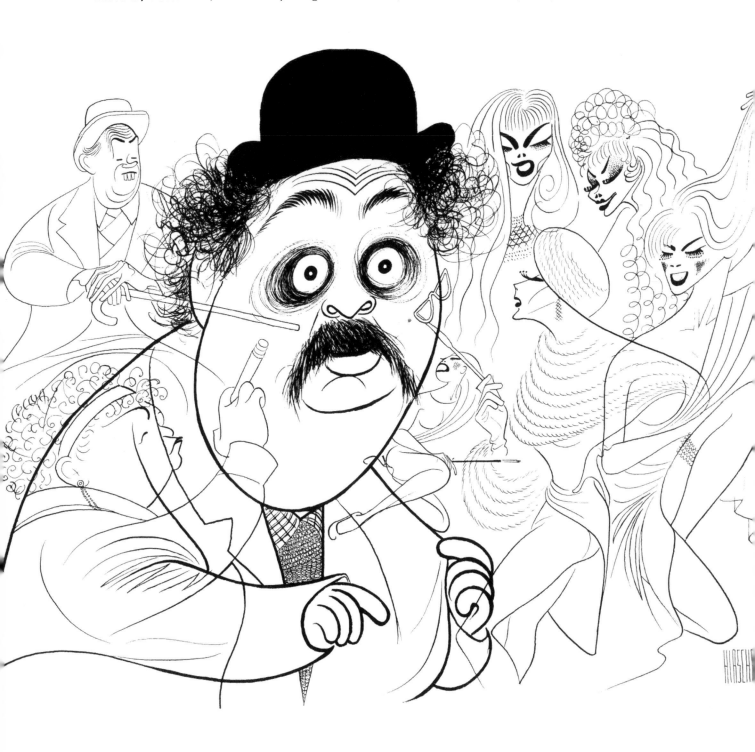

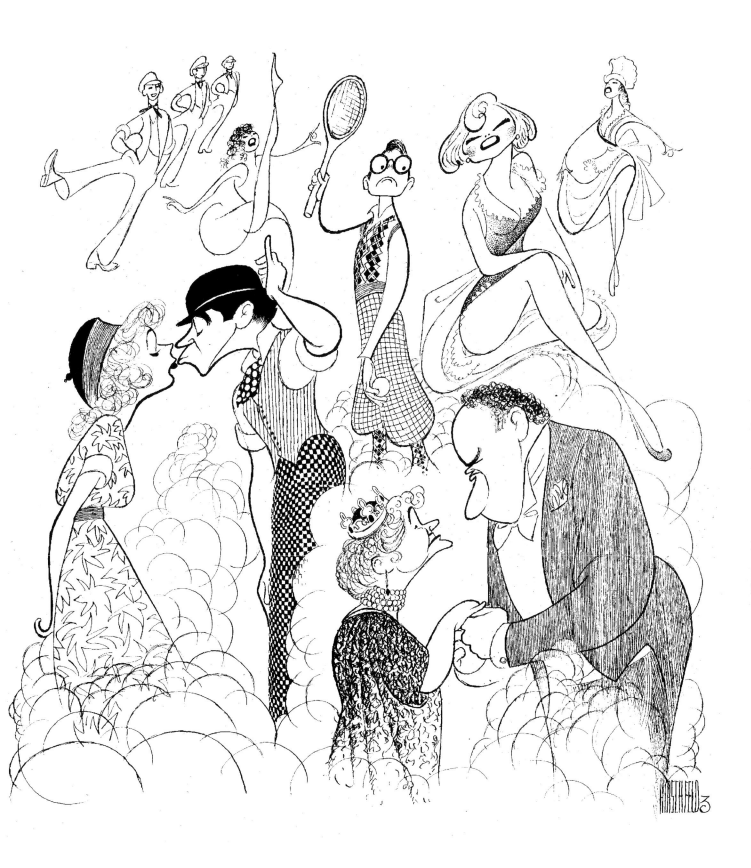

ME AND MY GIRL

Book & lyrics by L. Arthur Rose & Douglas Furber, book revised by Stephen Fry; music by Noël Gay; directed by Mike Ockrent; scenic design by Martin Johns; costume design by Ann Curtis; actors: Maryann Plunkett, Robert Lindsay, Nick Ullett, Jane Summerhays, George S. Irving & Jane Connell; *NYT,* 1986

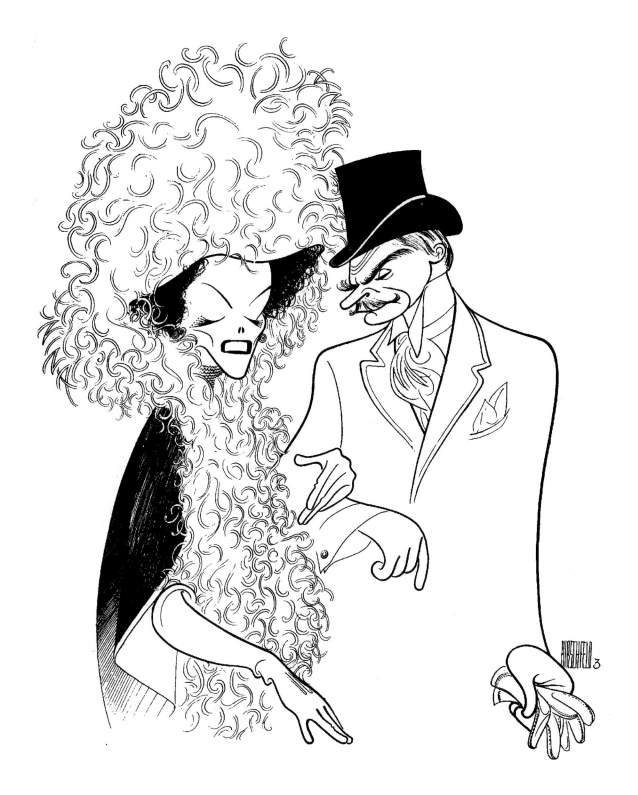

LOVE AMONG THE RUINS
Teleplay by James Costigan; directed by George Cukor;
actors: Katharine Hepburn & Laurence Olivier; private commission, 1975

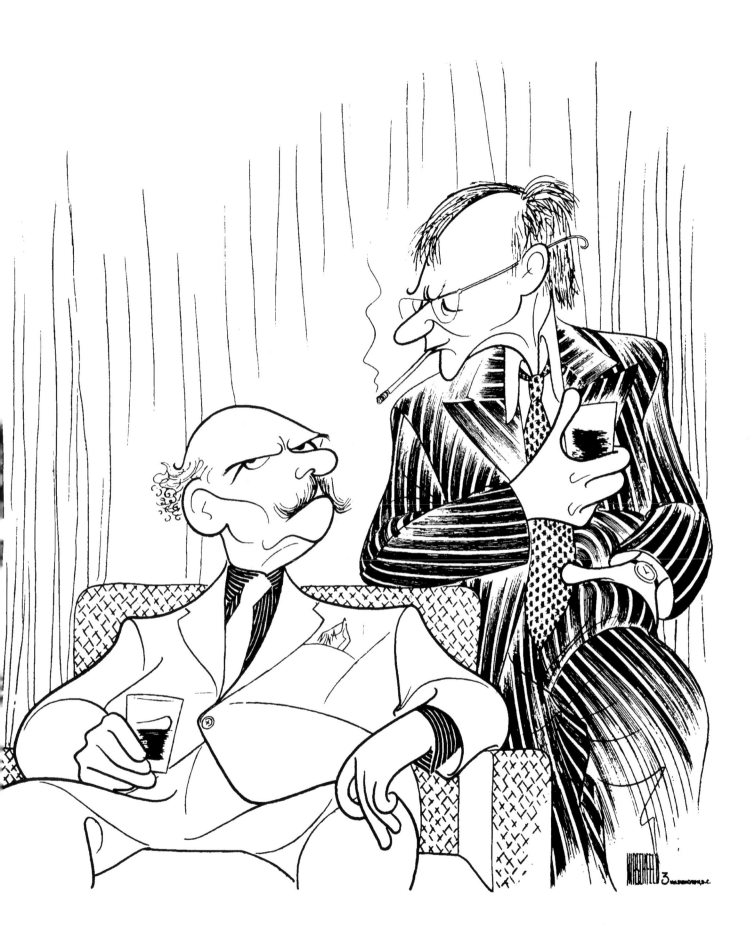

NO MAN'S LAND
by Harold Pinter; directed by Peter Hall; actors: Ralph Richardson & John Gielgud; *NYT,* 1976

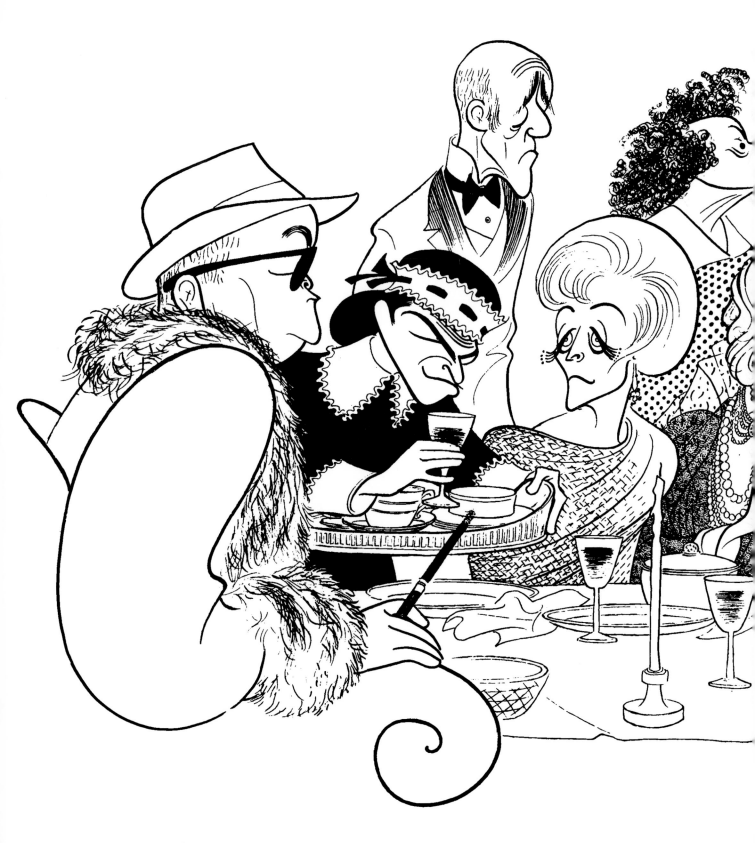

MURDER BY DEATH

Screenplay by Neil Simon; directed by Robert Moore; actors: Truman Capote, Nancy Walker,
Alec Guinness, Maggie Smith, Estelle Winwood, Elsa Lanchester, Peter Sellers, Peter Falk,
Eileen Brennan, James Coco & David Niven; Columbia Studios promotion, 1976

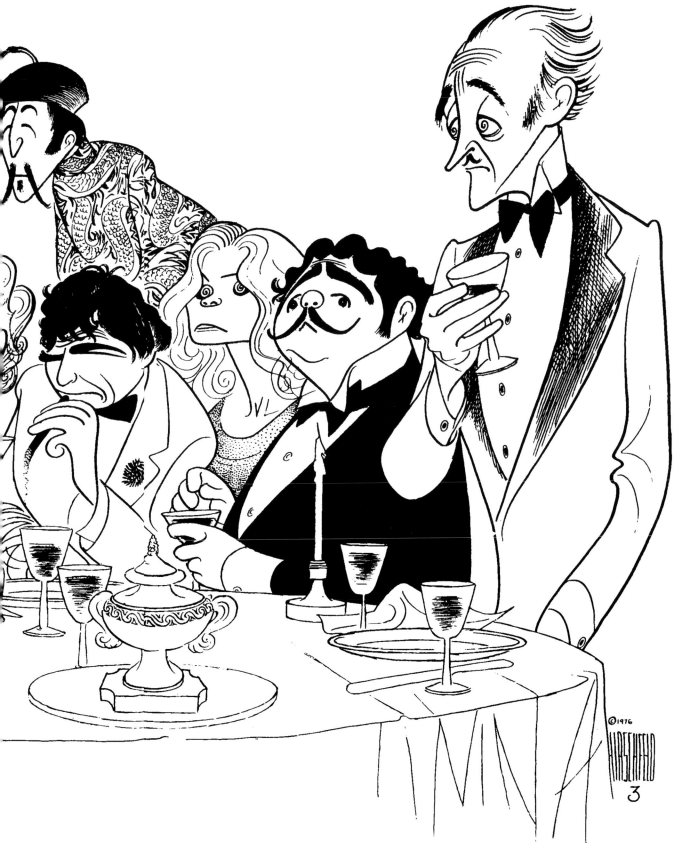

☞ Hirschfeld's nib has never been so assured as in this brilliant tableau.
The concave profile of Capote, the spiral irises of the aging Niven;
Maggie Smith may not be guilty of murder but she is definitely guilty of
scene stealing. — *Barry Humphries*

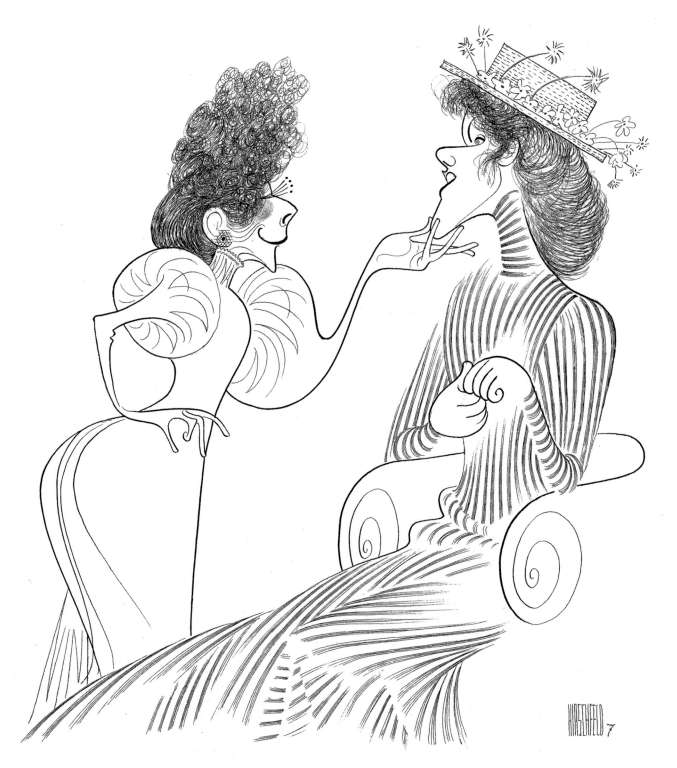

MRS. WARREN'S PROFESSION

by George Bernard Shaw; directed by Gerald Freedman;
costume design by Theoni V. Aldredge; actors: Ruth Gordon & Lynn Redgrave; *NYT,* **1976**

What a drawing! What an immaculate depiction of the confrontation between witty and wily experience and the ingenuousness of a greatly gifted newcomer. How generously the courteous Al has enlivened Lynn Redgrave's supporting status with an amalgam of sprightly stripes! How deftly her upholstered armchair is established through one seemingly continuous swirl! How tenderly he constrasts the soft puppy paws of Lynn's youth with the extenuation and sophistication of Ruth Gordon's delicately dancing fingers! What calculation in the creation of their graphically balanced coiffure: the lady's heroically striving ever-upward. The lass's tumbling ever-down! How exquisitely their profiles are contrasted and their postures contrived! And the brilliantly perceptive caricaturist even manages to convey the fact that each actress could be considered by their peers — in their markedly different ways — the most endearing of all possible creatures. And seven Ninas no less! — Tony Walton

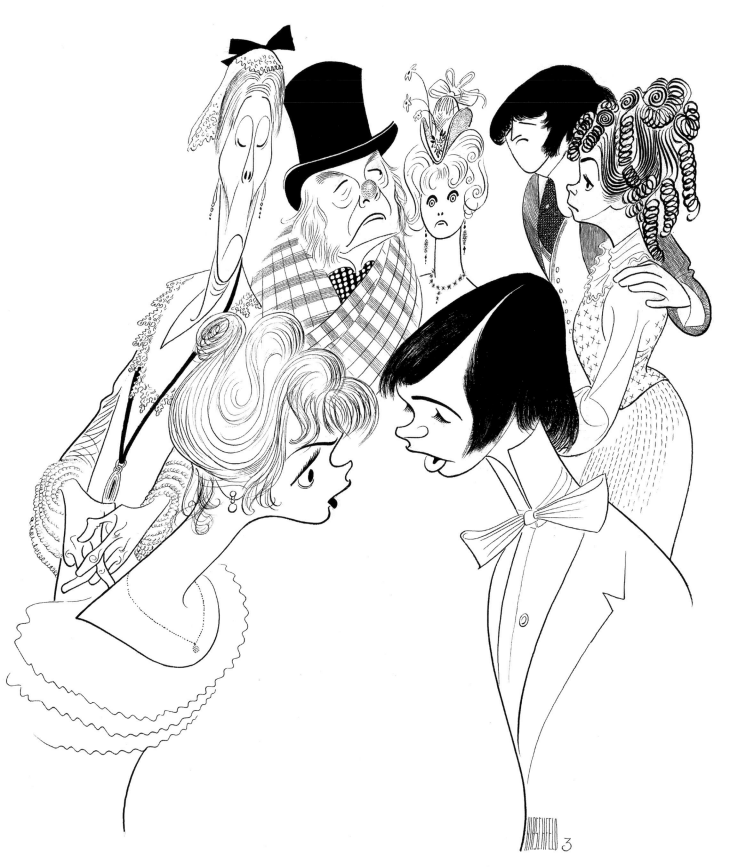

TRELAWNEY OF THE WELLS

by Sir Arthur Wing Pinero; directed by A.J. Antoon;
actors: Rachel Kempson, Roland Culver, Moira Redmond,
John Alderton & Elizabeth Seal surround Elaine Taylor &
Ian Ogilvy; Mobil Classic Theatre BBC/PBS, 1975

THE ENGLISH PLAYWRIGHTS

Simon Gray, David Rudkin, Harold Pinter, Alan Ayckbourn, Trevor Griffiths, Peter Shaffer & Tom Stoppard; *NYT,* 1977

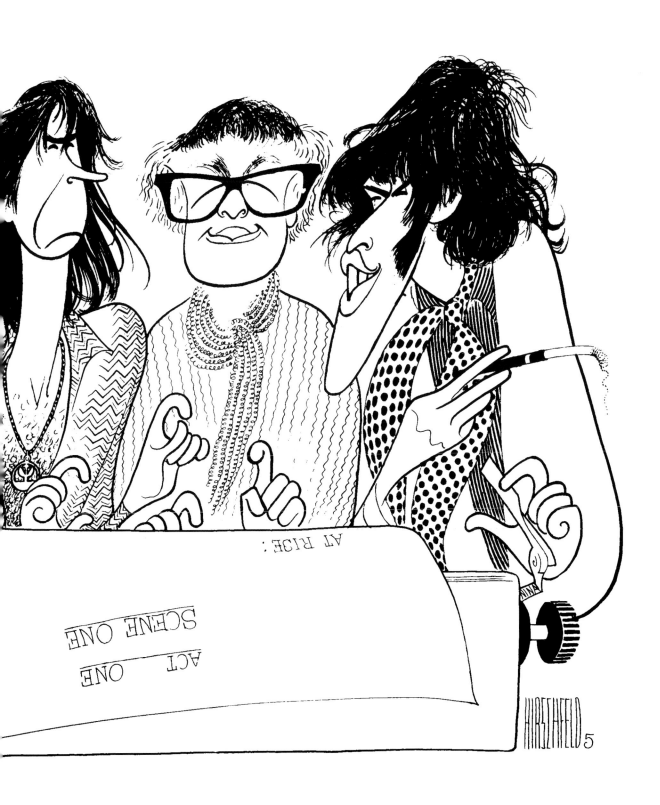

On the typewriter paper: AT RISE: / SCENE ONE / ACT ONE

HIRSCHFELD 5

What happened to all that lovely hair? But what's wonderful is that they're all still writing and writing very well. — **Simon Callow**

TONY WALTON

Oscar, Tony & Emmy winning production & costume designer;
also stage producer, director, graphic artist & illustrator; private collection, 2002

I didn't know, when I first saw Sandy Wilson's 'Valmouth' in the West
End in 1958 and was entranced by the settings and costumes, that I
would later meet the designer of it and be equally entranced by him. We
worked together on Dick Lester's 'Petulia,' on Francois Truffaut's 'Fahrenheit 451'
and on Mike Nichols's 'Uncle Vanya' on Broadway
for which he designed for me one of the most
beautiful costumes I have ever worn.
Throughout that time he and his wife,
Gen LeRoy, have been the most loyal of
pals.

The drawing has caught for me that
moment when a friend has walked into
Tony's studio and his face lights up in
welcome as if that was the one person on
earth he most wanted to see. What the
portrait captures, too, is Tony's sparkling and
constant enthusiasm and the warmth with
which he embraces all the people with
whom he works. — *Julie Christie*

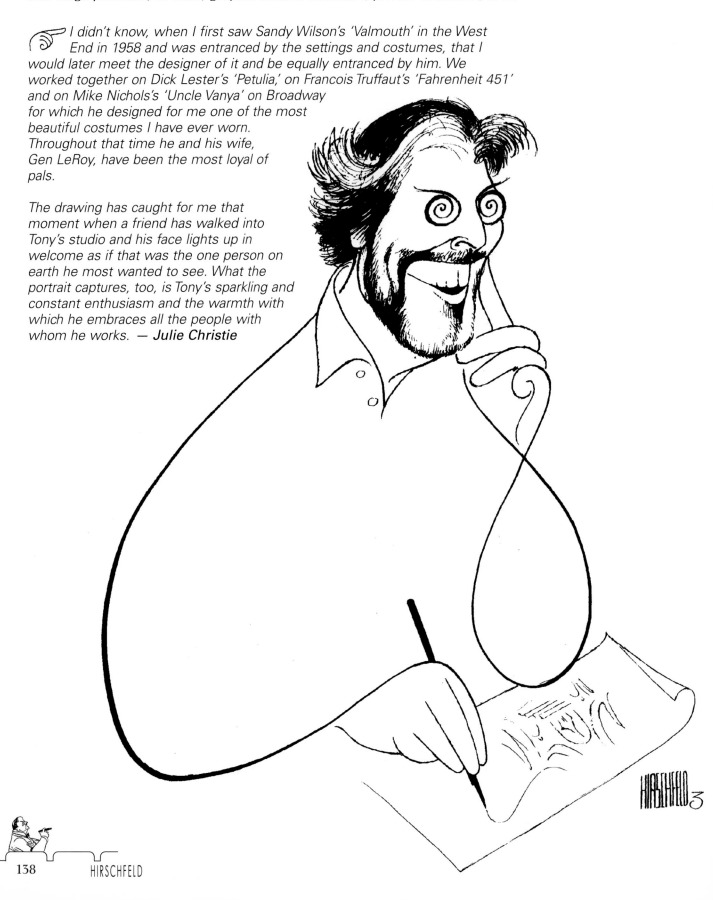

RALPH STEADMAN

Artist; *Esquire*; 1974

☞ The student graphic artists of my generation were all in awe of — and indebted to — our heroes Ronald Searle and George Grosz, but few of us had the guts to take their linear bravura even further. The striking exceptions to this were the brilliantly extreme and acidic Gerald Scarfe and the ferociously feisty Ralph Steadman — both of whom recklessly plunged headlong into even darker graphic and political territory than their famous forebears.

Steadman and I had stuff in common. We had both served in the Royal Air Force during the early fifties. He had worked briefly for the 'London Times' and I for the Observer — yet, despite this and our equal indebtedness to Searle and Grosz, there was no overlap — alas — in our graphic styles.

Steadman's brave and frequently violent work — especially in his illustrations for the writings of Hunter S. Thompson in 'Rolling Stone' and his relatively youthful yet startlingly adult versions of 'Alice' and 'Through the Looking Glass' — made me and most of my cohorts in graphics feel like a bunch of wusses.

His work has continued to grow more remarkable and more courageous and more his own each successive year. His vigorously collaged and pieced-together and blotted and scraped paintings for Roald Dahl's 'The Mildenhall Treasure' in 1999 are among the most brilliant book illustrations I know of. He has, of course, been bombarded with every award imaginable in his field and yet — as Hirschfeld manages to indicate in this drawing from the seventies (and it's even truer today) — the ferocity remains. — *Tony Walton*

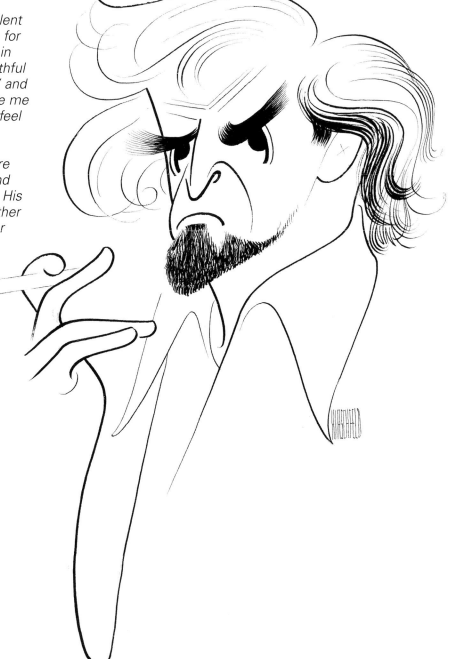

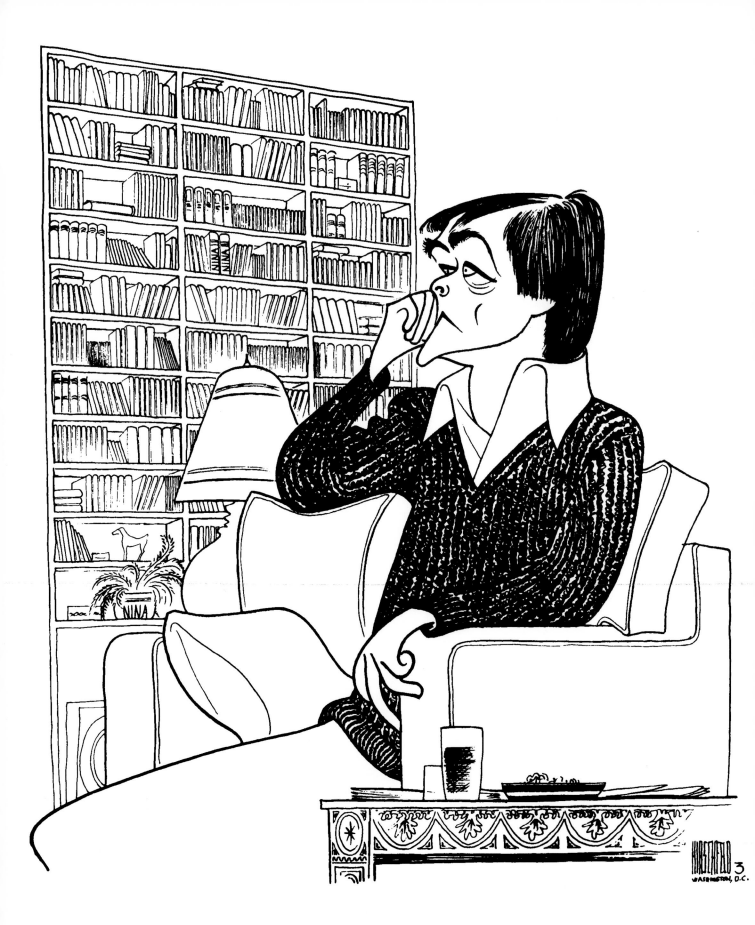

OTHERWISE ENGAGED
by Simon Gray; directed by Harold Pinter; actor: Tom Courtenay; *NYT,* 1977

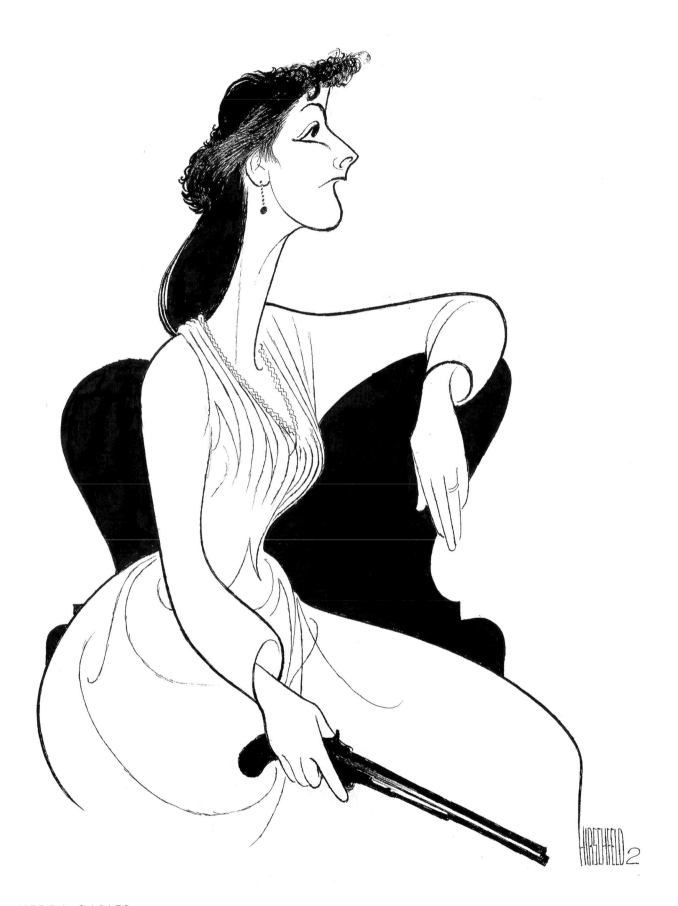

HEDDA GABLER

Teleplay by Una Ellis-Fermor, from the play by Henrik Ibsen;
directed by Deborah Warner; actor: Fiona Shaw; Masterpiece Theatre/PBS, 1992

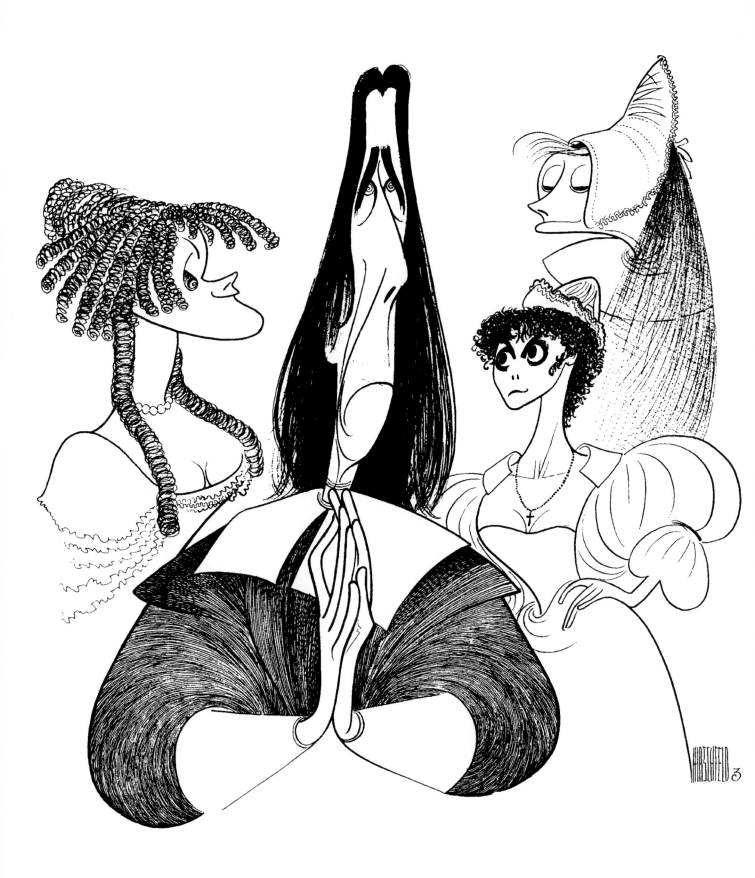

TARTUFFE
by Molière, English verse translation by Richard Wilbur; directed by Stephen Porter;
actors: Tammy Grimes, John Wood, Patricia Elliott & Mildred Dunnock; *NYT*, 1977

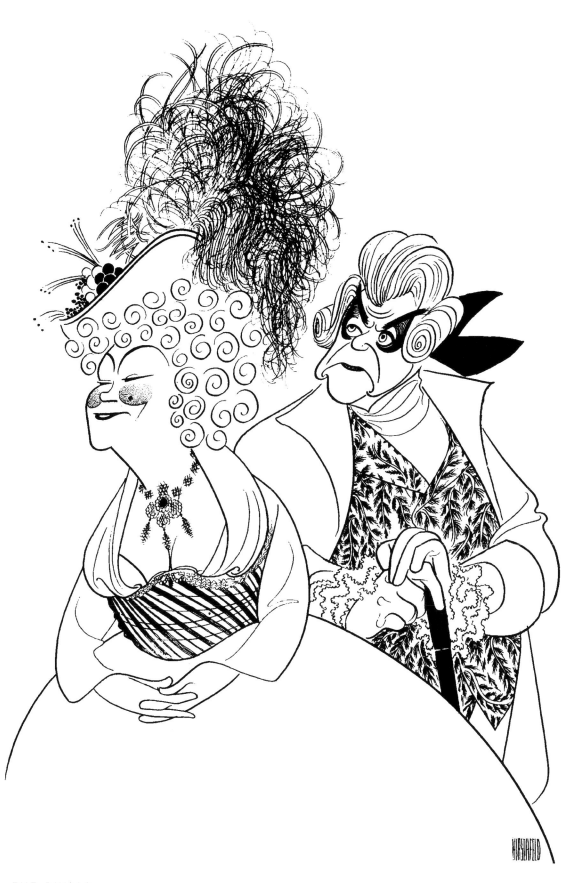

THE RIVALS

by R.B. Sheridan; actors: Beryl Reid & Andrew Cruickshank;
Mobil Classic Theatre BBC/PBS, 1975

BEDROOM FARCE

by Alan Ayckbourn; directed by Alan Ayckbourn & Peter Hall; production design by Timothy O'Brien & Tazeena Firth; actors: Michael Stroud, Polly Adams, Michael Gough (Tony Award), Joan Hickson (Tony Award), Stephen Moore, Delia Lindsay, Susan Littler & Derek Newark; *NYT*, 1979

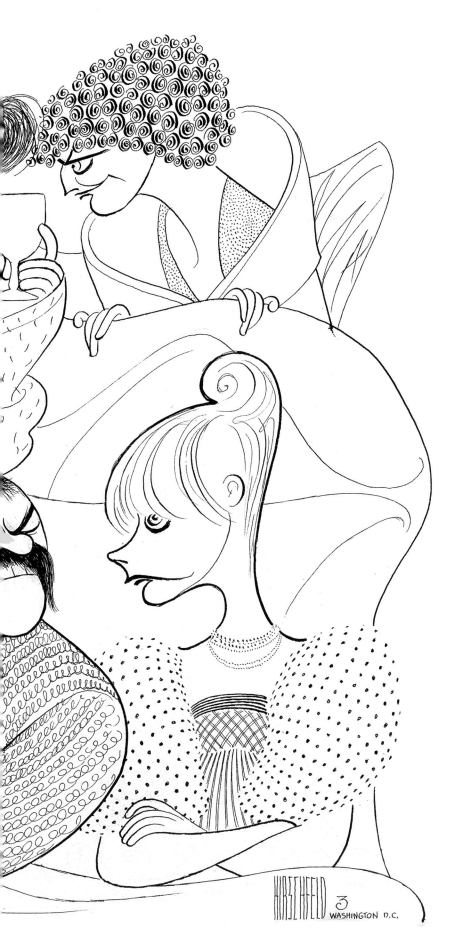

Alan Ayckbourn worries the English intelligentsia because he is so infuriatingly prolific. The poet John Betjeman once said to me ruefully, 'To be popular in England means always to be distrusted.' There is no mistaking the popularity of Ayckbourn, whose dramatic work, like Betjeman's verse, is concerned with middle-class England, its eccentricities, inhibitions and prosaic splendors. And what a drawing! Like an Ayckbourn play, it makes the difficult look effortless. — *Barry Humphries*

Hirschfeld's stunningly deft depiction of the company of 'Bedroom Farce' somehow makes it possible to recall almost every aspect of that hilarious production and of its individually inspired performances.

In his early career as an actor, Alan Ayckbourn appeared in the first provincial production of Harold Pinter's first play, 'The Birthday Party' (the London premiere of which had recently been critically lambasted). He had been cast as one of the not entirely endearing brothers.

To the company's astonishment, the always somberly dressed playwright mysteriously materialized and quietly positioned himself in the back row of the darkened auditorium to observe the dress rehearsal.

Taking advantage of this fortuitous circumstance, Ayckbourn peered across the footlights and wondered aloud if Mr. Pinter would care to elucidate about the character of the particular brother he was attempting to perform.

After what had begun to seem like an interminable pause, the nearly invisible playwright solemnly intoned: 'Mind your own business.'

Fortunately for us, Ayckbourn has never followed this deathless advice . . . and we are all the luckier — and better entertained — for it. — *Tony Walton*

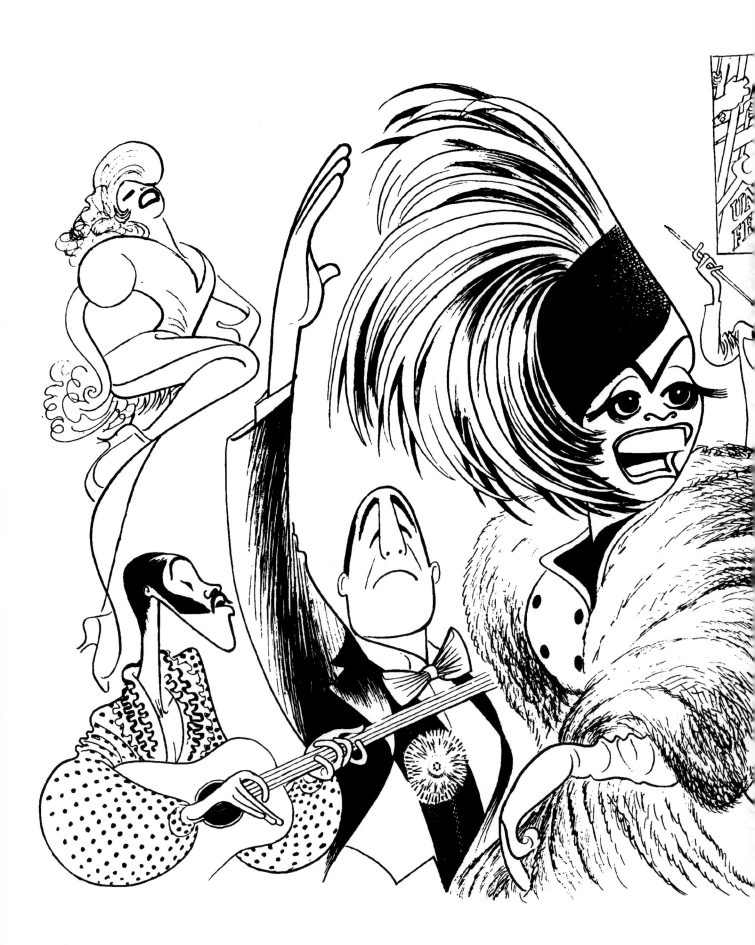

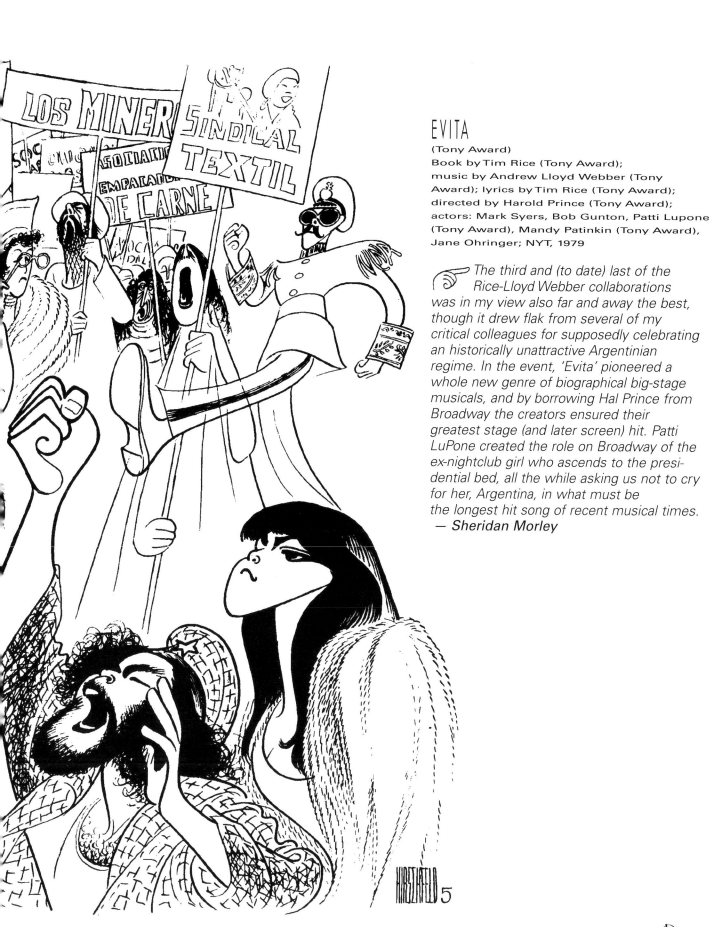

EVITA

(Tony Award)
Book by Tim Rice (Tony Award);
music by Andrew Lloyd Webber (Tony
Award); lyrics by Tim Rice (Tony Award);
directed by Harold Prince (Tony Award);
actors: Mark Syers, Bob Gunton, Patti Lupone
(Tony Award), Mandy Patinkin (Tony Award),
Jane Ohringer; NYT, 1979

The third and (to date) last of the
Rice-Lloyd Webber collaborations
was in my view also far and away the best,
though it drew flak from several of my
critical colleagues for supposedly celebrating
an historically unattractive Argentinian
regime. In the event, 'Evita' pioneered a
whole new genre of biographical big-stage
musicals, and by borrowing Hal Prince from
Broadway the creators ensured their
greatest stage (and later screen) hit. Patti
LuPone created the role on Broadway of the
ex-nightclub girl who ascends to the presi-
dential bed, all the while asking us not to cry
for her, Argentina, in what must be
the longest hit song of recent musical times.
— Sheridan Morley

BETRAYAL

by Harold Pinter; directed by Peter Hall; actors: Roy Scheider, Blythe Danner & Raul Julia; *NYT,* **1979**

Here Hirschfeld captures a portentous dramatic moment, one of many which have given to the theatrical vocabulary the epithet 'Pinteresque.' The distinguished playwright borrowed freely from Samuel Beckett in the employment of the indefinite pause. It is one of these enigmatic caesuras that Hirschfeld depicts here, from which the audience desperately struggles to divine some profound meaning. It should be noted that this is one of Hirschfeld's few drawings where the protagonists' mouths are firmly shut. — **Barry Humphries**

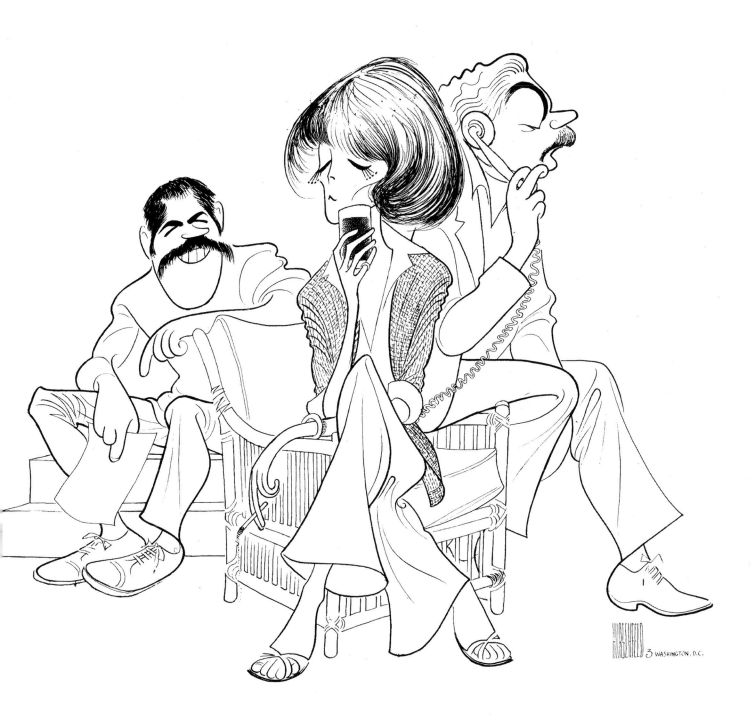

NIGHT AND DAY

by Tom Stoppard; directed by Peter Wood;
actors: Paul Hecht, Maggie Smith & Joseph Maher; *NYT,* 1979

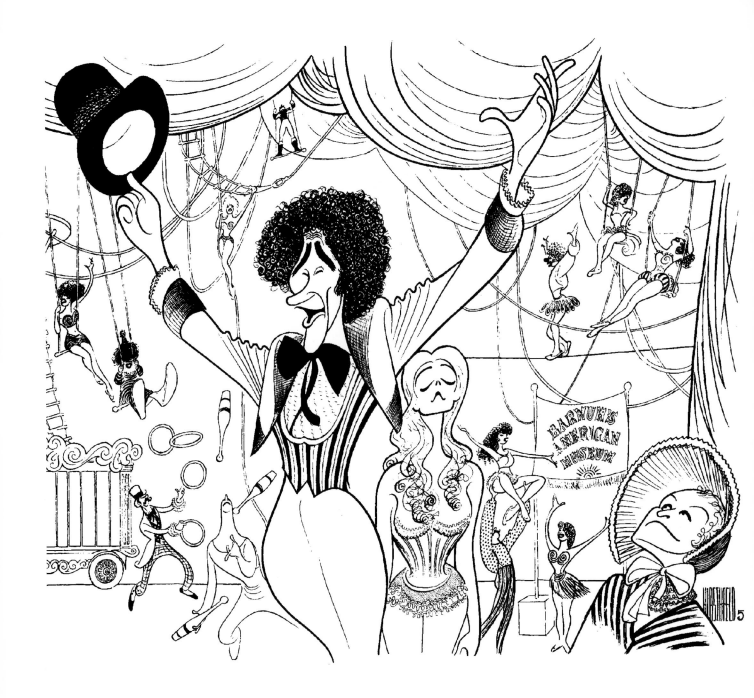

BARNUM

Book by Mark Bramble; music by Cy Coleman; lyrics by Michael Stewart; directed by Joe Layton; scenic design by David Mitchell (Tony Award); costume design by Theoni V. Aldredge (Tony Award); actors: Jim Dale (Tony Award) & Glenn Close; *NYT*, 1980

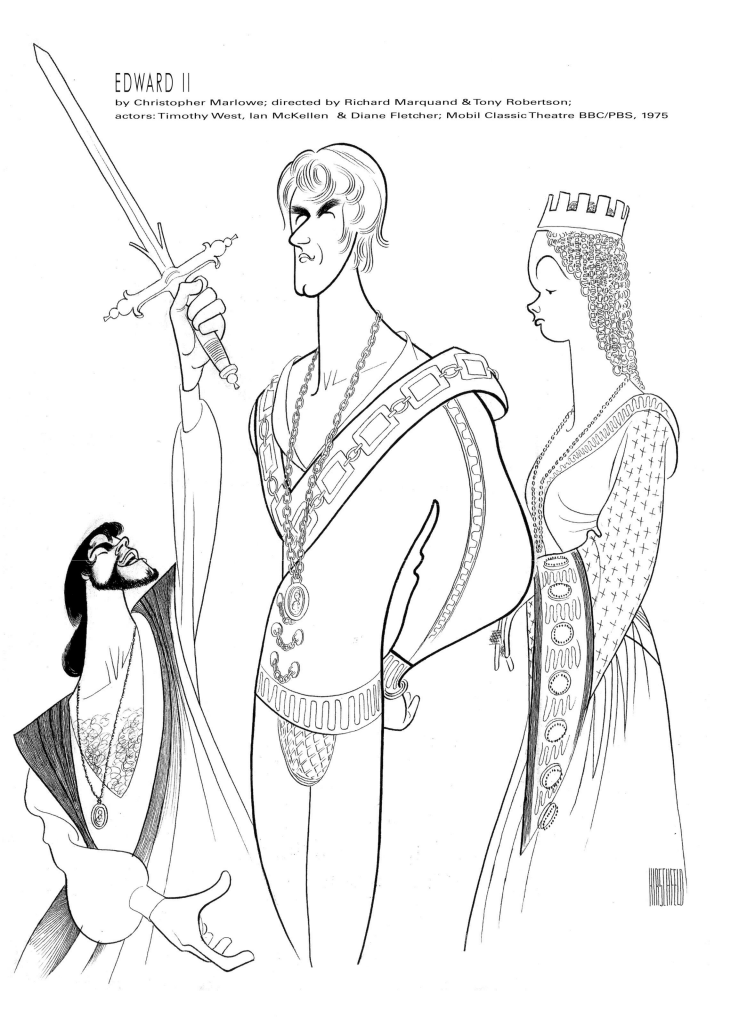

EDWARD II

by Christopher Marlowe; directed by Richard Marquand & Tony Robertson;
actors: Timothy West, Ian McKellen & Diane Fletcher; Mobil Classic Theatre BBC/PBS, 1975

AMADEUS

by Peter Shaffer; directed by Peter Hall; scenic, costume & lighting design by John Bury;
actors: Jane Seymour, Ian McKellen & Tim Curry; NYT, 1980

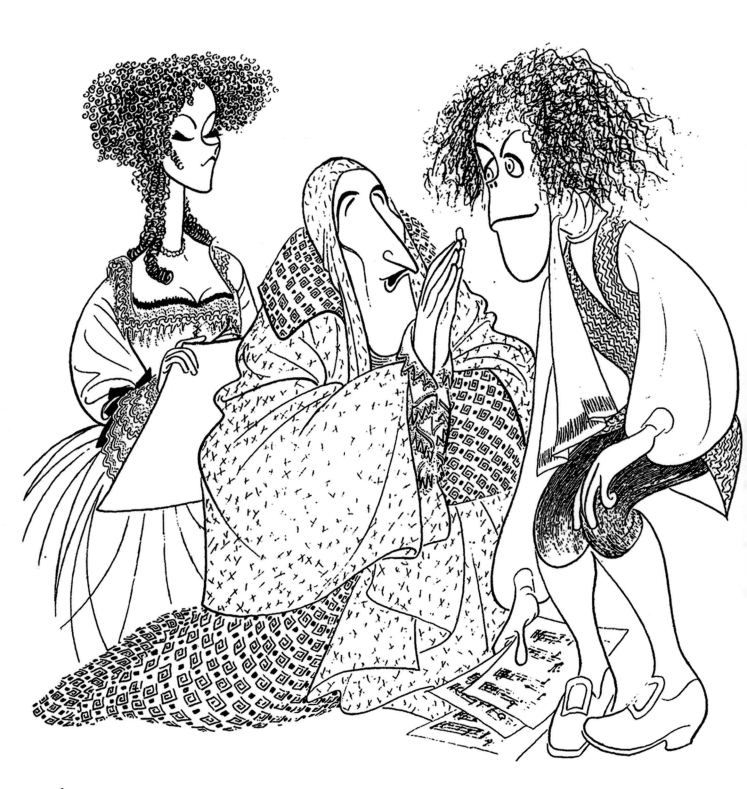

HAPPY DAYS

by Samuel Beckett; directed by Andrei Serban;
actor: Irene Worth; detail of drawing, *NYT,* 1979

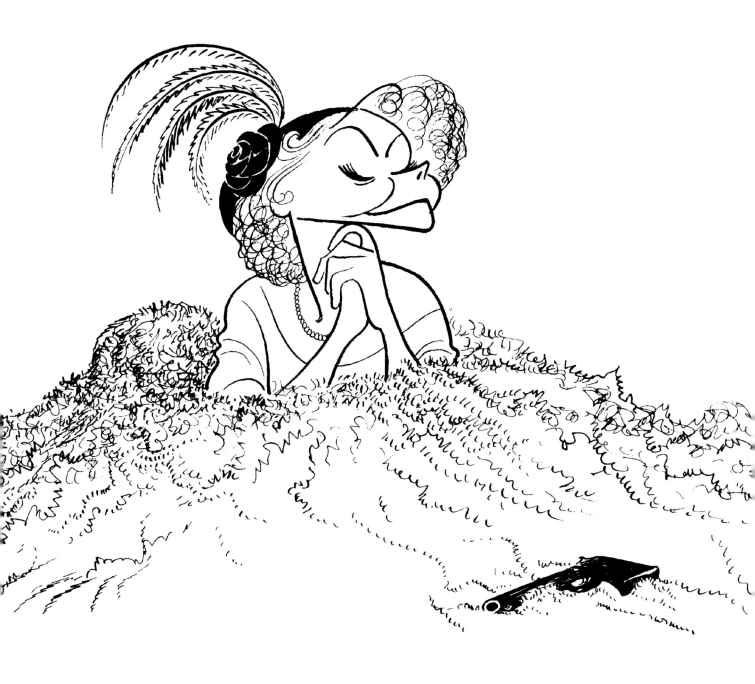

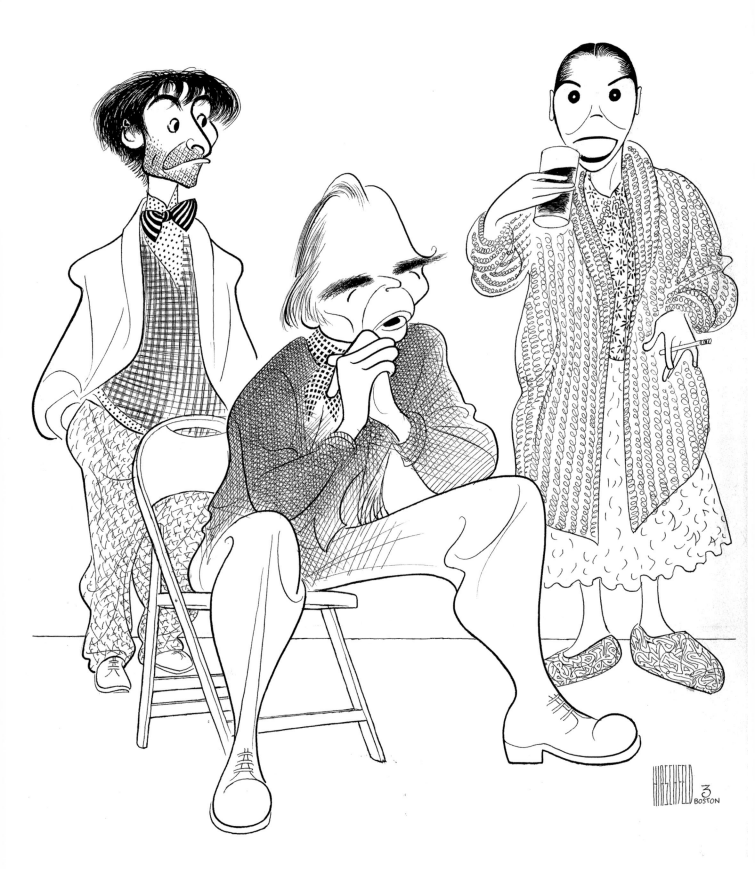

FAITH HEALER

by Brian Friel; directed by Jose Quintero;
actors: Donal Donnelly, James Mason, Clarissa Kaye; *NYT*, 1979

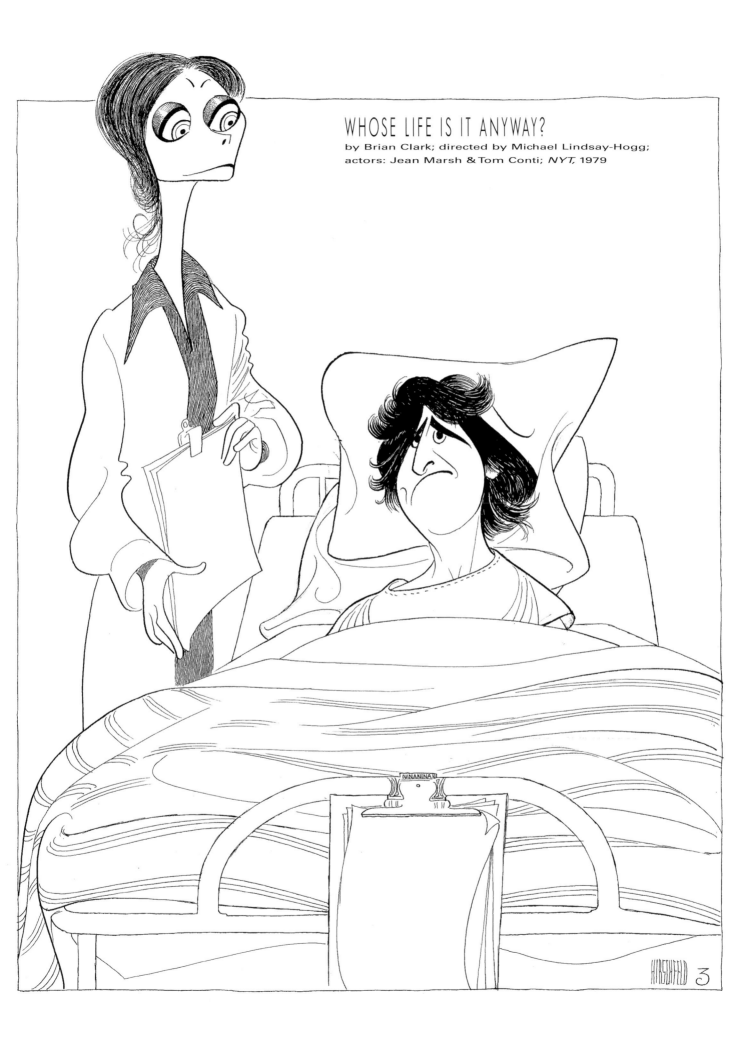

WHOSE LIFE IS IT ANYWAY?
by Brian Clark; directed by Michael Lindsay-Hogg;
actors: Jean Marsh & Tom Conti; *NYT,* 1979

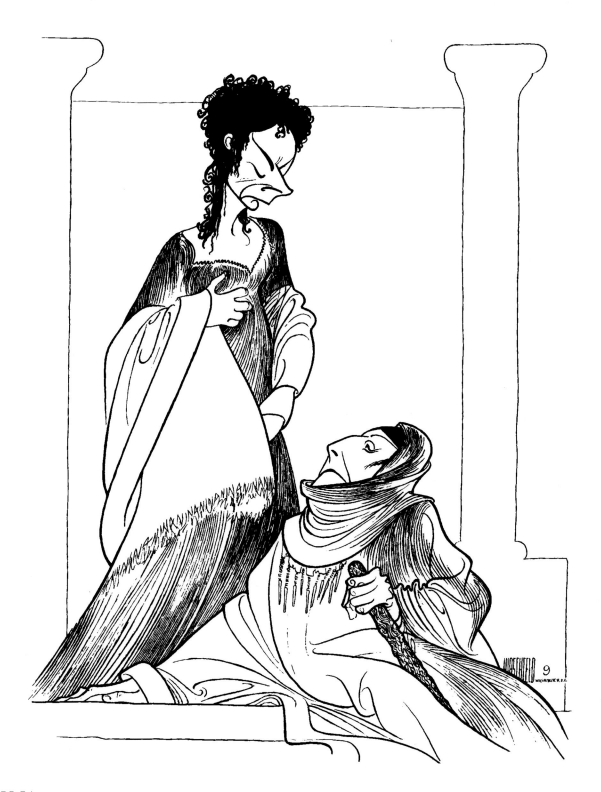

MEDEA

by Euripides; directed by Robert Whitehead; costume design by Jane Greenwood; actors: Zoe Caldwell (Tony Award) & Judith Anderson; *NYT,* 1982

Two great Australian actresses vie for supremacy in Euripides' tragedy. By slipping to her knees, Judith Anderson has contrived to get her raised face in a blaze of light. Zoe Caldwell, standing above, and just a touch upstage of her, recognizes the strategy and is thinking about stepping on her fingers. Murder is definitely in the air. — Michael Blakemore

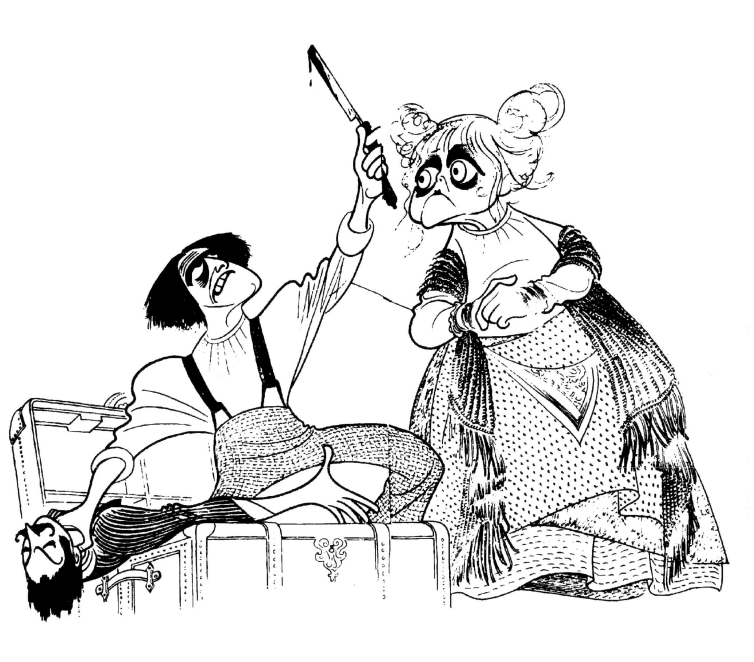

SWEENEY TODD

(Tony Award)

Book by Hugh Wheeler (Tony Award); music & lyrics by Stephen Sondheim
(Tony Award); directed by Harold Prince; actors: Len Cariou (Tony Award)
& Angela Lansbury (Tony Award); detail of drawing; *NYT,* 1979

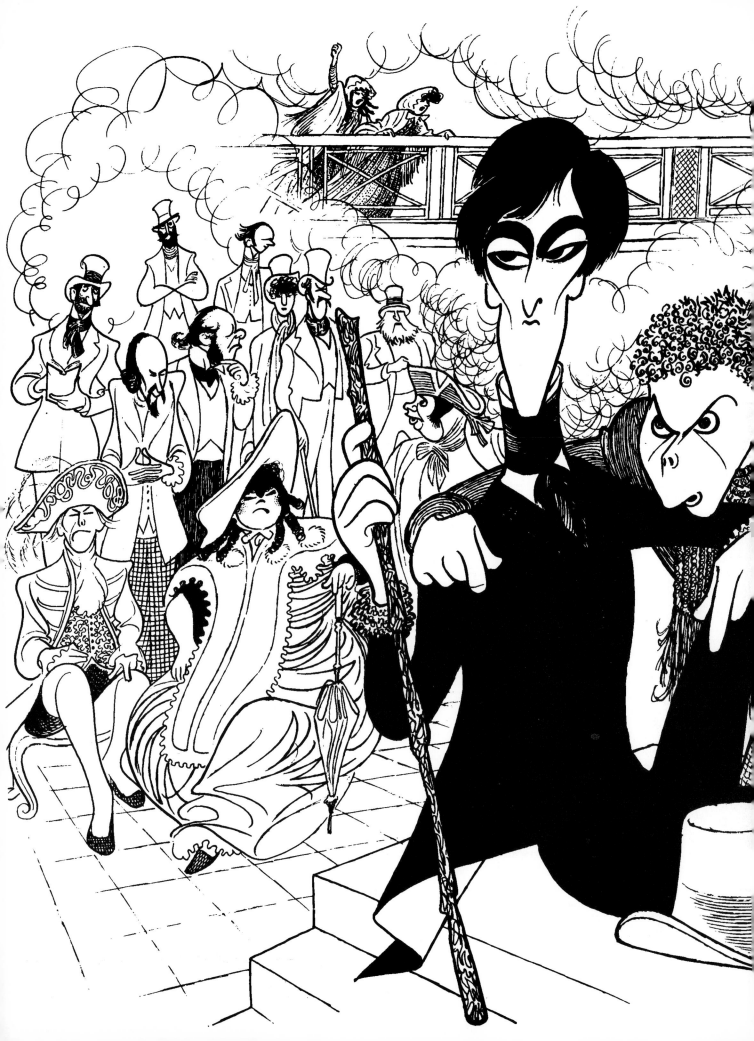

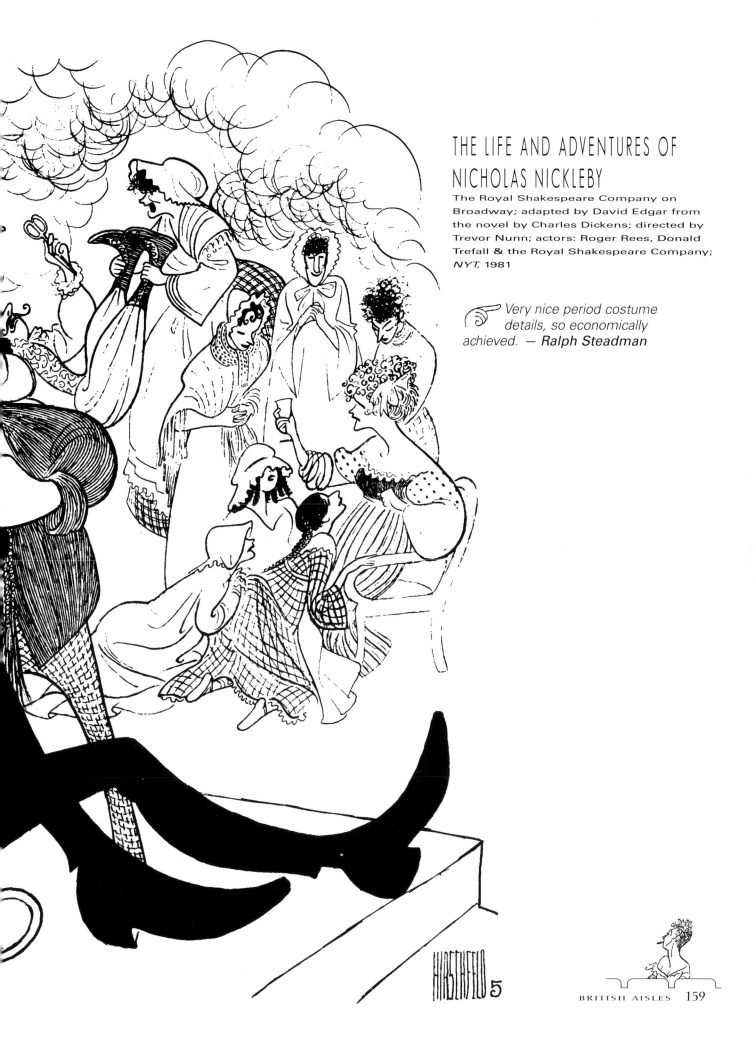

THE LIFE AND ADVENTURES OF NICHOLAS NICKLEBY

The Royal Shakespeare Company on Broadway; adapted by David Edgar from the novel by Charles Dickens; directed by Trevor Nunn; actors: Roger Rees, Donald Trefall & the Royal Shakespeare Company; *NYT,* 1981

☞ *Very nice period costume details, so economically achieved.* — *Ralph Steadman*

THE PIRATES OF PENZANCE
(Tony Award)
Words & music by W. S. Gilbert & Sir Arthur Sullivan; directed by Wilford Leach (Tony Award);
actors: Kevin Kline (Tony Award), Linda Ronstadt, George Rose & Rex Smith;
NY Shakespeare Festival; produced by Joseph Papp; *NYT,* 1980

THE MIKADO

by W. S. Gilbert; music by Sir Arthur Sullivan; actors: Clive Revill, Cynthia Buchan,
William Conrad & Jane Collins; Mobil Presents Gilbert & Sullivan for PBS, 1984

In my first incarnation on Broadway I recreated my original modest role of the undertaker in Lionel Bart's 'Oliver' for which he kindly wrote me a song, 'That's Your Funeral.' I also understudied Fagin, performed at the Imperial Theatre by the versatile actor Clive Revill. Clive obligingly fell ill on a number of occasions, surrendering Fagin's beard and cloak to his ever-accommodating standby. 'The Mikado' was the first Gilbert and Sullivan operetta I ever saw in my life. Sadly, I never saw Clive in the show, but Hirschfeld's pen makes me think I did. — Barry Humphries

CATS

(Tony Award) Producers: Cameron Mackintosh, The Really Useful Theatre Company Ltd.,
David Geffen & the Shubert Organization; book based on T.S. Eliot's *Old Possum's Book of Practical Cats* (Tony Award); music by Andrew Lloyd Webber (Tony Award); lyrics by T.S. Eliot; additional lyrics by Trevor Nunn; directed by Trevor Nunn; scenic & costume design by John Napier; with cast; detail of drawing, *NYT*, 1982

When in 1980 Andrew Lloyd Webber first told me his idea of turning T. S. Eliot's poems into a musical, I already knew that nearly everyone in the musical theatre had dismissed the idea as madness — even Trevor Nunn, eager to work with Andrew, first responded to my invitation to direct the show with the observation that he thought he'd been offered the only duff idea Andrew had ever had. — *Sir Cameron Mackintosh*

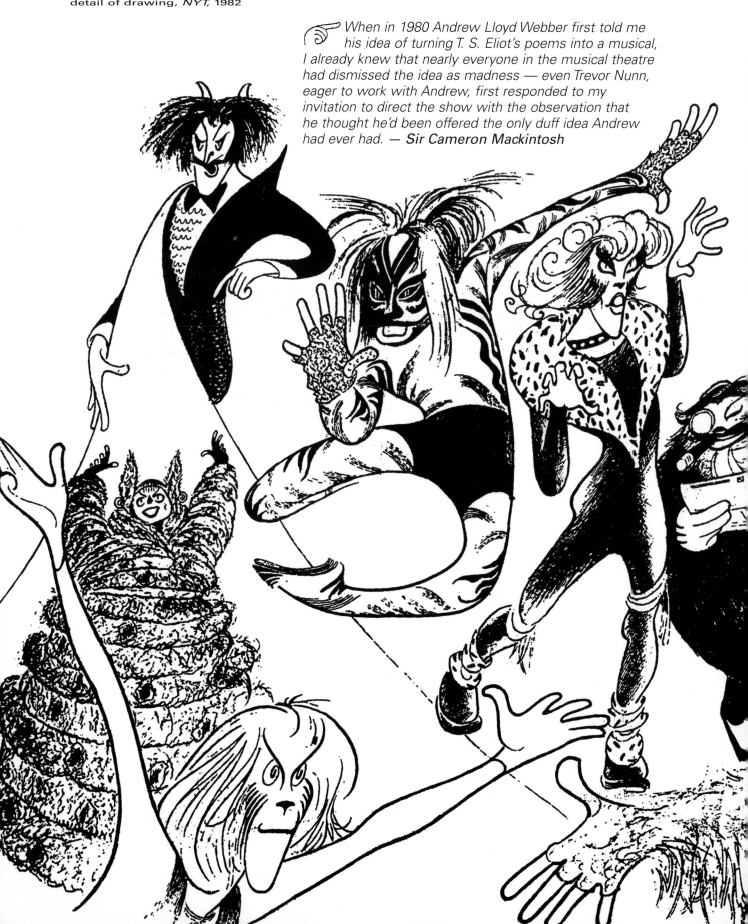

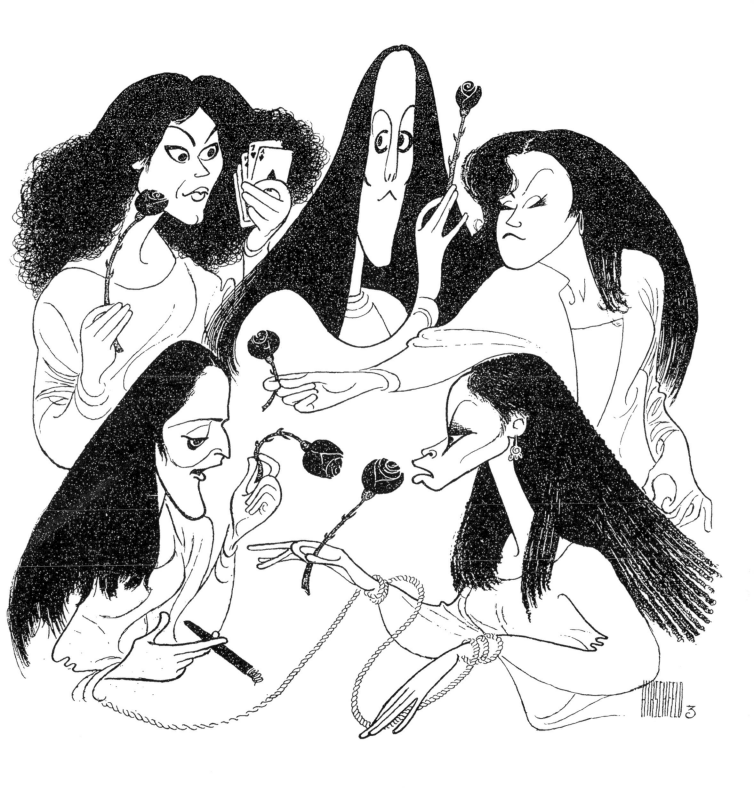

LA TRAGEDIE DE CARMEN

Music & lyrics by Georges Bizet; directed by Peter Brook; actors: clockwise, Patricia Schuman, Eva Saurova, Emily Golden, Helene Delavault & Cynthia Clarey; *NYT,* 1983

☞ *There is no Peter Brook onstage in Hirschfeld's illustration of the landmark 'Carmen.' But all the portents and symbols are there: the roses, the cigar and most of all the power of the female characters.* — *Mel Gussow*

STRANGE INTERLUDE

by Eugene O'Neill; directed by Keith Hack; actors: Edward Petherbridge,
Glenda Jackson, Brian Cox & James Hazeldine; *NYT,* 1985

ROSE

by Andrew Davies; directed by Alan Dossor; actors: Glenda Jackson & Jessica Tandy; *NYT,* 1981

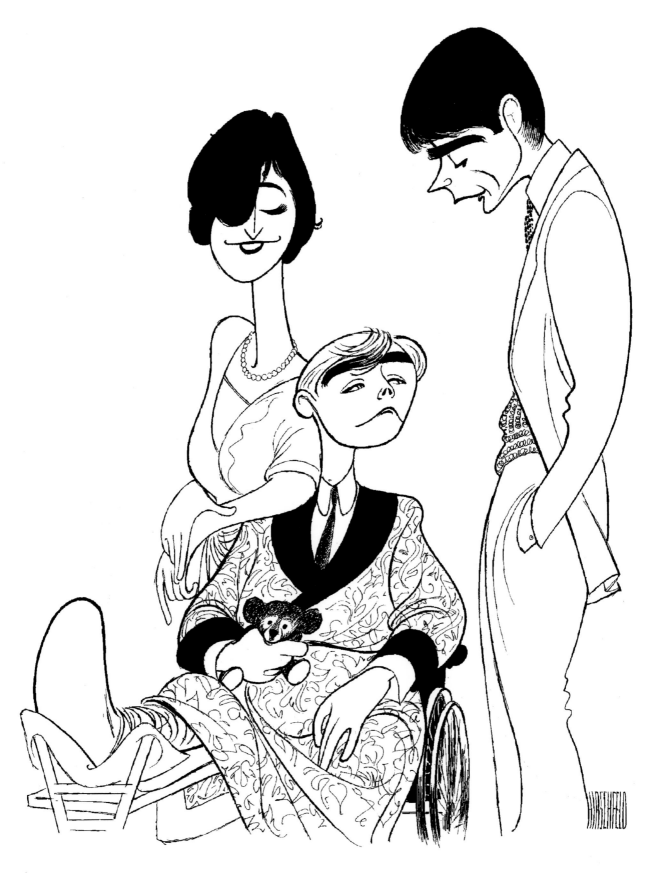

BRIDESHEAD REVISITED
Teleplay by John Mortimer, based on the novel by Evelyn Waugh; directed by
Michael Lindsay-Hogg & Charles Sturridge; actors: Phoebe Nicholls, Anthony Andrews
& Jeremy Irons; Great Performances/WNET, 1985

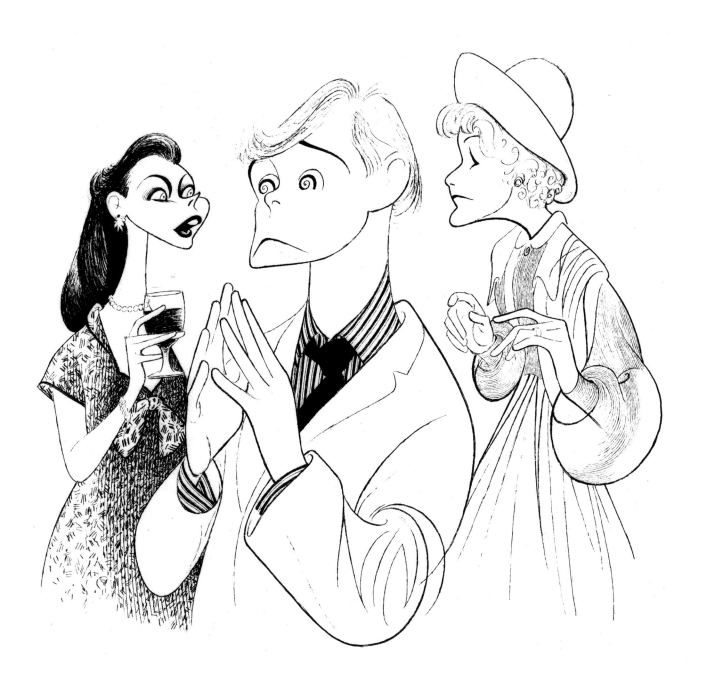

BREAKING THE CODE

by Hugh Whitemore, based on the book *Alan Turing: The Enigma* by Andrew Hodges;
directed by Clifford Williams; actors: Jenny Agutter, Derek Jacobi & Rachel Gurney; *NYT*, 1987

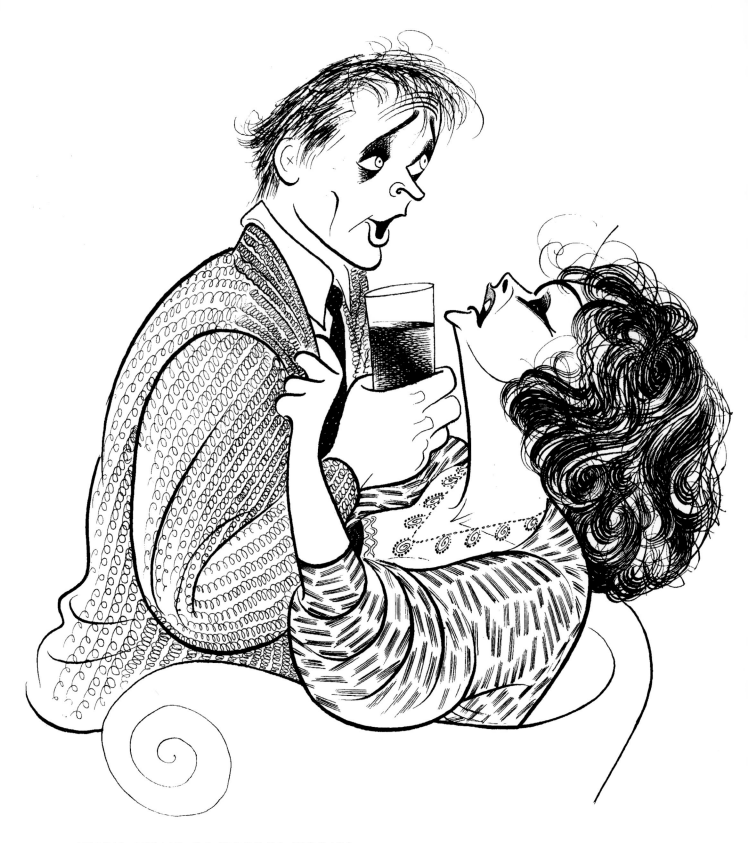

WHO'S AFRAID OF VIRGINIA WOOLF?
Screenplay by Ernest Lehman, based on the play by Edward Albee; directed by Mike Nichols;
actors: Richard Burton & Elizabeth Taylor (Oscar); detail of drawing, *NYT*, 1966

PRIVATE LIVES

by Noël Coward; directed by Milton Katselas;
actors: Elizabeth Taylor & Richard Burton;
London Daily Mail, 1983

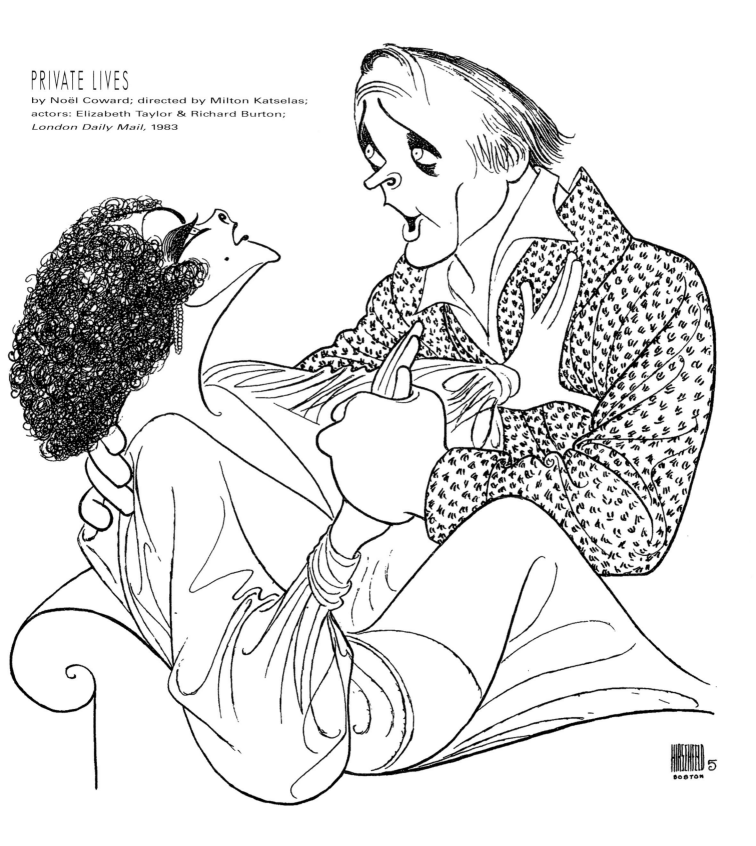

Two great stars in their own private galaxy. Together they transfixed the public's imagination for a generation, and then some. Love, life, and art are entwined, gripped by a struggle that transcends whatever roles they played. They cling, cajole, tear at each other, landing bruising caresses, leaving psychic scars. Like the mythic lovers of ancient Greece, death seemed only to forge a deeper bond between them in the public consciousness. The tabloids tabulate Taylor's spousal reckonings; the public smiles, but knows: subsequent vows can never add up, never equal the undying devotion Elizabeth Taylor pays to the Welsh actor with the sonorous voice. One feels the classic sculpted passion, at once violent and all-embracing in Hirschfeld's impressions over three decades. — **Louise Kerz Hirschfeld**

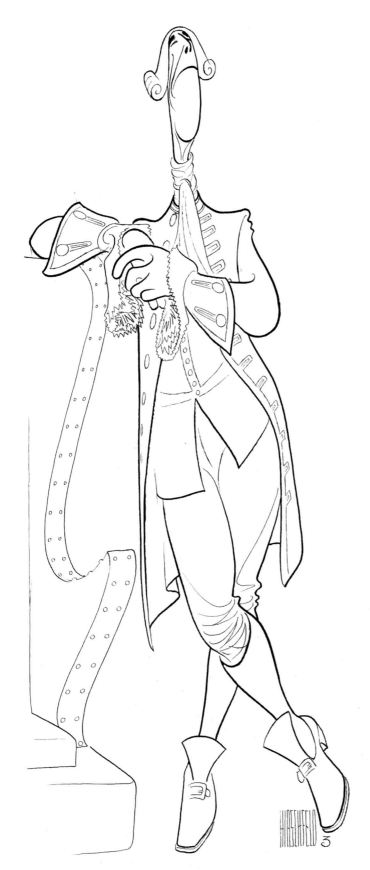

AMADEUS

by Peter Shaffer; directed by Peter Hall;
scenic, costume & lighting design by John Bury;
actor: John Wood; *NYT,* 1981

☞ *John made a superb Salieri, as individual and convincing as could be desired. What Hirschfeld stresses here is elongation, implying a rigid stiffness barely concealing a racking desperation. I recall Wood's formidable verbal technique was much to the fore, displaying a thrillingly anguished volubility.*

Despite this great English actor's apparently total confidence, I remember once finding him in his dressing room at the Broadhurst Theatre in New York sitting despondently, just before going out to face a packed audience, declaring that he couldn't do it anymore. 'As soon as I appear,' he moaned, 'I can feel them all thinking "Look at him: he's old and plain."'

*I did my best to urge him out of this black self-contemplation and finally, with much reluctance, he rose up in his long, stained dressing robe (his costume as the aged Salieri) and shambled miserably out on to the stage. There he proceeded to give a simply blazing performance. At its end an entire audience was baying its heartfelt admiration, calling out to him with noisy emotional endorsements. When I went back stage to congratulate him, however, John was again seated gloomily at his mirror. Speaking — almost incredibly, but I believe sincerely — as if he had never heard the feral sounds of American acclamation before, he demanded moodily: 'What were they all shouting at me?' 'Well,' I replied, 'I can't vouch for the whole house, but around me they were yelling, "Old and plain! … Old and plain!"' He had the grace to laugh — albeit rather cautiously. — **Sir Peter Shaffer**

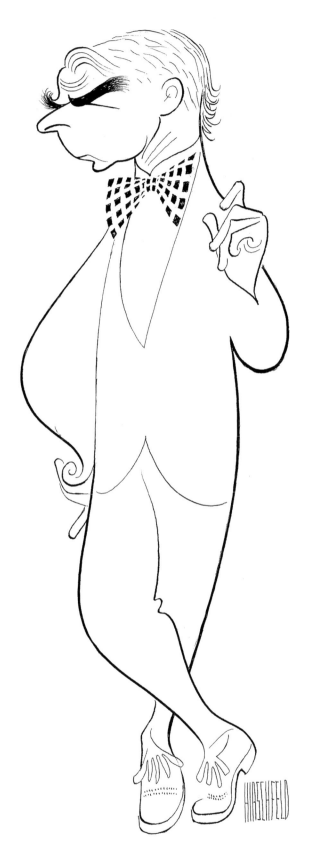

THE PLAYBOY OF THE
WEEKEND WORLD
devised by Emlyn Williams
from the stories of Saki;
directed by Peter Woodthorpe;
actor: Emlyn Williams; *NYT*, 1978

☞ *Hirschfeld enjoyed a
crowded scene, but he
was equally deft with masters of
the one-man show. Here, Emlyn
Williams, the gifted Welsh actor
and playwright, relaxes as if in
his own parlor in front of an
audience of a thousand guests.
Hirschfeld gave him both the
dandified bearing and one of the
spectacular bow ties that were
part of Williams' singular
presence on stage.*
— *John Russell*

ALAN BATES
Butley by Simon Gray;
directed by James Hammerstein; *NYT,* 1972

TIM CURRY
The Art of Success by Nick Dear; directed by Adrian Noble;
set & costume design by David Ultz; *NYT,* 1990

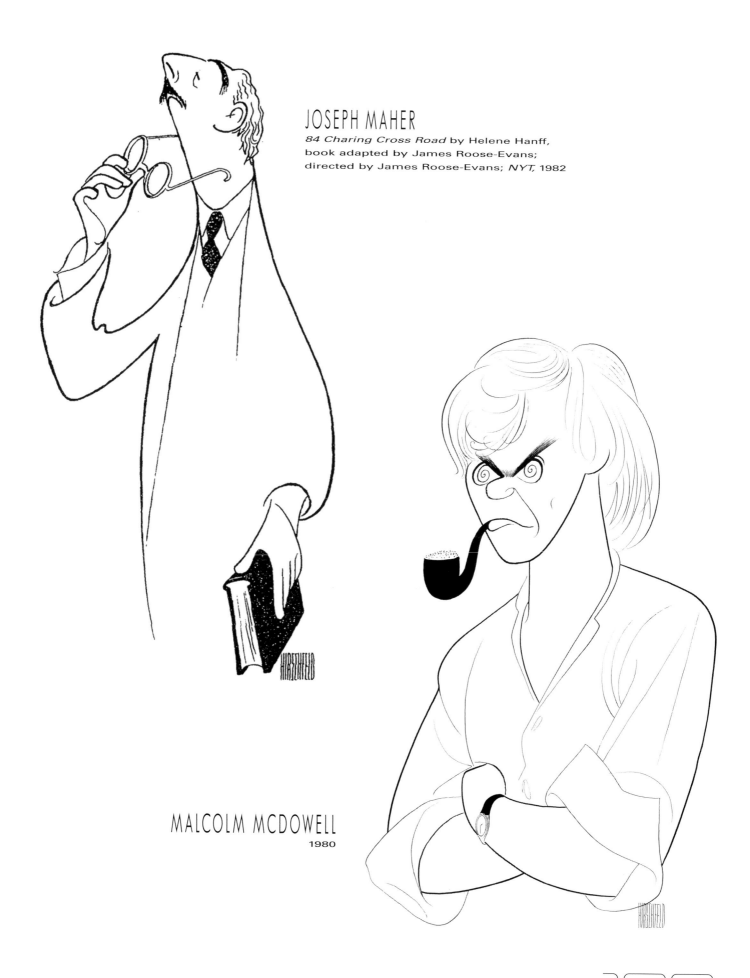

JOSEPH MAHER
84 Charing Cross Road by Helene Hanff,
book adapted by James Roose-Evans;
directed by James Roose-Evans; *NYT,* 1982

MALCOLM MCDOWELL
1980

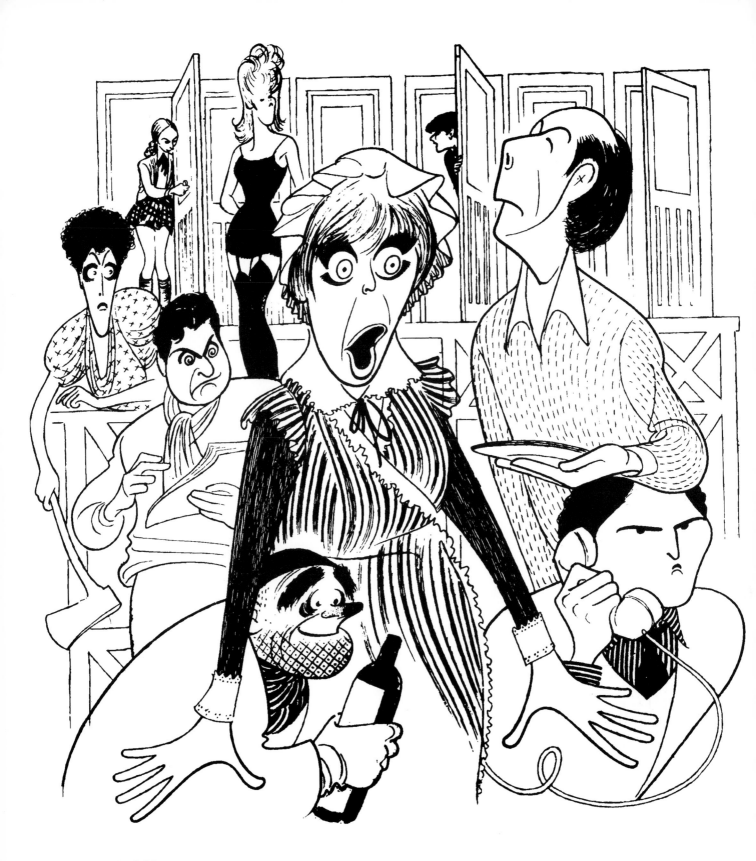

NOISES OFF

by Michael Frayn; directed by Michael Blakemore; actors: Paxton Whitehead, Victor Garber, Douglas Seale, Brian Murray, Linda Thornton, Amy Wright, Deborah Rush, Jim Piddock surround Dorothy Loudon; *NYT*, 1983

☞ *Farce is about people in desperate straits and Hirschfeld was an expert on driven people. And no wonder; show business is full of them. In this drawing, Dorothy Loudon broadcasts panic like a fire alarm. On all sides of her, others follow individual trajectories to comic doom. — Michael Blakemore*

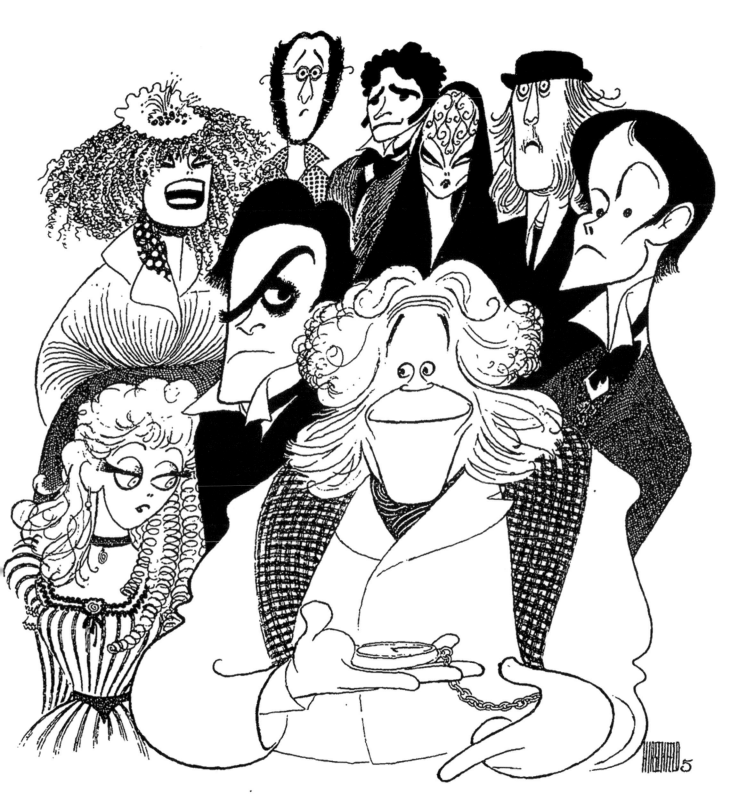

THE MYSTERY OF EDWIN DROOD

(Tony Award)
Music, lyrics & book: Rupert Holmes, suggested by an unfinished novel by Charles Dickens
(Tony Award); directed by Wilford Leach (Tony Award); actors: clockwise from front center,
George Rose, Howard McGillin, Patti Cohenour, Cleo Laine, Joe Grifasi, John Herrera, Jana
Schneider, George N. Martin, Betty Buckley; *NYT,* 1985

CYRANO

Royal Shakespeare Company on Broadway; by Edmond Rostand; directed by Terry Hands; actors: Derek Jacobi & Sinead Cusack; detail of drawing, *NYT,* 1984

One should not have to say it, but great acting lives on in Hirschfeld drawings. As shown here, he can retain for us the genius of the stage in a single stroke, bringing back Derek Jacobi center stage as Cyrano. — Mel Gussow

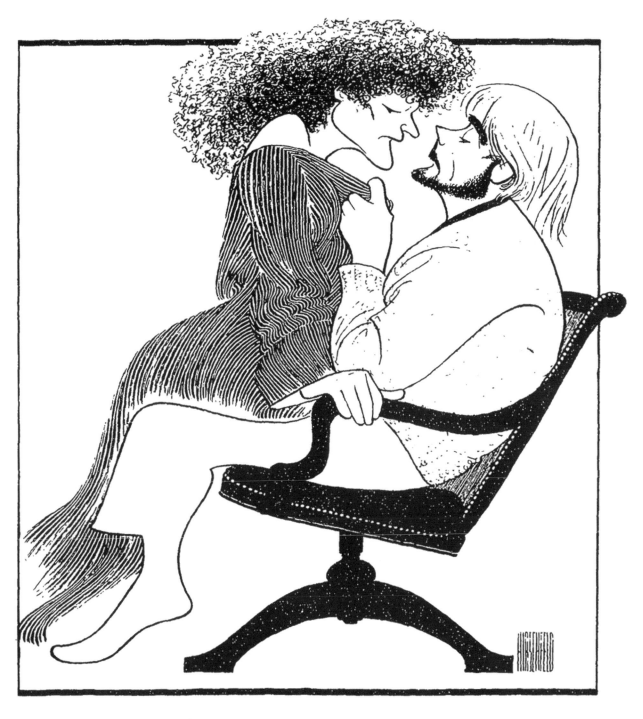

THE REAL THING

(Tony Award)

by Tom Stoppard; directed by Mike Nichols (Tony Award);
actors: Glenn Close (Tony Award) & Jeremy Irons (Tony Award); *NYT,* 1984

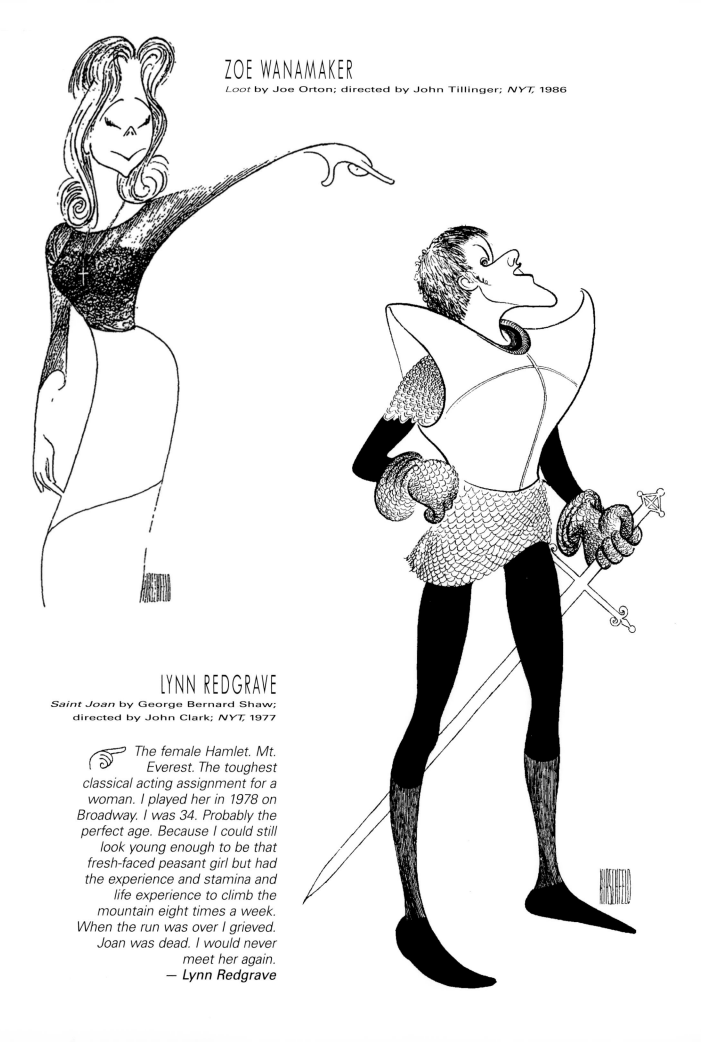

ZOE WANAMAKER
Loot by Joe Orton; directed by John Tillinger; *NYT,* 1986

LYNN REDGRAVE
Saint Joan by George Bernard Shaw;
directed by John Clark; *NYT,* 1977

☞ *The female Hamlet. Mt.
Everest. The toughest
classical acting assignment for a
woman. I played her in 1978 on
Broadway. I was 34. Probably the
perfect age. Because I could still
look young enough to be that
fresh-faced peasant girl but had
the experience and stamina and
life experience to climb the
mountain eight times a week.
When the run was over I grieved.
Joan was dead. I would never
meet her again.*
— Lynn Redgrave

TWIGGY

My One and Only; book: Peter Stone & Timothy S.
Mayer; music by George Gershwin,
lyrics by Ira Gershwin; staged & choreographed
by Tommy Tune & Thommie Walsh
(Tony Awards); *NYT,* 1984

☞ *Twiggy and Tommy Tune sang and
danced in an excerpt from 'My One
and Only' for Her Majesty's Royal Command
performance at the London Palladium in
1984. Laurence Olivier, in his introductory
announcement, described his visit to their
Broadway triumph and then solemnly
pronounced their partnership 'the hottest thing
on four legs.'*

Even with only two legs —

*Who's prettier by far and a far brighter
 star than Miss Piggy?
Well, Twiggy!
Who's forthright and fearless yet even
 more humble than Piglet?
Our Twiglet!
And who makes your tummy feel runny
 like syrup of figs?
Sweet Twiggs!*

*(Syrup of figs, by the way, is the English kids'
equivalent of castor oil.)*

*I have been lucky enough to collaborate with
her — and costume her — on a number of
occasions, including Ken Russell's delirious film
version of 'The Boy Friend.' After seeing her as
Elvira in Noël Coward's 'Blithe Spirit,' the fine
director Karel Reisz emerged from her dressing
room saying, 'Ah, at last I know what it means
when they refer to someone having been
touched by the angels.'*

*I agree, for to me she is entirely heavenly and
Al Hirschfeld has — as infallibly as ever in this
drawing — managed to suggest that he felt
the same. — Tony Walton*

LES MISERABLES

(Tony Award)

Produced by Cameron Mackintosh; book by Claude-Michel Schonberg & Alain Boublil (Tony Award); adapted & directed by Trevor Nunn & John Caird (Tony Awards); scenic design by John Napier (Tony Award); actors: Terrance Mann, Colm Wilkinson & cast; *NYT*, 1987

☞ *The first author I set to work on the English version of Boublil and Schonberg's 'Les Misérables' was poet and critic James Fenton, who took the novel on a canoe trip to the jungles of Borneo, and as he worked through its 1200 pages fed each chapter to the crocodiles. When 'Les Misérables' opened, the early British critics were equally voracious in tearing the show apart, and it quickly became known as 'The Glums.'*
— *Sir Cameron Mackintosh*

Though I am still not in a critical majority, I have always believed this to be the greatest musical written in my working lifetime. Alain Boublil and Claude-Michel Schonberg (with their genius South African translator Herbert Kretzmer) took the already victorious Victor Hugo novel of 19th century France and turned it into a historical thriller of immense depth and range with a score to die for, as many do during the show. But this was the show which redefined the limits of musical theatre: a dark, dangerous drama set to a score which in our lifetime only Sondheim has ever challenged. — **Sheridan Morley**

THE PHANTOM OF THE OPERA, THE JOURNEY

(Tony Award) by Andrew Lloyd Webber & Richard Stilgoe, based on the novel *Le Fantôme de L'Opéra*
by G. Leroux; music by Andrew Lloyd Webber; lyrics by Charles Hart; directed by Harold Prince (Tony Award);
scenic & costume design by Maria Bjornson (Tony Award); actors: Sarah Brightman & Michael Crawford
(Tony Award); detail of drawing; MF, 1988

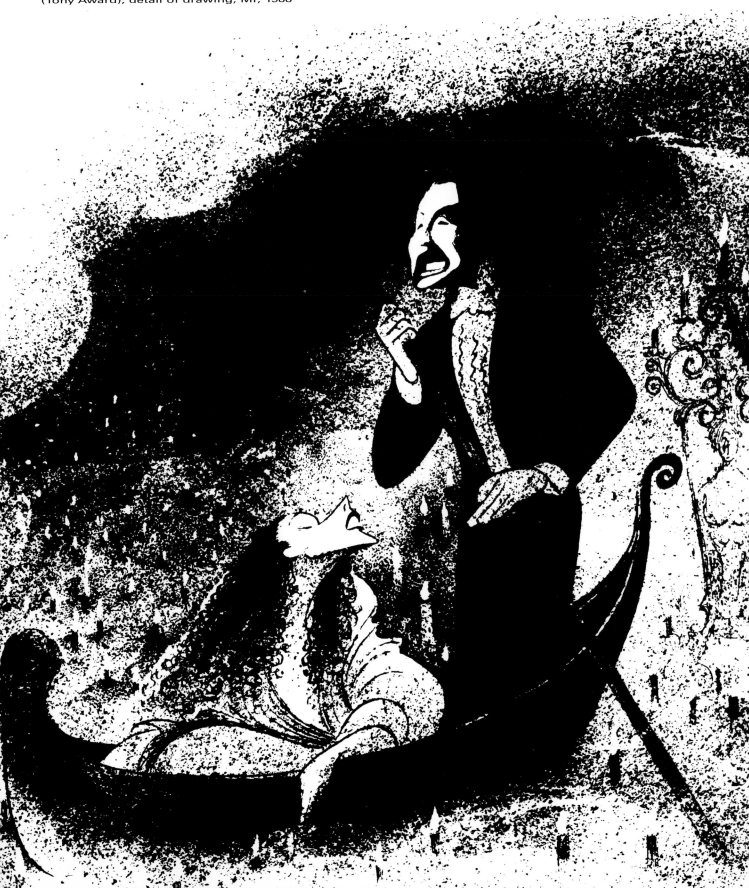

ANDREW LLOYD WEBBER
Private commission, 1995

☞ *The most commercially successful composer/producer/manager
ever to have emerged from the West End, Lord Lloyd Webber
followed a path laid out at home and abroad by Sir Noël Coward and
Ivor Novello, but given modern marketing techniques and the rise in
world travel, he was able to market himself with still greater global
results. Though he now tends to go through lyricists faster than
Kleenex, an early start with Tim Rice established his career both on
Broadway and in the West End. Born in 1948 (no, that is not a mis-
print), he was a published composer at 11 and was just 21 when his
'Jesus Christ Superstar' was first released as a single. Now a Peer of
the Realm, his interest in all things Victorian has been reflected by his
latest (2005) musical 'The Woman in White'; he writes scores at the
rough rate of one every couple of years, usually vastly more popular
with the public than with critics, but then again, what do we know?*
— *Sheridan Morley*

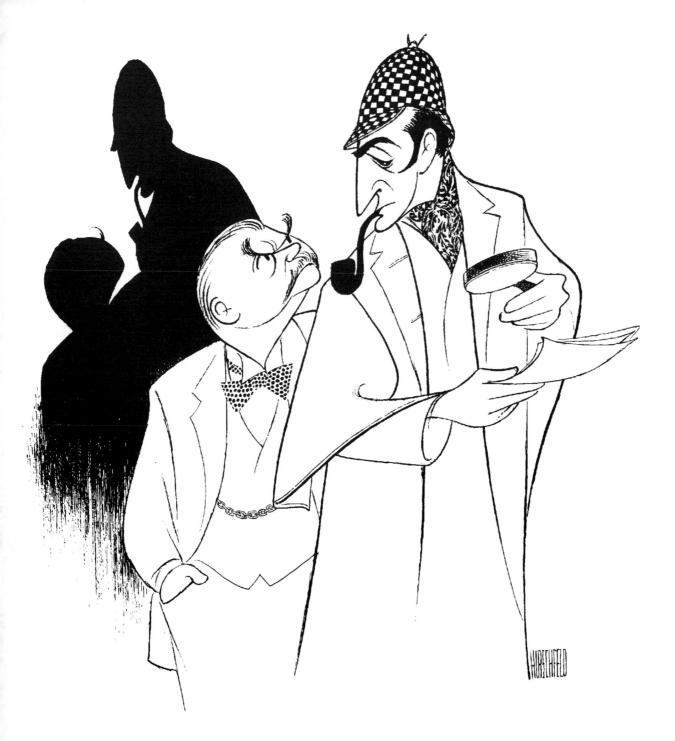

THE GAME'S AFOOT
SHERLOCK HOLMES
Actors: Basil Rathbone & Nigel Bruce; MF, 1990

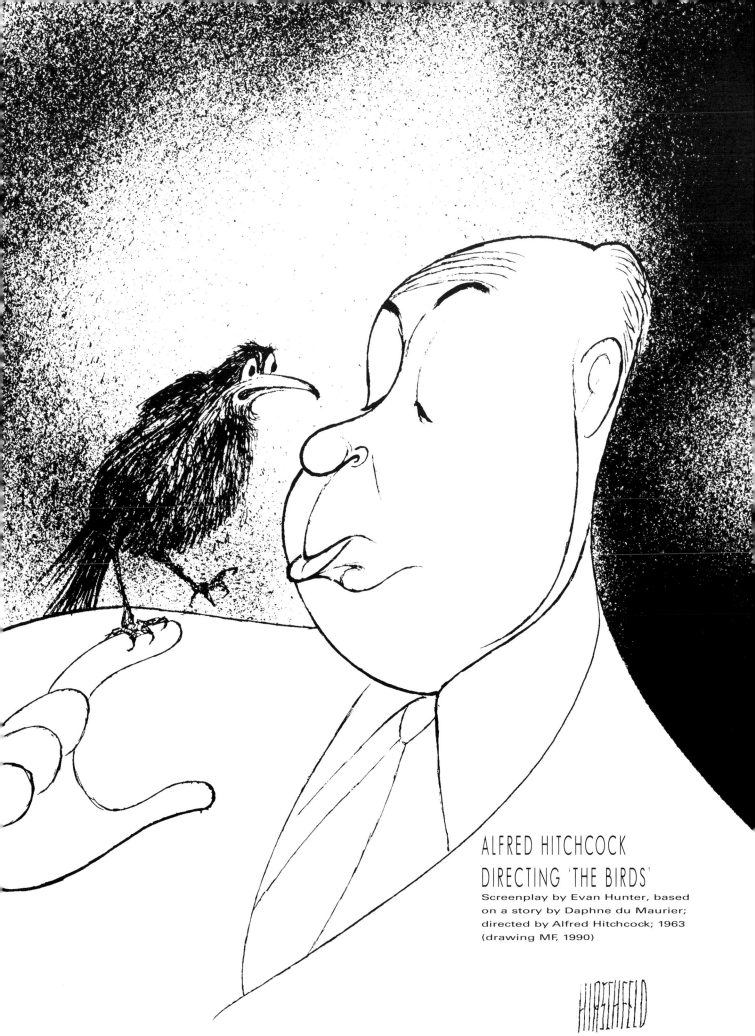

ALFRED HITCHCOCK
DIRECTING 'THE BIRDS'
Screenplay by Evan Hunter, based
on a story by Daphne du Maurier;
directed by Alfred Hitchcock; 1963
(drawing MF, 1990)

HIRSCHFELD

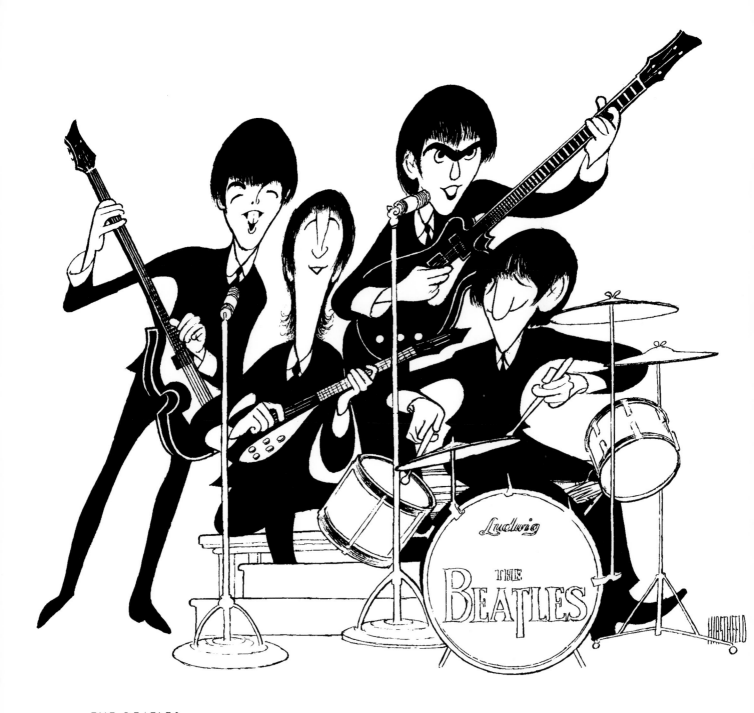

THE BEATLES
ca. 1960's (drawing MF, 1990)

☞ The Beatles were musicians who also could clown around expertly. I made this drawing of them from sketches I had done of them when they first arrived stateside in the early sixties. I later correlated them into this design in the early nineties. They really were just sweet young kids when they arrived, and I was just as enchanted with them as everybody else. I even enjoyed their music. — *Al Hirschfeld*

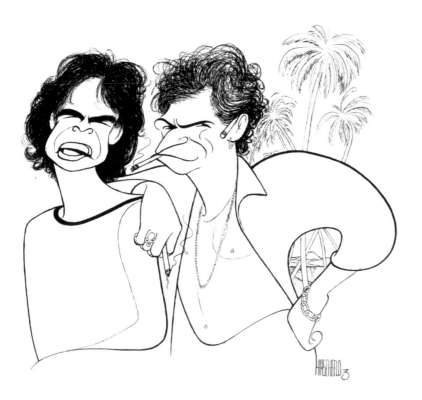

MICK JAGGER & KEITH RICHARDS
Neal Glazer commission, 1998

☞ *What other possible combination of marks on paper could evoke so thoroughly the beloved 'bad boys' of the British eruption of Rock and Roll? Hirschfeld has encapsulated everything we remember of this vibrantly cheeky pair as they tottered into their prime: attitudinal, mischievous, stunningly sassy, self-assured and appallingly appealing! It's all here in a miracle of observation and elegant shorthand. All it needs is the noise.*
— Tony Walton

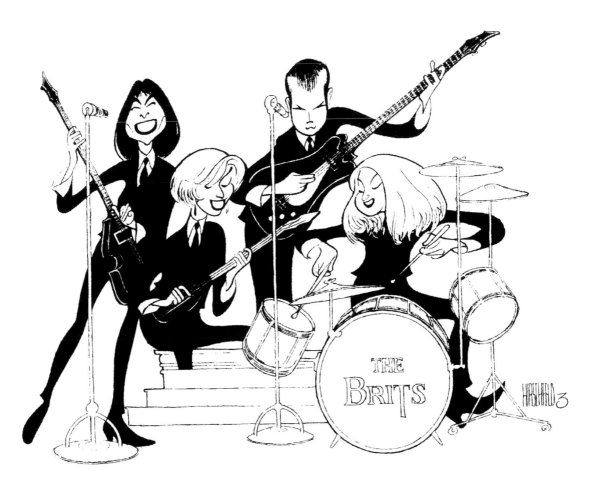

THE BRITISH INVASION
Anna Wintour, Tina Brown, Andrew Sullivan & Liz Tilberis; *Spy* magazine, 1992

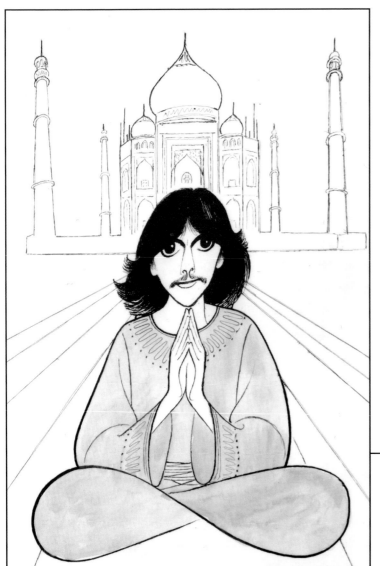

GEORGE HARRISON
MF, 2001

JOHN LENNON
Neal Glazer commission, 1997

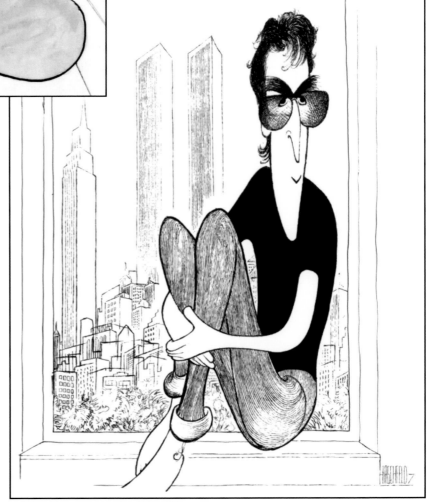

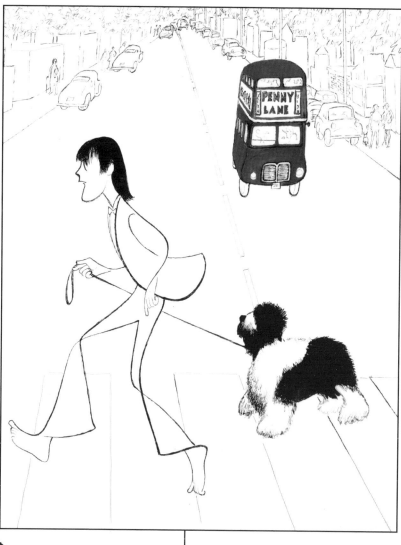

PAUL MCCARTNEY
on Abbey Road; MF, 2001

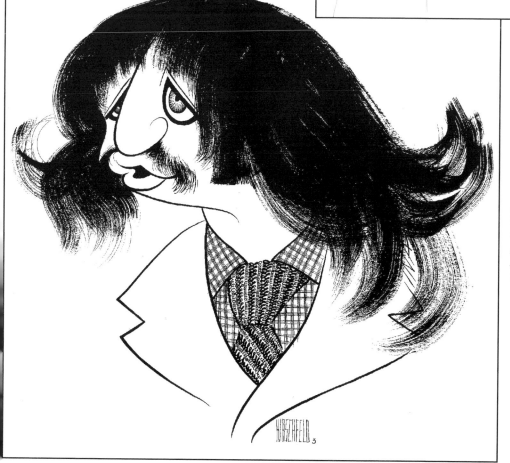

RINGO STARR
The Magic Christian;
screenplay by Terry Southern;
directed by Joseph McGrath;
NYT, 1969

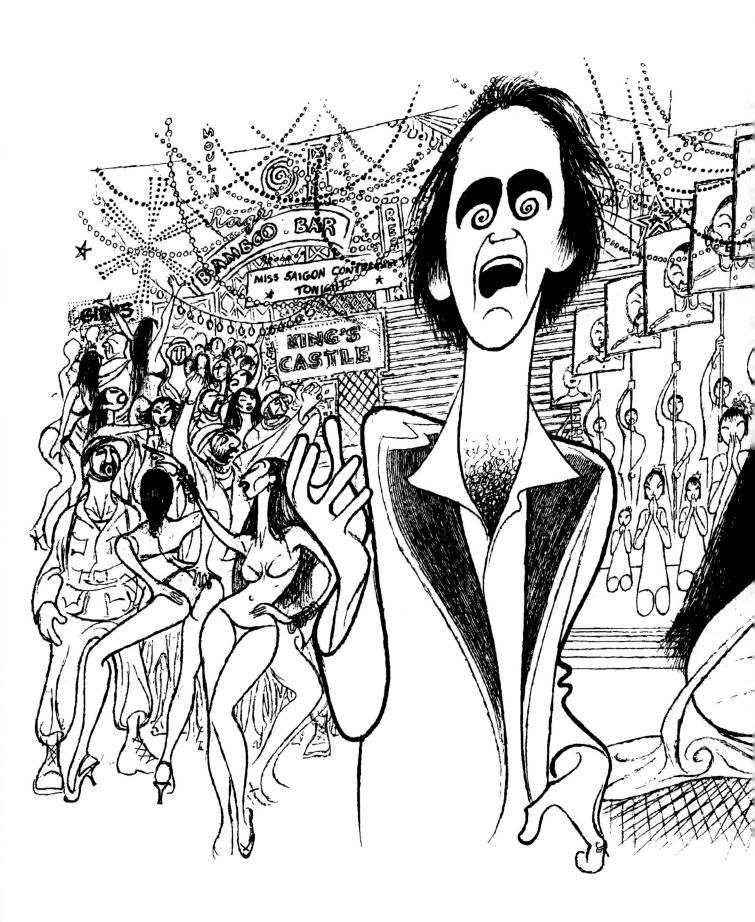

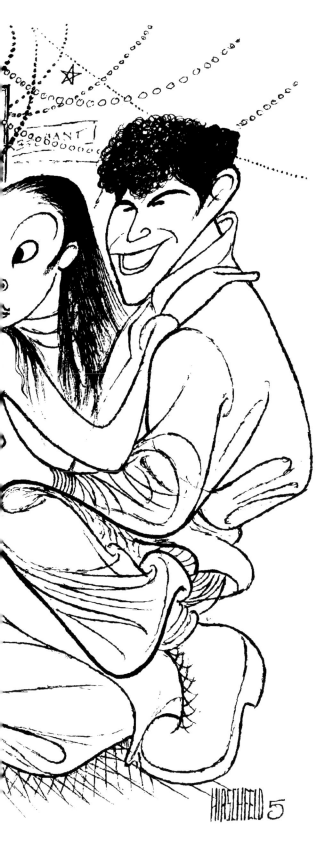

MISS SAIGON

Produced by Cameron Mackintosh;
book & lyrics by Alain Boublil & Richard Maltby, Jr.;
music by Claude-Michel Schonberg;
directed by Nicholas Hytner; scenic design by John Napier;
actors: Jonathan Pryce (Tony Award), Lea Salonga
(Tony Award) & Willy Falk; *NYT*, 1991

It was thanks to 'The Phantom of the Opera' that Jonathan Pryce became a musical star. Shortly after 'Phantom' opened, Jonathan expressed interest in taking over the title role from Michael Crawford.

It didn't come to pass, but I did remember that he could sing, and he became the unanimous choice for the role of the engineer in 'Miss Saigon,' which brought him another Tony Award. — Sir Cameron Mackintosh

Betwixt rehearsals for Mike Nichols' 1976 Broadway production of 'The Comedians,' my wife and I were schmoozing over a cocktail or two with its principal imported thesp, Jonathan Pryce. Somehow the subject strayed to what had caused the collapse of our previous marriages.

Jonathan topped us both with a heartrending description of returning home late one night after a performance in his then current production and a pause for a little light refreshment at the local pub. Prior to tiptoeing upstairs to join his presumed-to-be-sleeping wife, he had taken a moment to ensure that the telephone receiver was properly settled on its cradle, for there seemed to be a sort of murmuring sound coming from it.

Lifting the receiver cautiously to his ear, he was flabbergasted to find himself listening in to some unknown suitor berating his clearly wide-awake-wife for not already having deserted Jonathan in favor of his clearly more deserving self. 'What on earth do you see in your husband? The poor man has nothing whatever to recommend him,' her suitor was insisting.

Jonathan found himself wanting to interrupt with an urgent protest of, 'But . . . but . . . I have really interesting eyes!' And has he ever!

Al Hirschfeld, with his usual acuity, made them the core of this stunningly comprehensive composition and even chose to draw them in a subtle variation of the winningly whirling way his own eyes appear in many of his self-portraits. — Tony Walton

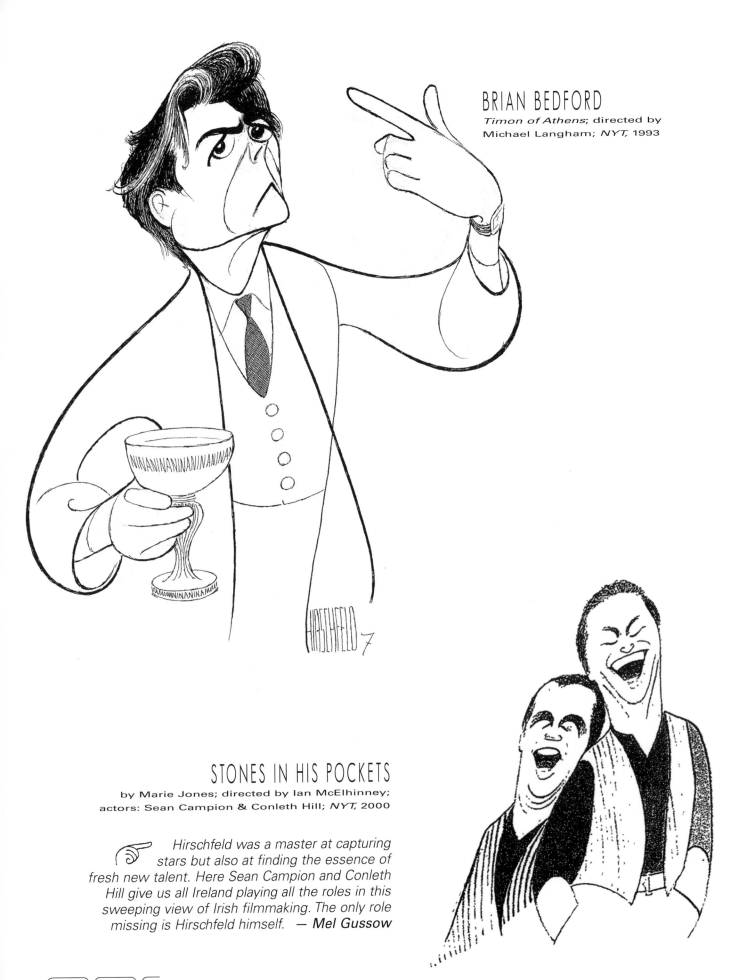

BRIAN BEDFORD
Timon of Athens; directed by
Michael Langham; *NYT,* 1993

STONES IN HIS POCKETS
by Marie Jones; directed by Ian McElhinney;
actors: Sean Campion & Conleth Hill; *NYT,* 2000

☞ *Hirschfeld was a master at capturing
stars but also at finding the essence of
fresh new talent. Here Sean Campion and Conleth
Hill give us all Ireland playing all the roles in this
sweeping view of Irish filmmaking. The only role
missing is Hirschfeld himself.* — *Mel Gussow*

CARY GRANT

To Catch a Thief; screenplay by John Michael Hayes, from
a novel by David Dodge; directed by Alfred Hitchcock;
1955 (drawing *IBM: Movies to Remember,* 1978)

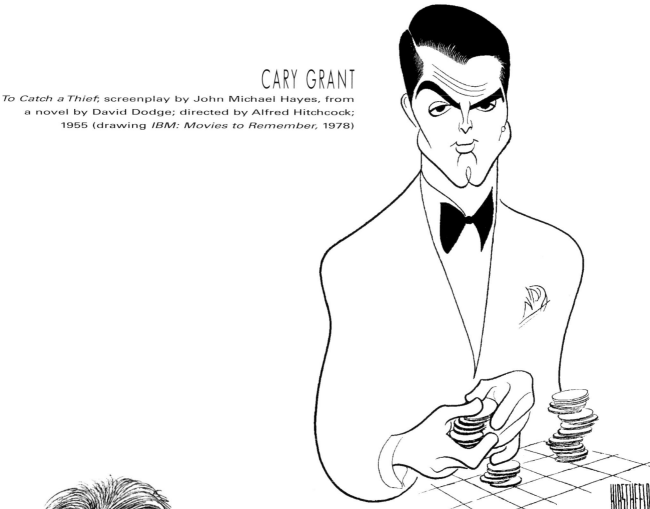

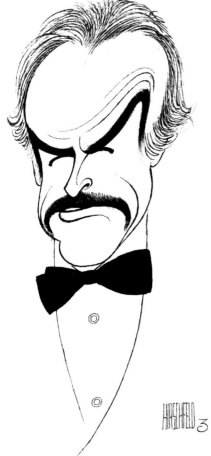

SEAN CONNERY
MF, 1992

*Occasionally shaken but never stirred, Sir Sean
Connery was the original bone-dry-vermouth 007,
and unlike many of his successors in Bondage, he has
managed to maintain a thriving movie-star career running
now to over fifty movies and at least one Oscar. His
personal wealth was recently estimated at sixty million
pounds; somehow it all seems a long way from his
late-fifties start in 'Darby O'Gill and the Little People.'*
— Sheridan Morley

*Connery is the original, the only, James Bond, dressed
apparently for another night at the casino. He's got those
great eyebrows, like an eagle's wingspan, and that Scottish
one-sided sneer. And a nose like a bottle opener. Ian
Fleming's ideal for his character James Bond was Hoagy
Carmichael, who looked — not surprisingly — just like Ian
Fleming. Connery made the role entirely over in his own
image. Others have been trying to catch up ever since.*
— Al Hirschfeld

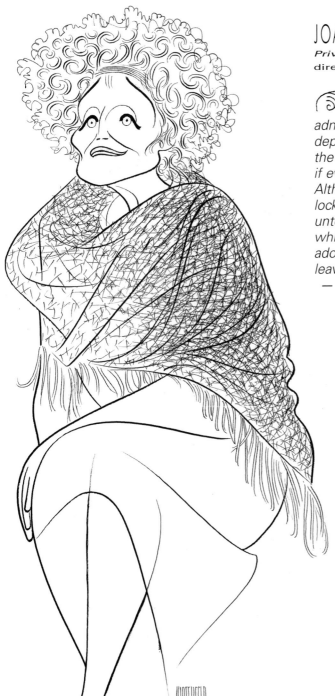

CONSTANCE CUMMINGS

Wings by Arthur Kopit;
directed by John Madden; *NYT,* 1978

JOAN COLLINS

Private Lives by Noël Coward;
directed by Arvin Brown; *NYT,* 1992

☞ *Joan Collins is one of my favourite women,
and many people think we're sisters. I must
admit, we do have a lot in common in the charisma
department and although she has the looks, I have
the bone structure. Joan and I are both survivors and
if ever there is a photo opportunity, we are it.
Although there are a few silver threads in my wisteria
locks, amazing Joan still retains her brunette coiffure,
untouched by time. Like me, she can laugh at herself,
which is probably just as well. She is married to an
adorable Peruvian possum named Percy, who could
leave his poncho on my bedpost anytime he likes.*
— *Dame Edna Everage*

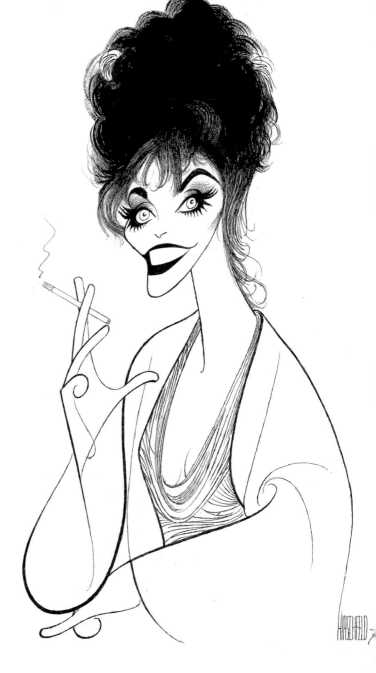

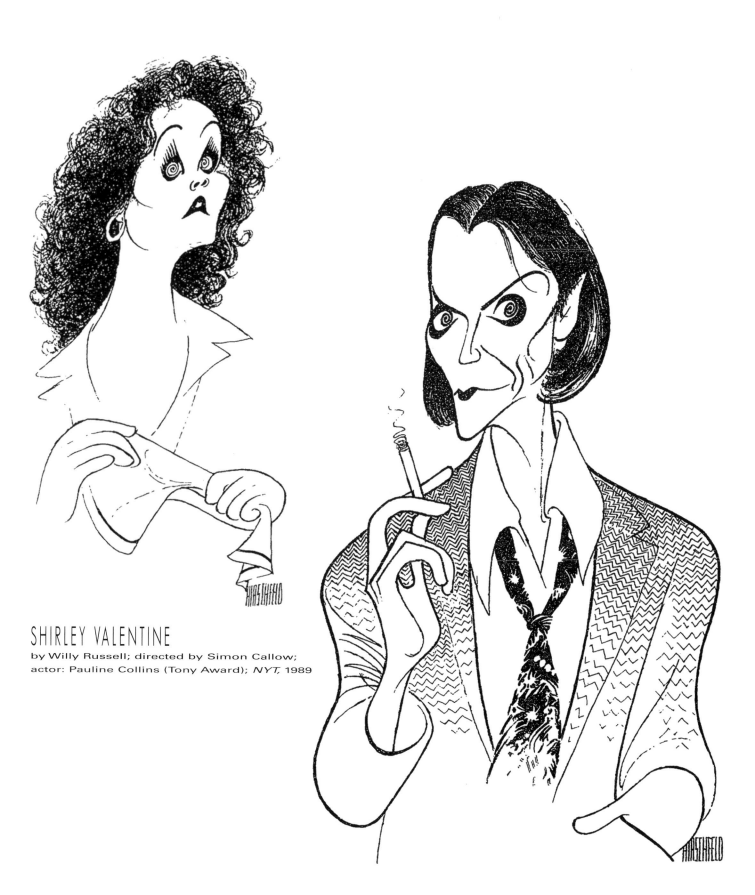

SHIRLEY VALENTINE
by Willy Russell; directed by Simon Callow;
actor: Pauline Collins (Tony Award); *NYT,* 1989

A ROOM OF ONE'S OWN
Based on Virginia Woolf texts; directed by Patrick Garland;
actor: Eileen Atkins; *NYT,* 1991

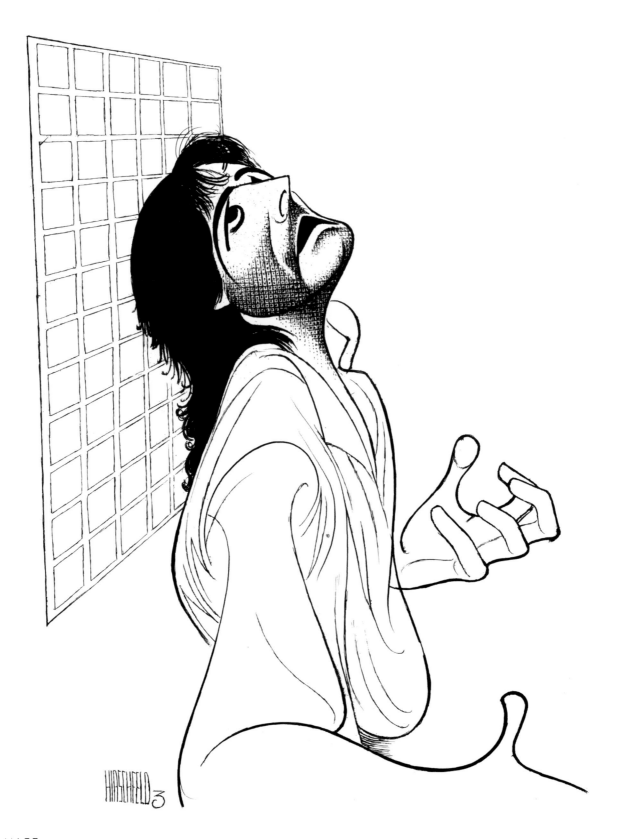

HAMLET
Directed by Jonathan Kent; actor: Ralph Fiennes; *NYT,* 1995

Ralph Fiennes. I worked with him in David Cronenberg's film 'Spider.' He has the quietest, most zen-like focus when he works. There's an aura that surrounds him. You don't want to invade that space. His thoughts are private. In his chair he waits for the director to call the scene. Like a panther who appears to be dozing on a rock but is aware of everything. 'The readiness is all.' — **Lynn Redgrave**

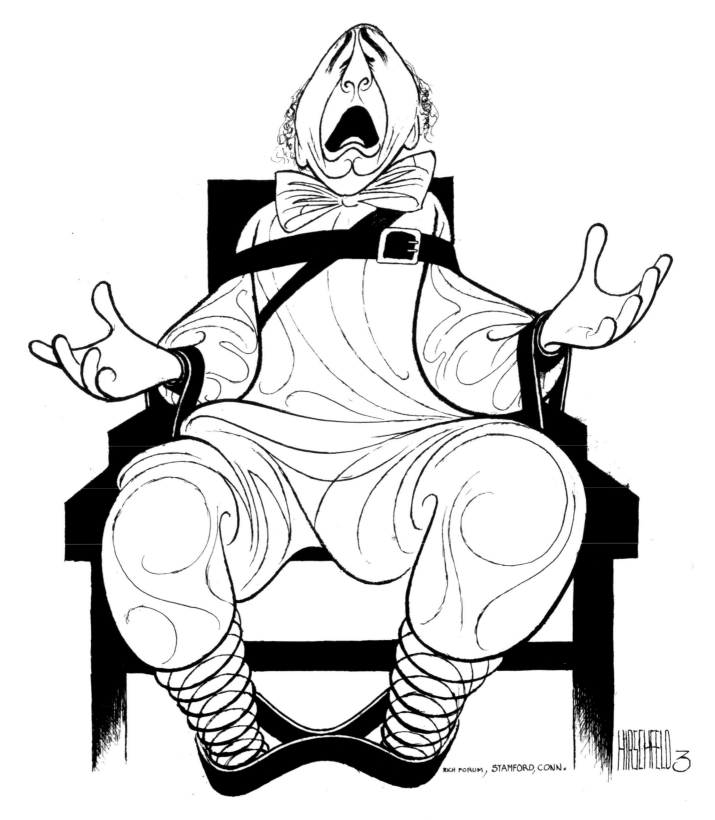

THE MADNESS OF KING GEORGE

by Alan Bennett; directed by Nicholas Hytner; actor: Nigel Hawthorne; *NYT,* 1993

I saw a late run-through in a rehearsal-room at the National. Hawthorne was extraordinary, committed with every atom of his being to the tragedy of a decent, perplexed old numskull going through hell. I'd seen him often in other plays, thinking of him always as a delicately nuanced viola player. Now he was hitting as many notes as a symphony orchestra. The notion that anyone would be surprised by his range would have annoyed Nigel Hawthorne intensely. He'd spent much of his life as an unknown jobbing actor, and his lack of recognition during these early years was a sore point which success did little to heal. — *Nicholas Wright*

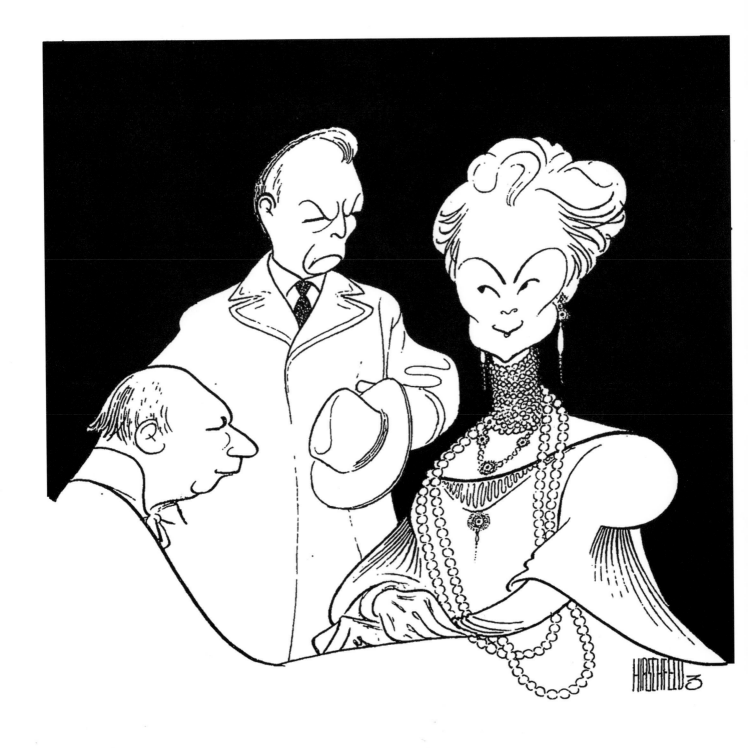

AN INSPECTOR CALLS
(Tony Award) by J.B. Priestley; directed by Stephen Daldry (Tony Award);
actors: Philip Bosco, Kenneth Cranham, Rosemary Harris; *NYT*, 1994

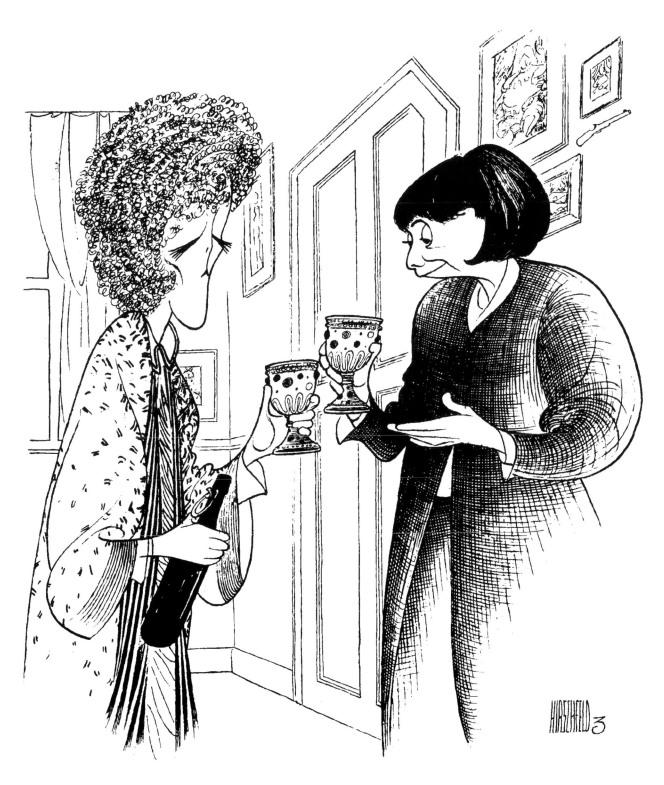

LETTICE & LOVAGE

by Peter Shaffer; actors: Maggie Smith & Margaret Tyzack (Tony Awards); *NYT,* 1990

☞ *This shows the last scene of my 'environmental' comedy, written for Maggie Smith and for which both ladies were presented with Tony Awards in New York. At the end of the play, the two stand facing each other: one is an ardent tour guide, given to fantasy; the other, an especially punctilious senior official working in the Preservation Trust of Great Britain. As a result of two earlier, less convivial encounters between them, each has been made unemployed by the other. Now they are about to toast the reconciling birth of a new venture: a partnership dedicated to showing tourists the Fifty Ugliest New Buildings in London. As I look at Hirschfeld's wonderfully accurate and agile draughtmanship, it seems to conjure up again for me the sound of the huge cascades of laughter which greeted that last scene as it was played out. — Sir Peter Shaffer*

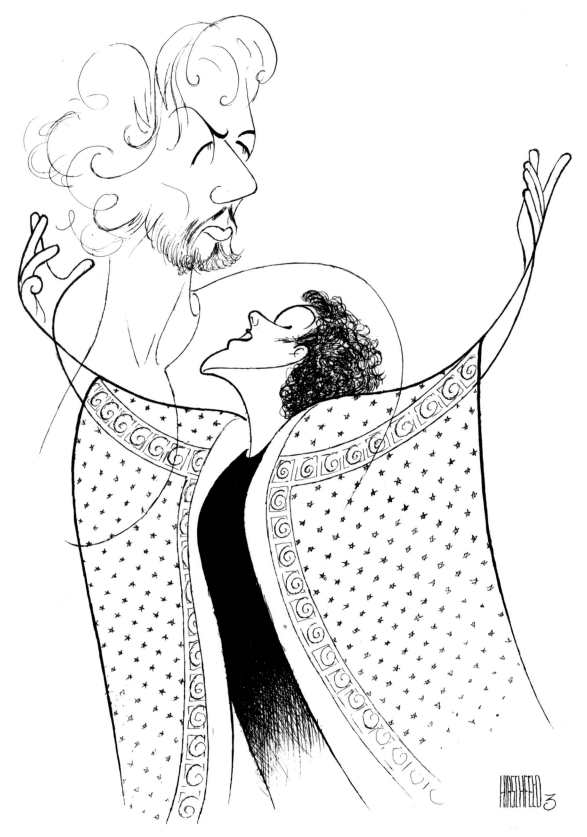

SHAKESPEARE FOR MY FATHER
Lynn Redgrave with image of Michael Redgrave; 1993

Lynn Redgrave asked Al Hirschfeld to make a drawing of her with her father, Michael Redgrave, who had died in 1983. This was a delicate undertaking in that Shakespearean postures without Shakespeare's words can seem both stagey and contrived. But Hirschfeld brought to it an irresistible human sympathy, together with a linear finesse, and father and daughter were deftly reunited. — *John Russell*

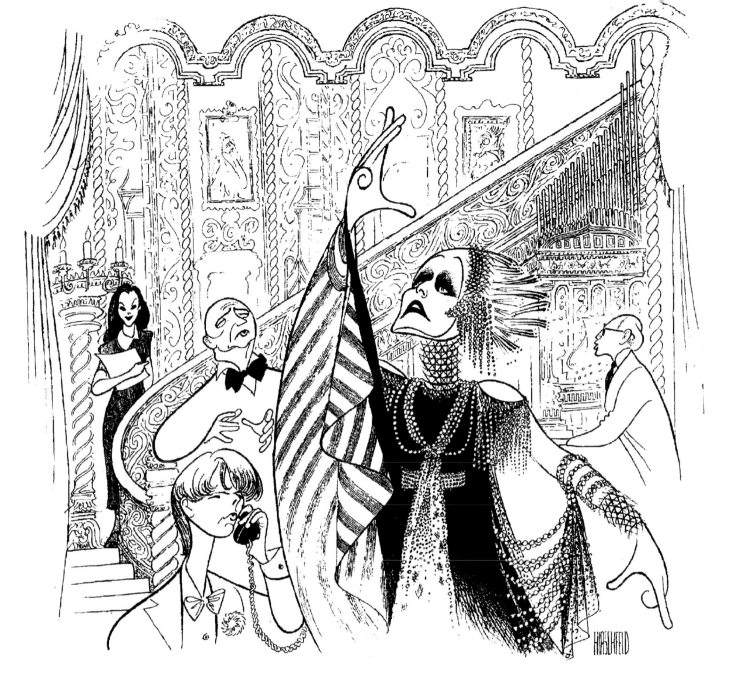

SUNSET BOULEVARD

(Tony Award) Book & lyrics by Don Black & Christopher Hampton (Tony Awards), based on the film by Billy Wilder; music by Andrew Lloyd Webber (Tony Award); directed by Trevor Nunn; scenic design by John Napier (Tony Award); costume design by Anthony Powell; actors: Alice Ripley, Alan Campbell, George Hearn (Tony Award), Glenn Close (Tony Award), Alan Oppenheimer; *NYT,* 1994

☞ *Around every bend along the twisting road to the Pacific Ocean, Hollywood mullahs huddle in their palatial mansions insulated from their fans by 20th-century versions of the medieval moat. Norma Desmond, sequestered in her darkened castle against the arching shadow of her eclipsed fame — the dreaded counterpart to stardom — meticulously rehearses her past. In 1918, Cecil B. Demille cast the young, vivacious Gloria Swanson as his lead in the silent film, 'Don't Change Your Husband.' Both director and his former star were reunited in Wilder's haunting film about the Hollywood system. Glenn Close re-created Swanson's role for Andrew Lloyd Webber's musical. For the moment, time stands still; the power, fame and glamour of a bygone era course through her being, reinvigorating the air around her. Hirschfeld pays special tribute to the powerful stage and costume designs with special detail throughout.* — **Louise Kerz Hirschfeld**

Glenn Close, as the fading silent star, looks like a cross between an Anglican priest and an Indian chief here. But that's the way they dressed during the swashbuckling Fairbanks and Pickford days in Hollywood. The elaborate costuming and sets were crucial to this production. For once, Broadway designers had to fear not going over the top enough. — **Al Hirschfeld**

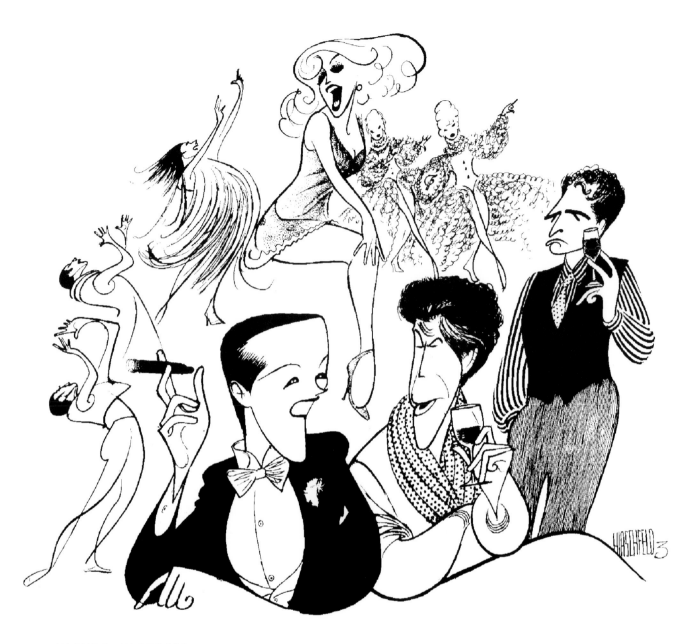

VICTOR, VICTORIA

Produced by Blake Edwards et al.; book by Blake Edwards; music by Henry Mancini; directed by Blake Edwards; actors: Julie Andrews, Rachel York, Tony Roberts & Michael Nouri; *NYT,* 1995

When Hirschfeld drew a likeness of me, he always made my chin quite pronounced — even slack-jawed. This began, I believe, during the 'My Fair Lady' years when my portrayal of Eliza, as a cockney girl, did have a somewhat slack-jawed air. And I guess the impression stuck! Some thirty or forty years later — by which time the chin had definitely filled out — Tony Walton tactfully suggested to Hirschfeld that he modify the likeness a bit and the dear man did! — **Julie Andrews**

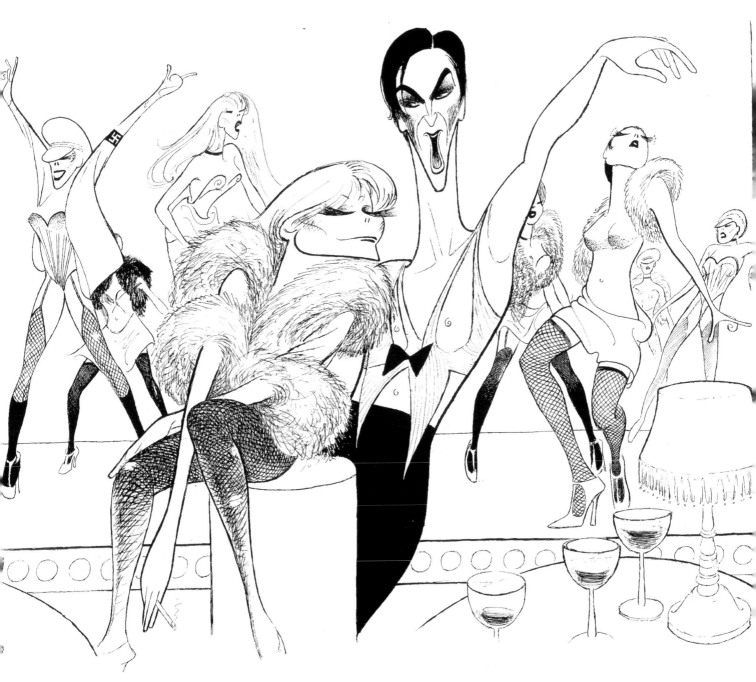

CABARET AT THE KITKAT CLUB

(Tony Award)

by Joe Masterof, based on a play by John van Druten, based on stories by Christopher Isherwood;
music by John Kander; lyrics by Fred Ebb; directed by Sam Mendes & Rob Marshall; costumes by
William Ivey Long; actors: Natasha Richardson (Tony Award) & Alan Cumming (Tony Award); *NYT,* 1998

*The swirling grotesquerie of the lines expresses pain and revulsion. How could it not? The show is a lie.
The Weimar Republic wasn't especially lubricious. People didn't go to nightclubs or have sex with each
other any more than we do. And the way in which 'Cabaret' twins the supposed decadence of 1930's Berlin with
the growth of Nazism, as though pleasure and reaction are somehow linked, is sheer moralistic finger-wagging.
— Nicholas Wright*

*Natasha Richardson taking on the Sally Bowles part in a revival of 'Cabaret.' This remake was a departure,
however. They took the theatre and made it into a café, like the Berlin one in the story. You are there, in the
drama. I admit this threw me, graphically. At the last minute, I set those tables in the foreground with the lamps
and the glasses to convey the feeling you got in the café theatre. It was really a wonderful, decadent depiction
of Germany during those times. And pretty hip these days. The final curtain leaves the audience spellbound. I
remember during the thirties many of the great cabaret entertainers from Berlin's 'Katacombe Café' left
Germany before the axe finally fell, as well as most of the actors, from the legit theatre to musicals, along with
the playwrights, composers, directors and stage designers. — Al Hirschfeld*

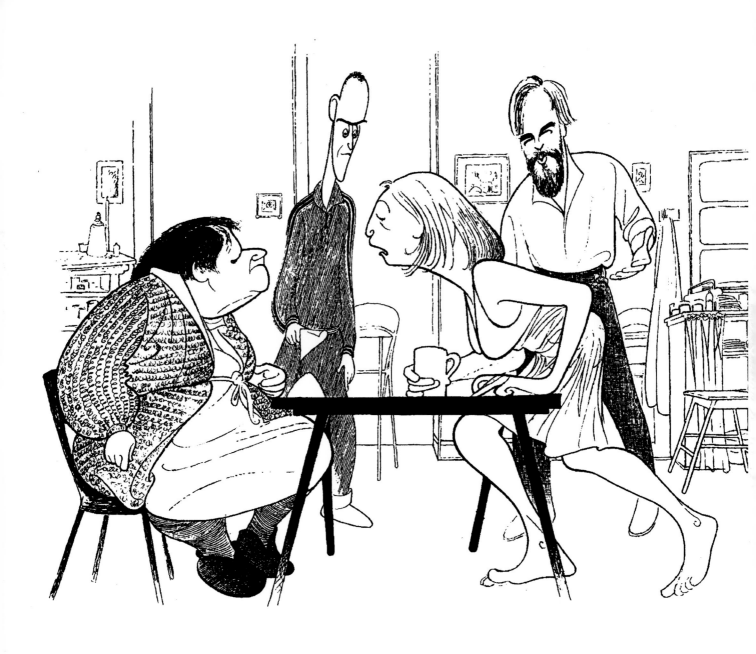

THE BEAUTY QUEEN OF LEENANE

by Martin McDonagh; directed by Garry Hynes (Tony Award); actors: Anna Manahan (Tony Award),
Tom Murphy, Marie Mullen (Tony Award), Brian F. O'Byrne; *NYT,* 1998

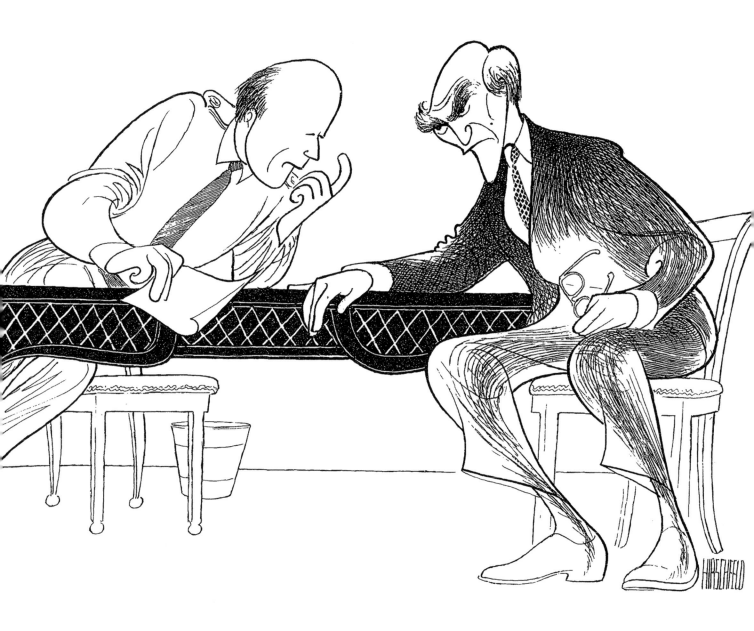

TAKING SIDES

by Ronald Harwood; directed by David Jones; actors: Ed Harris & Daniel Massey; *NYT,* 1996

☞ *The foremost conductor of the Weimar Republic, William Fürtwangler interpreted Mozart and Hindemith but ultimately could not explain himself. Under interrogation in post-WW II Berlin, the maestro does not preside over this event. A U.S. Army officer whose musical repertoire is confined to his transistor radio takes charge of the moral tone of the play. How does this great cultural leader justify having entertained Hitler? The musical genius whose cultured forehead retains whole symphonic scores seems now to draw a blank. Hirschfeld draws a huge body that resists memory. The straight Teutonic spine bends and after the trial before him will never stand tall again. — Louise Kerz Hirschfeld*

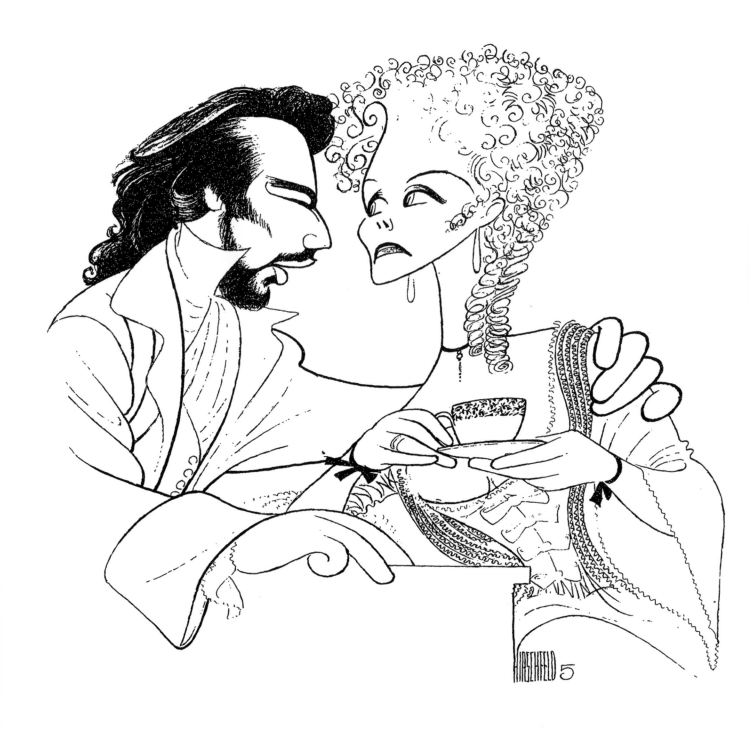

LES LIAISONS DANGEREUSES

by Christopher Hampton, from the novel by Choderlos de Laclos; directed by Howard Davies;
scenic & costume design by Bob Crowley; actors: Alan Rickman & Lindsay Duncan (Tony Award); *NYT*, 1987

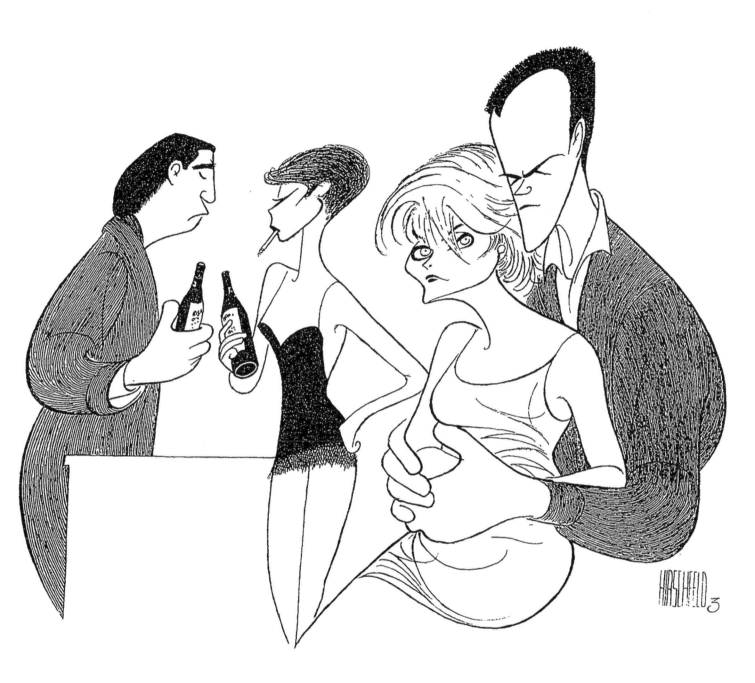

CLOSER
Written & directed by Patrick Marber; actors: Ciaran Hinds, Anna Friel,
Natasha Richardson & Rupert Graves; NYT, 1999

☞ *Patrick Marber's latterday 'Private Lives' was also the story of two couples who can live neither apart nor together; premiering at the National in 1997, it transferred to the West End and Broadway and then the wide screen in 2004. A sharp, tense account of relationships in total moral and sexual breakdown, it confirmed Marber ('Dealer's Choice') as one of the most impressive of all young British dramatists. Like Coward, he has a remarkable talent for making us fall in love with appalling people. — Sheridan Morley*

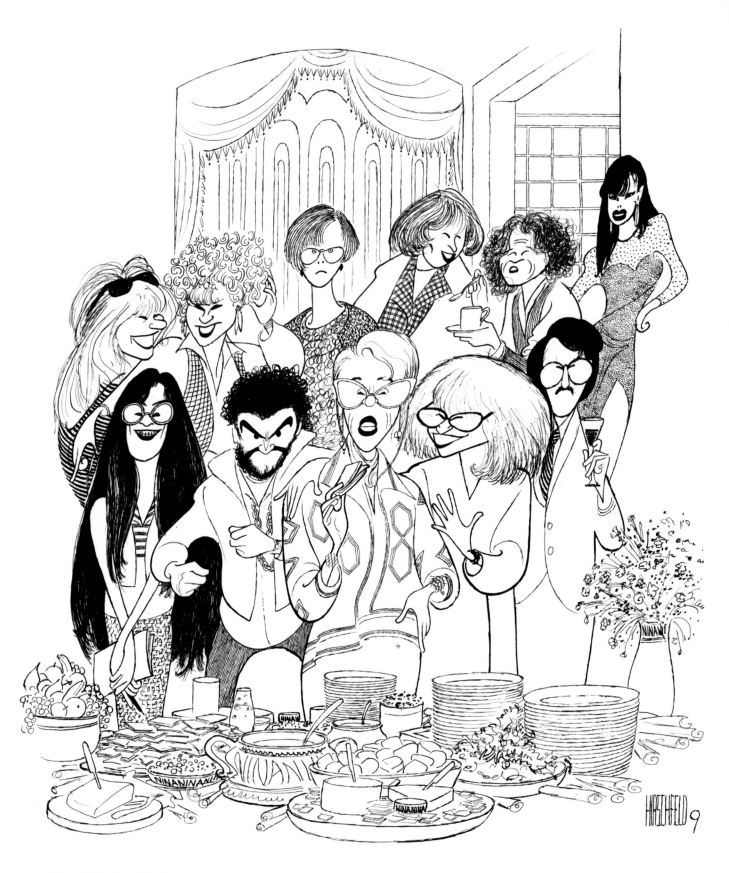

TRACEY ULLMAN (AS 11 CHARACTERS)
HBO television; 1997

*One of the greatest of all comic actresses and writers, the incomparable Tracey Ullman serves up a smorgasbord of Ullman characters jostling for attention at a sumptuous buffet. One laughs uproariously, of course, at Miss Ullman's virtuosic performances, but the genius of Hirschfeld enables us to laugh also at his drawing. — **Barry Humphries***

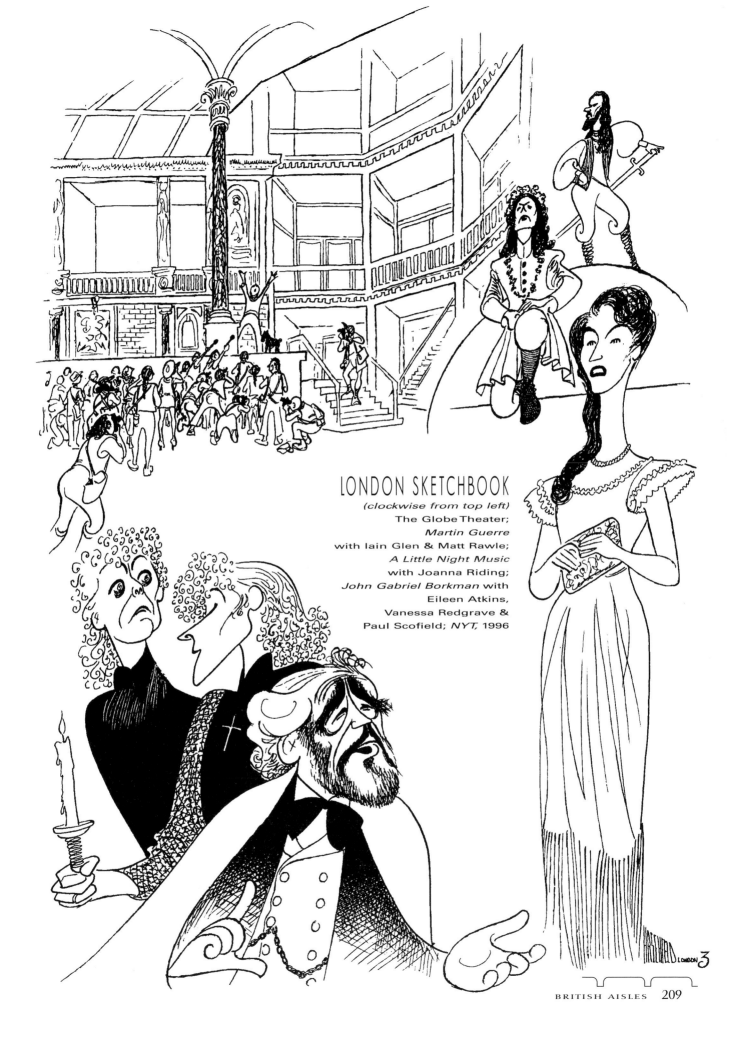

LONDON SKETCHBOOK
(clockwise from top left)
The Globe Theater;
Martin Guerre
with Iain Glen & Matt Rawle;
A Little Night Music
with Joanna Riding;
John Gabriel Borkman with
Eileen Atkins,
Vanessa Redgrave &
Paul Scofield; *NYT,* 1996

PATRICK STEWART

The Tempest; directed by George C. Wolfe; *NYT,* 1995

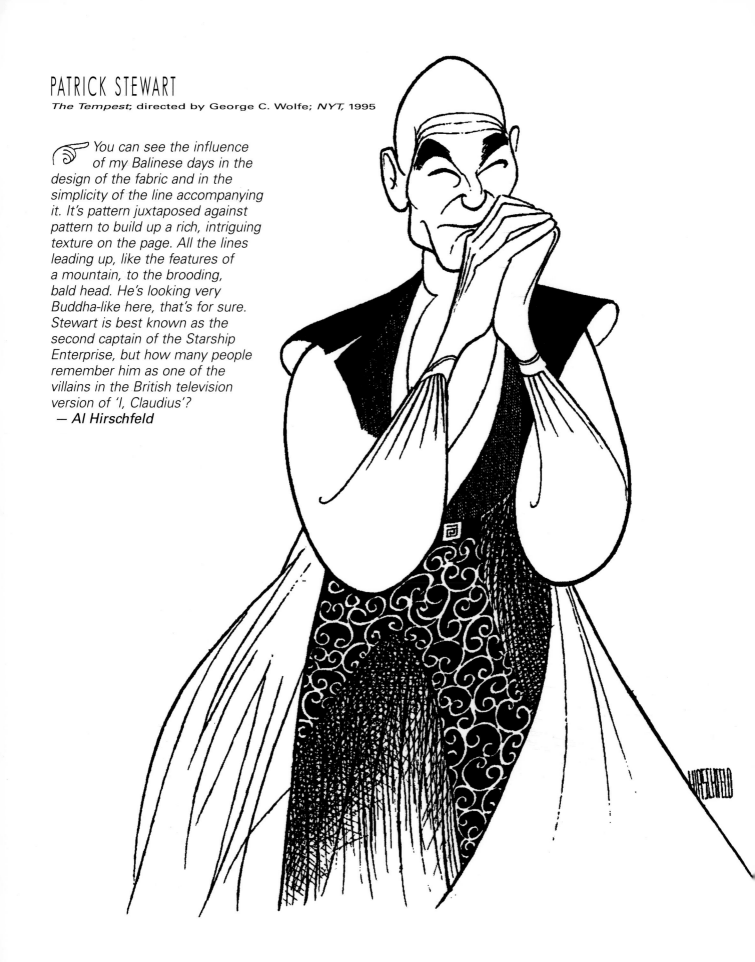

☞ *You can see the influence of my Balinese days in the design of the fabric and in the simplicity of the line accompanying it. It's pattern juxtaposed against pattern to build up a rich, intriguing texture on the page. All the lines leading up, like the features of a mountain, to the brooding, bald head. He's looking very Buddha-like here, that's for sure. Stewart is best known as the second captain of the Starship Enterprise, but how many people remember him as one of the villains in the British television version of 'I, Claudius'?*
— Al Hirschfeld

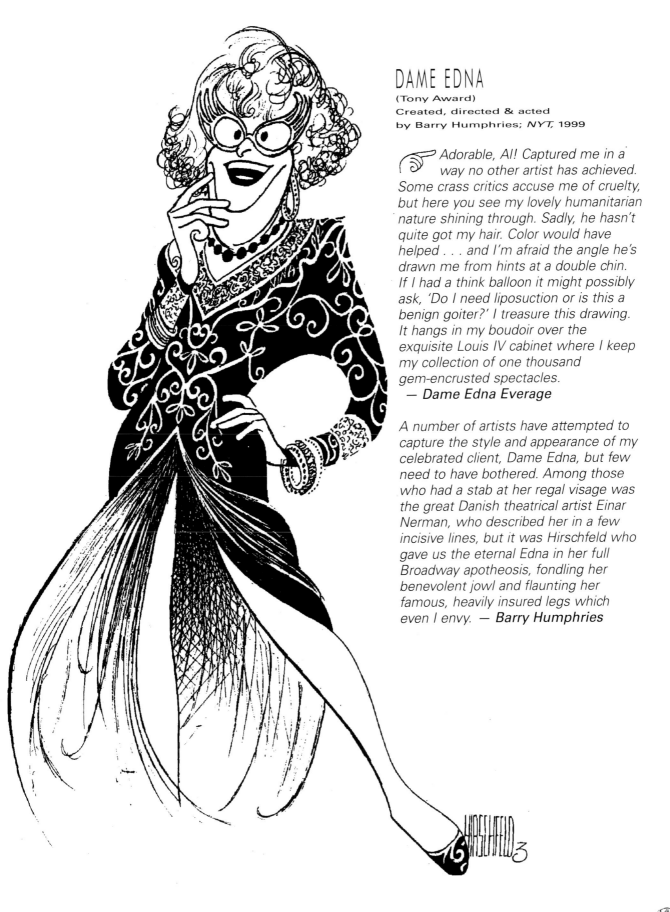

DAME EDNA
(Tony Award)
Created, directed & acted
by Barry Humphries; *NYT*, 1999

Adorable, Al! Captured me in a way no other artist has achieved. Some crass critics accuse me of cruelty, but here you see my lovely humanitarian nature shining through. Sadly, he hasn't quite got my hair. Color would have helped . . . and I'm afraid the angle he's drawn me from hints at a double chin. If I had a think balloon it might possibly ask, 'Do I need liposuction or is this a benign goiter?' I treasure this drawing. It hangs in my boudoir over the exquisite Louis IV cabinet where I keep my collection of one thousand gem-encrusted spectacles.
— *Dame Edna Everage*

A number of artists have attempted to capture the style and appearance of my celebrated client, Dame Edna, but few need to have bothered. Among those who had a stab at her regal visage was the great Danish theatrical artist Einar Nerman, who described her in a few incisive lines, but it was Hirschfeld who gave us the eternal Edna in her full Broadway apotheosis, fondling her benevolent jowl and flaunting her famous, heavily insured legs which even I envy. — *Barry Humphries*

DAME GRACIE FIELDS

Comedienne & singer; album cover for
Gracie Fields Forever, undated

VANESSA REDGRAVE
NYT, 1997

I saw her at Stratford in 'Cymbeline' in a performance so seemingly self-revelatory that I felt that I'd known her all my life. After the show, I caught sight of her at a café table and sat myself down and started chatting. It seemed the natural thing to do. I was 20. She responded like any aristocrat, with unsurprised familiarity. I have adored her ever since. At the National, in 'The Cherry Orchard,' she gave the finest Brechtian performance I've seen since the Berliner Ensemble visited London in the 60's. Faced with the notion that capitalism might actually work, Madame Ranevskaya shrieked with laughter: poor doomed soul. Only a serious leading actress who was also a Marxist could convey such pathos while being so harshly critical of the character she was playing. But ambivalence has always been deeply lodged in the Redgrave soul. — **Nicholas Wright**

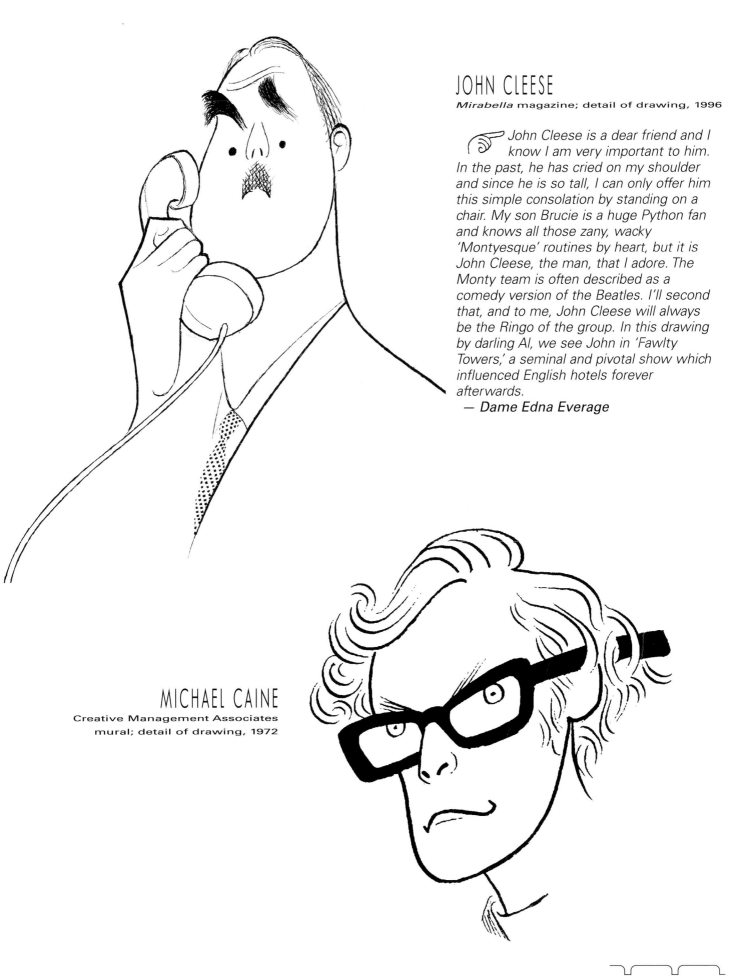

JOHN CLEESE
Mirabella magazine; detail of drawing, 1996

👉 *John Cleese is a dear friend and I know I am very important to him. In the past, he has cried on my shoulder and since he is so tall, I can only offer him this simple consolation by standing on a chair. My son Brucie is a huge Python fan and knows all those zany, wacky 'Montyesque' routines by heart, but it is John Cleese, the man, that I adore. The Monty team is often described as a comedy version of the Beatles. I'll second that, and to me, John Cleese will always be the Ringo of the group. In this drawing by darling Al, we see John in 'Fawlty Towers,' a seminal and pivotal show which influenced English hotels forever afterwards.*
— **Dame Edna Everage**

MICHAEL CAINE
Creative Management Associates
mural; detail of drawing, 1972

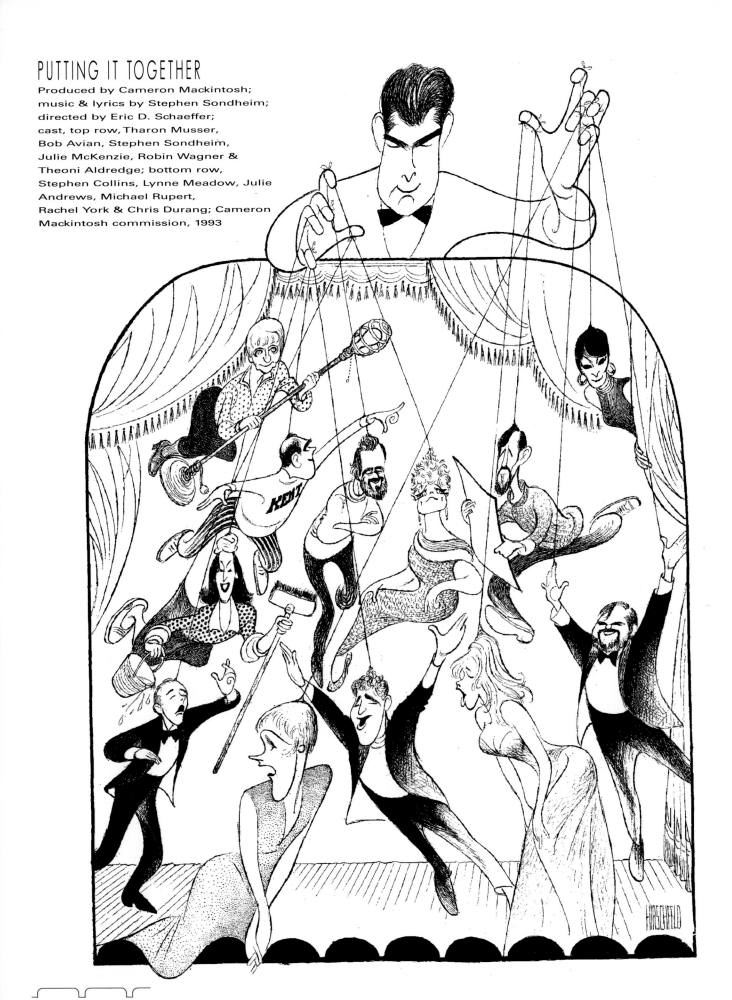

PUTTING IT TOGETHER

Produced by Cameron Mackintosh;
music & lyrics by Stephen Sondheim;
directed by Eric D. Schaeffer;
cast, top row, Tharon Musser,
Bob Avian, Stephen Sondheim,
Julie McKenzie, Robin Wagner &
Theoni Aldredge; bottom row,
Stephen Collins, Lynne Meadow, Julie
Andrews, Michael Rupert,
Rachel York & Chris Durang; Cameron
Mackintosh commission, 1993

☞ When Julia McKenzie, Bob Avian and I were putting 'Putting It Together' together we all threw out our dream casting idea — Julie Andrews. To my amazement and delight I was able to persuade her to make her Broadway comeback after a 30-year absence. Hirschfeld's reinterpretation of his own brilliant original 'My Fair Lady' poster is one of my favourites.
— *Sir Cameron Mackintosh*

Sir Cameron Mackintosh, pulling the strings of the cast of the Stephen Sondheim anthology 'Putting It Together' on Broadway in 1999. Mackintosh had also produced the very first Steve anthology, 'Side By Side By Sondheim' in London and New York back in 1976/77, and after that there were of course several others on both sides of the Atlantic. Al used the 'puppet' concept in 1947 to portray Maurice Evans' 'Man and Superman' and again in 1956 to illustrate Bernard Shaw manipulating Rex Harrison and Julie Andrews as Higgins and Eliza on the original 1956 posters for 'My Fair Lady.'
— *Sheridan Morley*

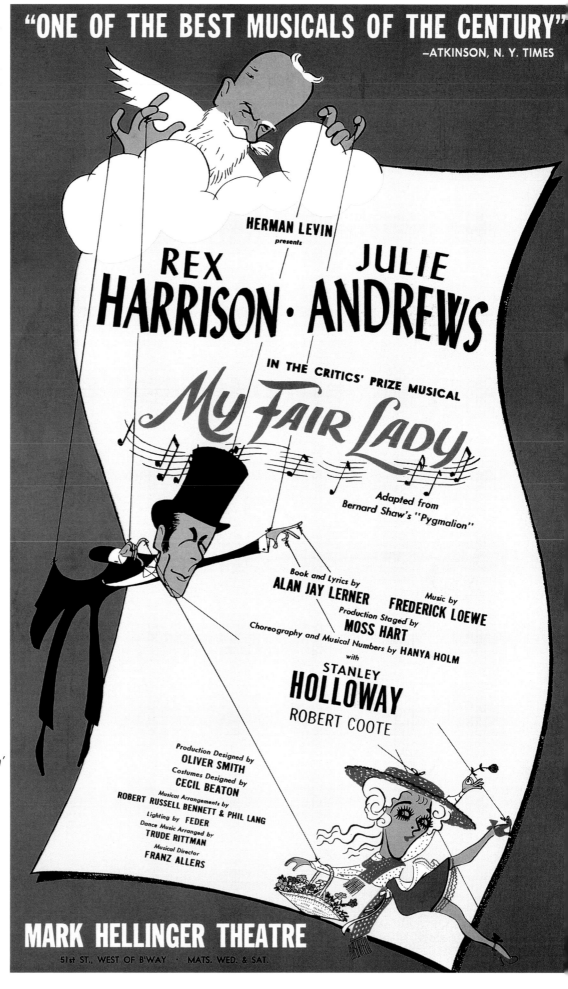

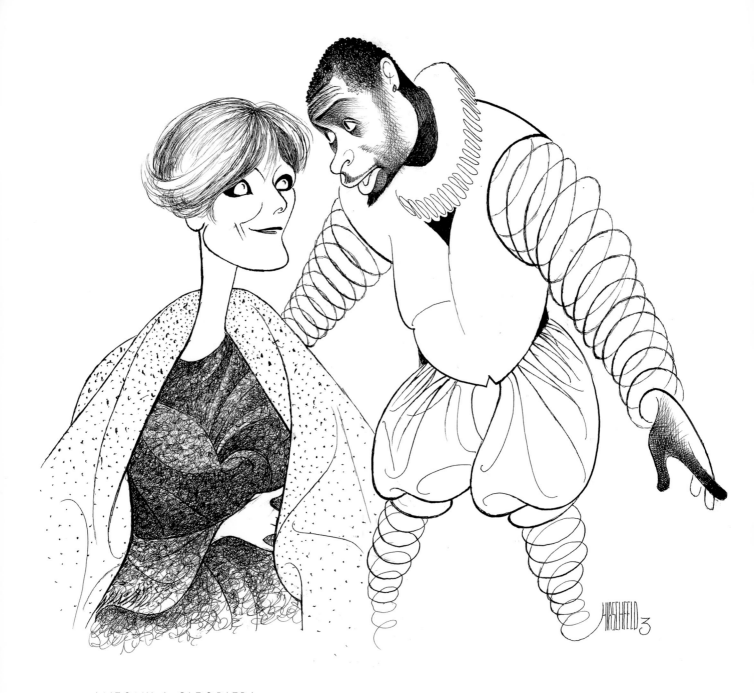

ANTONY & CLEOPATRA

Directed by Vanessa Redgrave; actors: Vanessa Redgrave & David Harewood; *NYT,* 1997

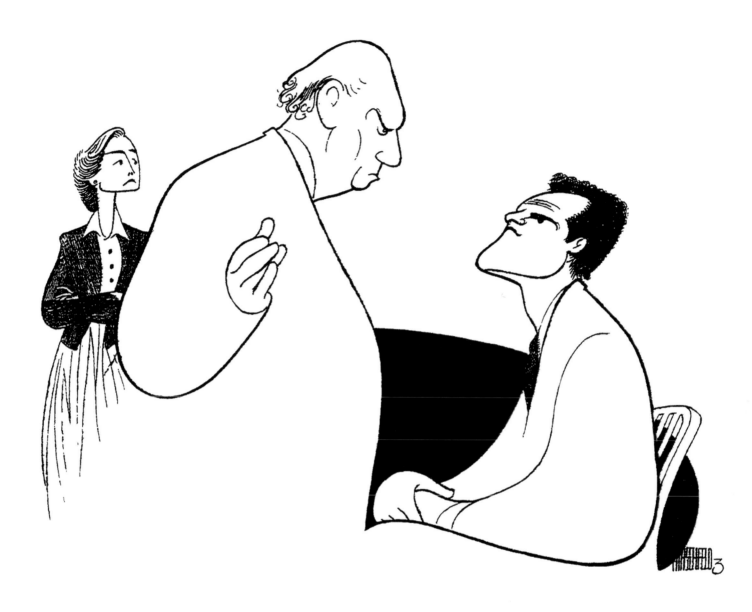

COPENHAGEN
(Tony Award)
by Michael Frayn; directed by Michael Blakemore (Tony Award);
actors: Blair Brown (Tony Award), Philip Bosco & Michael Cumpsty; *NYT,* 2000

☞ *Michael Cumpsty and Philip Bosco (with Blair Brown in the background) in the American production of Michael Frayn's 'Copenhagen,' a bold intellectual drama set against the race between two scientists for the atomic bomb in World War II. As in London, it was directed by Michael Blakemore. Here they are in Hirschfeld's rendition — man against man with the world at stake. — Mel Gussow*

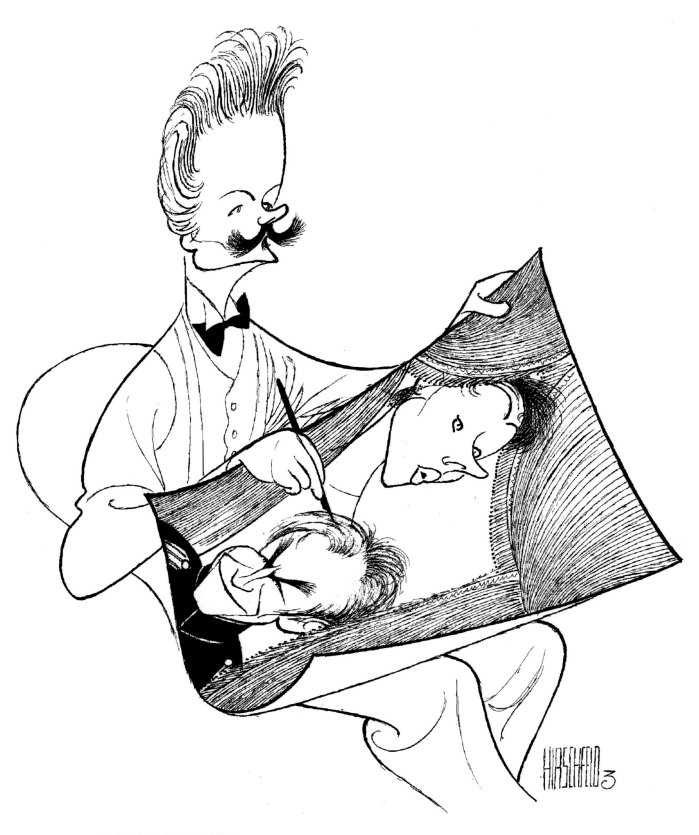

DANCE OF DEATH

by August Strindberg, adapted by Richard Greenberg;
directed by Sean Mathias; actors: Helen Mirren & Ian McKellen; *NYT,* 2001

☞ *When Al Hirschfeld drew Strindberg in the act of completing his play, 'The Dance of Death,' he knew that Strindberg was himself a very gifted artist. He was, in fact, able to produce this remarkable image in which Strindberg seems to summon up his two characters from his own being.* — *John Russell*

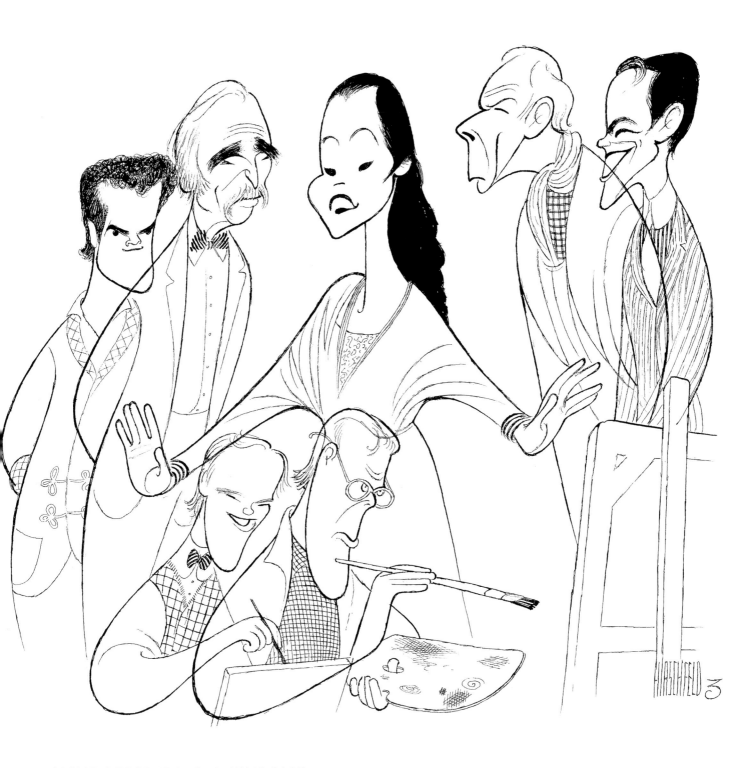

ARTIST DESCENDING A STAIRCASE

by Tom Stoppard; directed by Tim Luscombe; actors: Stephanie Roth surrounded by Michael Cumpsty, Harold Gould, Paxton Whitehead, Jim Fyfe, Michael Winther & John McMartin; *NYT*, 1989

AMY'S VIEW
by David Hare; directed by Richard Eyre; actor: Judi Dench (Tony Award); *NYT,* 1999

THE JUDAS KISS
by David Hare; directed by Richard Eyre; actor: Liam Neeson; *NYT,* 1998

CONTRIBUTORS

JULIE ANDREWS

Miss Andrews performed for the Royal Family in her youth, became an immediate success in *The Boyfriend* on Broadway, and five decades later she remains the most popular and beloved star to cross the Atlantic. She received an Oscar for *Mary Poppins*, initiated the role of Eliza Doolittle in *My Fair Lady*.

MICHAEL BLAKEMORE

The distinguished theatre and film director was associate director at The National under Laurence Olivier and directed him in *Long Day's Journey Into Night*. His Broadway credits include *Joe Egg, City of Angels, Noises Off, Democracy* and *Lettice and Lovage*. He is the only director to win two Tony Awards during the same season — for *Copenhagen* and *Kiss Me Kate*.

KEVIN BROWNLOW

Eminent filmmaker, historian, movie editor, author whose efforts to preserve landmark films has been a major achievement in film history. From studies of Chaplin, the restoration of Able Gance's *Napoleon* to a recent documentary, *Cecil B. De Mille: American Epic*, his films explore the magic of filmmaking.

SIMON CALLOW

Laurence Olivier once suggested to this bookseller that he work at the Old Vic box office. He has been box office ever since on stage, film and on bookshelves. His highly acclaimed books include *Being an Actor, Orson Welles: The Road to Xanadu*, and *A Difficult Actor: Charles Laughton*. Among his notable acting roles: *Amadeus, Shakespeare in Love*, and *Four Weddings and a Funeral*.

JULIE CHRISTIE

One of England's legendary film stars, she won an Oscar for her role in *Darling*. Her other memorable movies include *Dr. Zhivago, Far from the Madding Crowd* and *Finding Neverland*.

MEL GUSSOW

A *New York Times* drama and literary critic, with a focus on the British theatre, his recent books about Beckett, Pinter, Stoppard and Gambon have enlightened American and British audiences alike. A personal friend of Al Hirschfeld, he wrote many thoughtful pieces about his life and art.

LOUISE KERZ HIRSCHFELD

A theatre historian and curator, she organized the 2005 London Hirschfeld Celebration. She has worked as a research consultant for over 25 years in numerous television projects. She was a member of the Tony Award nominating committee and now serves as president of the Al Hirschfeld Foundation.

BARRY HUMPHRIES

One of Australia's most popular satirists, his comedic creation of *Dame Edna Everage* is an international favorite of audiences for which he won a Tony in 2001. A Renaissance man, a landscape painter, his autobiography won the JR Ackerly Prize in 1993. He received the Order of Australia in honor of his achievements.

SIR CAMERON MACKINTOSH

The most prominent producer in modern theatre times, his *Les Misérables* remains the longest running musical in West End history while his *Phantom of the Opera* is destined to become the longest running Broadway show on January 26, 2006. The owner of several major West End theatres, he is the co-creator of the recent stage musical *Mary Poppins*. He was knighted in 1996.

SHERIDAN MORLEY

Author of the authorized biography of John Gielgud, he has worked as a journalist and a broadcaster on the BBC. He is the author of many distinguished entertainment biographies and the creator and performer of several works for the stage. He has served as Arts Editor of *Punch* and Drama Critic for the *International Herald Tribune*, the *Spectator* and currently for the *Daily Express*.

LYNN REDGRAVE

The youngest daughter of England's great theatrical dynasty, she has been performing professionally since 1962 with the leading actors of our time. She specializes in comedic roles and is also an accomplished writer. Her *Shakespeare For My Father* enjoyed a very successful Broadway run.

JOHN RUSSELL

The distinguished observer of art, theatre, music and people, worked for many years as journalist and art critic for *The London Sunday Times*. In 1974 he joined *The New York Times* and became its chief art critic. His biographies of great artists and cities are required reading. He received numerous awards and is a Commander of the British Empire.

SIR PETER SHAFFER

Proflic playwright and screenwriter, his plays include *Five Finger Exercise, The Royal Hunt for the Sun, Equus, Amadeus* and *Lettice and Lovage*. He is the recipient of the the *Evening Standard* and the London Theatre Critics awards as well as the Tony, New York Drama Critics Award and the Academy Award. He was knighted by Queen Elizabeth in 2001.

RALPH STEADMAN

One of England's most prominent artists, his biting political and social caricatures are world renowned. His numerous awards include the Francis Williams Book illustration award for *Alice in Wonderland*.

TONY WALTON

Scenic and costume designer, and director for stage and films. He received Tony awards for *Pippin, House of Blue Leaves* and *Guys and Dolls*. He began his career in film as costume designer and a visual consultant on *Mary Poppins*, and received an Academy Award for Design on *All That Jazz*.

NICHOLAS WRIGHT

Playwright and screenwriter, his stage work, which includes *Mrs. Klein* and *Vincent in Brixton*, has been produced to great acclaim at the RSC, the National and the Royal Court.